Teach Yourself VISUALLY™

Digital Photography

by Elaine Marmel

From

maranGraphics®

&

Hungry Minds™

HUNGRY MINDS, INC.
New York, NY • Cleveland, OH • Indianapolis, IN

Teach Yourself VISUALLY™ Digital Photography

Published by
Hungry Minds, Inc.
909 Third Avenue
New York, NY 10022
www.hungryminds.com

maranGraphics, Inc.
5755 Coopers Avenue
Mississauga, Ontario, Canada
L4Z 1R9

Library of Congress Control Number: 00-110869

ISBN: 0-7645-3565-X

Printed in the United States of America
10 9 8 7 6 5 4 3 2 1

1K/RQ/QV/QR/IN

Distributed in the United States by Hungry Minds, Inc.

Distributed by CDG Books Canada Inc. for Canada; by Transworld Publishers Limited in the United Kingdom; by IDG Norge Books for Norway; by IDG Sweden Books for Sweden; by IDG Books Australia Publishing Corporation Pty. Ltd. for Australia and New Zealand; by TransQuest Publishers Pte Ltd. for Singapore, Malaysia, Thailand, Indonesia, and Hong Kong; by Gotop Information Inc. for Taiwan; by ICG Muse, Inc. for Japan; by Intersoft for South Africa; by Eyrolles for France; by International Thomson Publishing for Germany, Austria and Switzerland; by Distribuidora Cuspide for Argentina; by LR International for Brazil; by Galileo Libros for Chile; by Ediciones ZETA S.C.R. Ltda. for Peru; by WS Computer Publishing Corporation, Inc., for the Philippines; by Contemporanea de Ediciones for Venezuela; by Express Computer Distributors for the Caribbean and West Indies; by Micronesia Media Distributor, Inc. for Micronesia; by Chips Computadoras S.A. de C.V. for Mexico; by Editorial Norma de Panama S.A. for Panama; by American Bookshops for Finland.

For corporate orders, please call maranGraphics at 800-469-6616 or fax 905-890-9434.

For general information on Hungry Minds' products and services please contact our Customer Care Department within the U.S. at 800-762-2974, outside the U.S. at 317-572-3993 or fax 317-572-4002.

For sales inquiries and reseller information, including discounts, premium and bulk quantity sales, and foreign-language translations, please contact our Customer Care Department at 800-434-3422, fax 317-572-4002, or write to Hungry Minds, Inc., Attn: Customer Care Department, 10475 Crosspoint Boulevard, Indianapolis, IN 46256.

For information on licensing foreign or domestic rights, please contact our Sub-Rights Customer Care Department at 212-884-5000.

For information on using Hungry Minds' products and services in the classroom or for ordering examination copies, please contact our Educational Sales Department at 800-434-2086 or fax 317-572-4005.

For press review copies, author interviews, or other publicity information, please contact our Public Relations department at 317-572-3168 or fax 317-572-4168.

For authorization to photocopy items for corporate, personal, or educational use, please contact Copyright Clearance Center, 222 Rosewood Drive, Danvers, MA 01923, or fax 978-750-4470.

Screen shots displayed in this book are based on pre-released software and are subject to change.

Trademark Acknowledgments

Permissions

Hungry Minds™ is a trademark of Hungry Minds, Inc.

U.S. Corporate Sales

Contact maranGraphics
at (800) 469-6616 or
Fax (905) 890-9434.

U.S. Trade Sales

Contact Hungry Minds
at (800) 434-3422 or
fax (317) 572-4002.

Some comments from our readers...

"I have to praise you and your company on the fine products you turn out. I have twelve of the *Teach Yourself VISUALLY* and *Simplified* books in my house. They were instrumental in helping me pass a difficult computer course. Thank you for creating books that are easy to follow."

 —*Gordon Justin (Brielle, NJ)*

"I commend your efforts and your success. I teach in an outreach program for the Dr. Eugene Clark Library in Lockhart, TX. Your *Teach Yourself VISUALLY* books are incredible and I use them in my computer classes. All my students love them!"

 —*Michele Schalin (Lockhart, TX)*

"Thank you so much for helping people like me learn about computers. The Maran family is just what the doctor ordered. Thank you, thank you, thank you."

 —*Carol Moten (New Kensington, PA)*

"I would like to take this time to compliment maranGraphics on creating such great books. Thank you for making it clear. Keep up the good work."

 —*Kirk Santoro (Burbank, CA)*

"I write to extend my thanks and appreciation for your books. They are clear, easy to follow, and straight to the point. Keep up the good work!

 —*Seward Kollie (Dakar, Senegal)*

"What fantastic teaching books you have produced! Congratulations to you and your staff. You deserve the Nobel prize in Education in the Software category. Thanks for helping me to understand computers."

 —*Bruno Tonon (Melbourne, Australia)*

"Over time, I have bought a number of your 'Read Less, Learn More' books. For me, they are THE way to learn anything easily."

 —*José A. Mazón (Cuba, NY)*

"I was introduced to maranGraphics about four years ago and YOU ARE THE GREATEST THING THAT EVER HAPPENED TO INTRODUCTORY COMPUTER BOOKS!"

 —*Glenn Nettleton (Huntsville, AL)*

"Compliments To The Chef!! Your books are extraordinary! Or, simply put, Extra-Ordinary, meaning way above the rest! THANK YOU THANK YOU THANK YOU! for creating these.

 —*Christine J. Manfrin (Castle Rock, CO)*

"I'm a grandma who was pushed by an 11-year-old grandson to join the computer age. I found myself hopelessly confused and frustrated until I discovered the Visual series. I'm no expert by any means now, but I'm a lot further along than I would have been otherwise. Thank you!"

 —*Carol Louthain (Logansport, IN)*

"Thank you, thank you, thank you....for making it so easy for me to break into this high-tech world. I now own four of your books. I recommend them to anyone who is a beginner like myself. Now....if you could just do one for programming VCR's, it would make my day!"

 —*Gay O'Donnell (Calgary, Alberta, Canada)*

"You're marvelous! I am greatly in your debt."

 —*Patrick Baird (Lacey, WA)*

maranGraphics is a family-run business
located near Toronto, Canada.

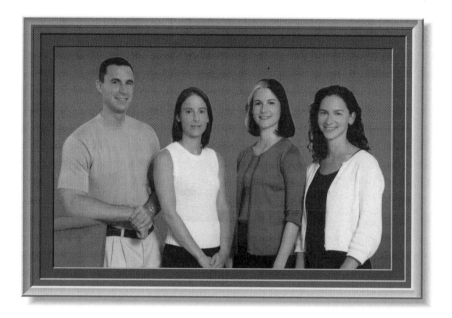

At **maranGraphics**, we believe in producing great computer books — one book at a time.

maranGraphics has been producing high-technology products for over 25 years, which enables us to offer the computer book community a unique communication process.

Our computer books use an integrated communication process, which is very different from the approach used in other computer books. Each spread is, in essence, a flow chart — the text and screen shots are totally incorporated into the layout of the spread.

Introductory text and helpful tips complete the learning experience.

maranGraphics' approach encourages the left and right sides of the brain to work together — resulting in faster orientation and greater memory retention.

Above all, we are very proud of the handcrafted nature of our books. Our carefully-chosen writers are experts in their fields, and spend countless hours researching and organizing the content for each topic. Our artists rebuild every screen shot to provide the best clarity possible, making our

screen shots the most precise and easiest to read in the industry. We strive for perfection, and believe that the time spent handcrafting each element results in the best computer books money can buy.

Thank you for purchasing this book. We hope you enjoy it!

Sincerely,

Robert Maran
President
maranGraphics
Rob@maran.com
www.maran.com
www.hungryminds.com/visual

CREDITS

Acquisitions, Editorial, and Media Development

Project Editor
Jade L. Williams

Acquisitions Editor
Jennifer Dorsey, Martine Edwards

Product Development Supervisor
Lindsay Sandman

Copy Editor
Timothy Borek

Technical Editor
Alfred DeBat

Editorial Manager
Rev Mengle

Media Development Manager
Laura Carpenter

Permissions Editor
Carmen Krikorian

Editorial Assistant
Candace Nicholson

Production

Book Design
maranGraphics®

Production Coordinator
Maridee Ennis

Layout
LeAndra Johnson, Adam Mancilla, Kristin Pickett

Screen Artists
Mark Harris, Jill A. Proll

Illustrators
Ronda David-Burroughs, David E. Gregory,
Suzana G. Miokovic, Steven Schaerer

Proofreaders
Susan Moritz, Marianne Santy, Sossity R. Smith

Indexer:
York Production Services, Inc.

Special Help
Jill Mazurczyk, Amy Pettinella

ACKNOWLEDGMENTS

General and Administrative

Hungry Minds, Inc.: John Kilcullen, CEO; Bill Barry, President and COO; John Ball, Executive VP, Operations & Administration; John Harris, CFO

Hungry Minds Technology Publishing Group: Richard Swadley, Senior Vice President and Publisher; Mary Bednarek, Vice President and Publisher; Walter R. Bruce III, Vice President and Publisher; Joseph Wikert, Vice President and Publisher; Mary C. Corder, Editorial Director; Andy Cummings, Publishing Director, General User Group; Barry Pruett, Publishing Director, Visual Group

Hungry Minds Manufacturing: Ivor Parker, Vice President, Manufacturing

Hungry Minds Marketing: John Helmus, Assistant Vice President, Director of Marketing

Hungry Minds Production for Branded Press: Debbie Stailey, Production Director

Hungry Minds Sales: Roland Elgey, Senior Vice President, Sales and Marketing; Michael Violano, Vice President, International Sales and Sub Rights

The publisher would like to give special thanks to Patrick J. McGovern,
without whom this book would not have been possible.

ABOUT THE AUTHOR

Elaine Marmel is President of Marmel Enterprises, Inc., an organization that specializes in technical writing and software training. Elaine has an MBA from Cornell University and worked on projects to build financial management systems for New York City and Washington, D.C. Elaine currently spends most of her time writing; she has been a contributing editor since 1994 to *Inside Peachtree for Windows* and *Inside QuickBooks* monthly magazines. She wrote *Peachtree for Dummies* and the *Microsoft Project Bible* and has authored and co-authored more than 25 books about Windows 98, Quicken for Windows, Quicken for DOS, Microsoft Excel, Microsoft Word for Windows, Word for the Mac, 1-2-3 for Windows, and Lotus Notes.

Elaine left her native Chicago for the warmer climes of Florida (by way of Cincinnati, OH; Jerusalem, Israel; Ithaca, NY; and Washington, D.C.) where she basks in the sun with her PC and her cats, Cato, Watson, and Buddy, and sings barbershop harmony. Her "wanderings" helped her get her start in writing and amateur photography. To become familiar with each place she lived, Elaine began to chronicle her travels. She took pictures of each place and kept a journal. Although initially her camera was an "attitude adjustment" tool to help her become comfortable with her surroundings, Elaine developed a real interest in the art and science of photography.

AUTHOR'S ACKNOWLEDGMENTS

This book was the effort of many. Thanks to Hewlett-Packard, Kodak, Olympus and Sony for the use of their equipment and to the many people who provided photographs that appear in this book. Lindsay Sandman and Shelley Lea fielded many rounds of questions on graphic formats, and the stunning artwork in this book is due to the efforts of Steven Schaerer, Suzanna Miokovic, David Gregory and Ronda David-Burroughs — I am in awe of your talents. A special thanks to Jill Mazurczyk and Tim Borek for their kind and constructive comments while editing the book, and to Alfred DeBat for helping to keep me technically accurate. Last, thank you to the people who kept me sane. Pat Schnaidt and Ann Herman went out of their way to make my life easier. Delicia Reynolds was very understanding about my *Inside Peachtree* and *Inside QuickBooks* magazine deadlines. Sue Plumley listened. And my mom, Susan Marmel, ignored me when I needed to be ignored and smiled at me when I needed it most.

TABLE OF CONTENTS

Chapter 1

INTRODUCTION TO DIGITAL IMAGING

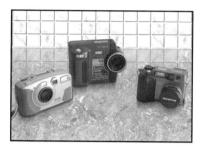

Chapter 2

DISCOVER HOW CAMERAS RECORD IMAGES

Chapter 3

EXPLORE DIGITAL PHOTOGRAPHY

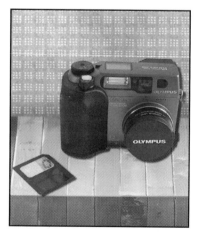

Chapter 4

Chapter 5

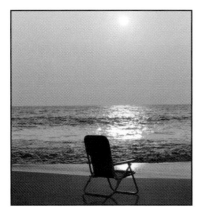
Chapter 6

TABLE OF CONTENTS

TABLE OF CONTENTS

Chapter 13

CREATE EFFECTS

Chapter 14

PRINT PHOTOS

Chapter 15

EXPLORE OTHER OUTPUT OPTIONS

Chapter 16

GET CREATIVE WITH YOUR PHOTOS

Introduction to Digital Imaging

Are you curious about digital photography? This chapter introduces you to digital imaging.

DISCOVER DIGITAL CAMERAS

Because digital cameras do not use film, you can view an image immediately after you take it — there is no time lost for development. And, with image-editing software, you can improve a digital photo.

Instant Feedback

Most digital cameras have *liquid crystal display* (LCD) panels that you can use to compose the shot. After you take a picture, you can view it on the LCD panel and, if you do not like it, you can delete it immediately.

Improve Quality

You can often salvage a less-than-perfect digital image by using image-editing software on your computer.

SAVE YOUR TRADITIONAL CAMERA

Digital cameras still have some
limitations that might make you
want to hang on to your
traditional camera a little longer,
while introducing your digital
camera into your life under
appropriate conditions.

Print Quality

If you intend to print your digital photographs, you need
a camera capable of shooting at high resolutions. High
resolutions enable you to produce a printed photo of a
quality that compares to a traditional photo. Cameras
that shoot at higher resolutions are typically more
expensive — anywhere from $500 to $15,000. See
"Compare Photo Quality " later in this chapter for a
quality comparison of digital and traditional images.

Action Shots

Digital cameras are not as well suited for capturing
action as traditional cameras. Many digital cameras
require a few seconds to store an image after you
press the shutter, and, during that time, you cannot
shoot another picture.

MAKE THE MOST OF DIGITAL IMAGES

You can use digital photographs in a variety of ways, including on a personal and professional level.

Vacations

For vacation photos, the LCD display on the digital camera allows you to check immediately to make sure you get the photo you want. You also can keep only the images that you really want, and delete others immediately.

Invitations

Create personalized stationery, invitations, and greeting cards with pictures you take with your digital camera.

Desktop Wallpaper

Use your favorite photo as the wallpaper on your computer desktop.

MAKE THE MOST OF DIGITAL IMAGES

Price List

Digital photographs can spruce up a variety of business applications. For example, you can create a photo-based company price list or inventory sheet.

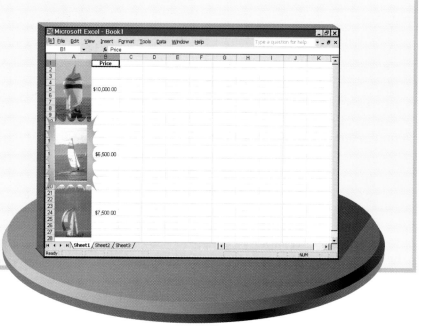

Web Page

You can place images of products on your Web page or on promotional giveaways such as mugs or T-shirts.

Industry

Digital cameras are widely used in more industries than you may think. Newspapers and television use digital cameras for fast turnaround on photos. Realtors take digital photos to create flyers to sell homes. Many insurance companies document auto accident damage by using digital cameras.

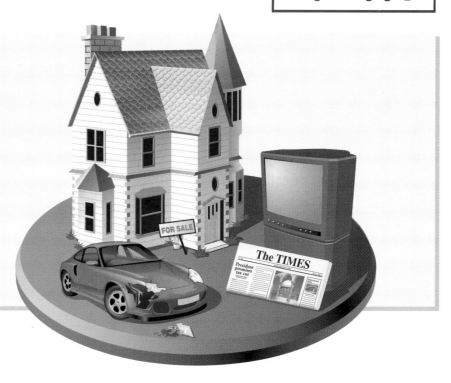

Science

Digital imagery has been used in astronomy for a long time, even on the Hubble telescope. Digital images are sent back to Earth via radio transmissions, eliminating the problem of trying to retrieve film.

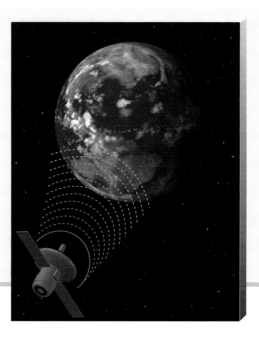

DISCOVER OTHER TYPES OF DIGITAL IMAGES

You can create digital images in other ways besides using a digital camera.

Drawn Images

Using drawing software, you can create images like this one.

Clip Art

Clip art is another form of digital imagery. Clip art images are drawn images that save you the trouble of drawing.

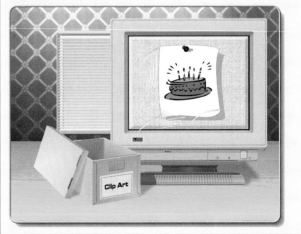

Find Clip Art Images

You can find some clip art in Adobe PhotoDeluxe, image-editing software that ships with many digital cameras. You also can use your Internet browser to search the Internet for clip art. You will find many sites that enable you to download free clip art.

Scanned Photos

You can convert a traditional photo into a digital image using a scanner. Scanners come in a variety of forms. For example, some scanners scan photographs, negatives, and slides. Other scanners scan documents and photographs, but not negatives or slides.

Photos from Digital Cameras

Using a digital camera, you can create a digital image.

DRAW A DIGITAL IMAGE

With a little artistic talent, you can create digital images by using computer-based drawing programs. Microsoft Paint is a very basic drawing program, and Adobe Illustrator and CorelDRAW! are both advanced drawing packages.

Open a Program

Open your favorite drawing program and use the tools it supplies to draw an image.

Save Your Drawing

When you save your drawing, usually by using the Save command on the File menu, you create a digital image.

CREATE A DIGITAL IMAGE BY SCANNING

You can buy scanners that are specifically designed to convert traditional photos, slides, and film into digital images.

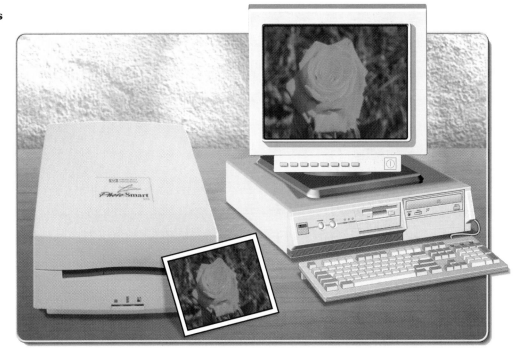

Scan a Photo

Using one of a variety of scanners, you can feed a photo, slide, or strip of film into the scanner, place the photo on the glass to scan it, or drag a handheld scanner over a small photo.

Save the Scanned Image

The scanner software displays a sample of the image and enables you to save the image to a file. If you need to edit the image, use image-editing software such as Adobe PhotoDeluxe or Photoshop, Jasc Paint Shop Pro, or Corel Photo-Paint.

AVAILABLE DIGITAL EQUIPMENT

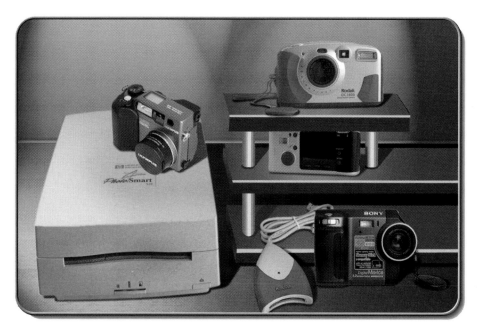

You can purchase digital scanners, digital photo printers, and other accessories that work with your digital camera. Digital cameras sell for as little as $100, and professional equipment can run as high as $15,000.

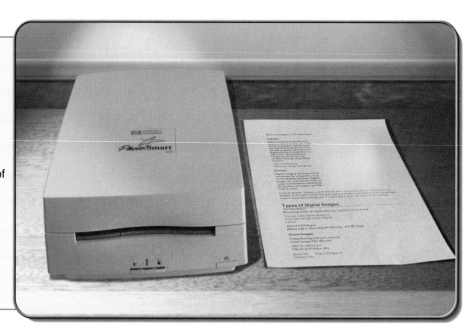

Hewlett Packard Photo Scanner

The HP PhotoSmart S20, physically just larger than a piece of paper and 3½ inches tall, enables you to convert traditional prints up to 5 x 7 inches in size, film, or slides into digital images. You can scan at a variety of resolutions and save to a variety of file formats.

Hewlett Packard Digital Camera

The HP PhotoSmart 618 digital camera is a 2.11 megapixel camera with a Pentax 3X optical zoom lens and a 2X digital zoom. This point-and-shoot camera also contains manual controls that enable you to set aperture and shutter priority, picture and metering modes, and ISO speed control.

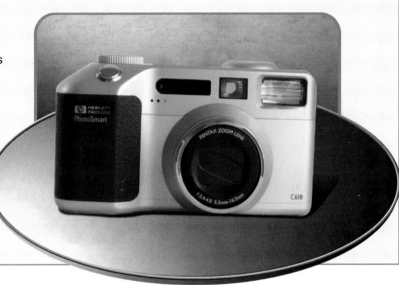

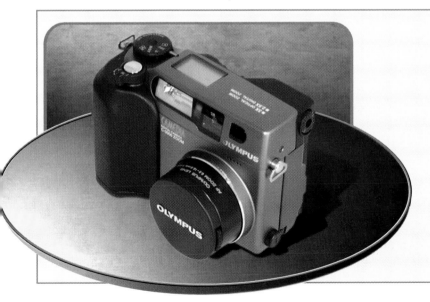

Olympus Digital Camera

The Olympus C-3000 is a 3.34 megapixel camera with a 3X optical zoom lens and a 2.5X digital zoom. This camera enables both manual and automatic operation and provides a variety of file formats for images.

AVAILABLE DIGITAL EQUIPMENT

Kodak Camera

The Kodak DC3400 is a 2.0 megapixel camera with a 2X optical and a 3X digital zoom. This easy-to-use camera enables you to set flash options, white balance, and exposure compensation.

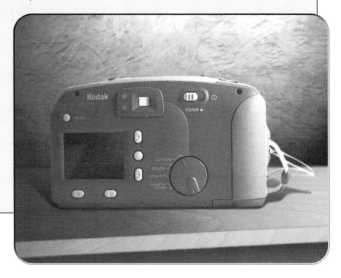

Sony Mavica

The Sony Mavica is a 1.3 megapixel camera with a 3X optical and a 6X digital zoom. This camera does not use memory chips; instead, you store images on standard floppy disks that fit inside the camera. The Sony Mavica can also take short movies — up to 60 seconds.

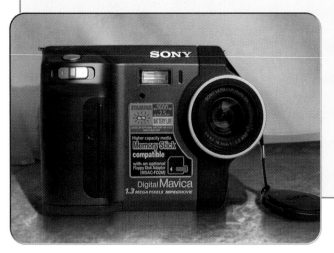

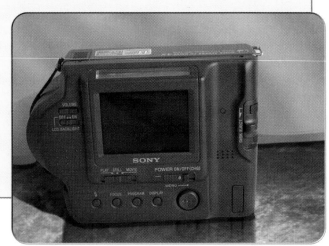

Kodak Picture Card Reader

This device retails for $39.95 and uses a high-speed USB connection to download photos you have taken onto your computer. Place the memory card from your camera into the Picture Card Reader to transfer images at high speed.

Photo Printers

Printing photos can be very easy, if you use a printer like the Stylus Photo 875DC printer from Epson, which retails for approximately $199.95. You do not need to connect the printer to your computer; instead, you insert a memory card containing photos into the printer and press a button to print.

COMPARE PHOTO QUALITY

Digital photos *can* be as good in quality as traditional photos, depending on several factors.

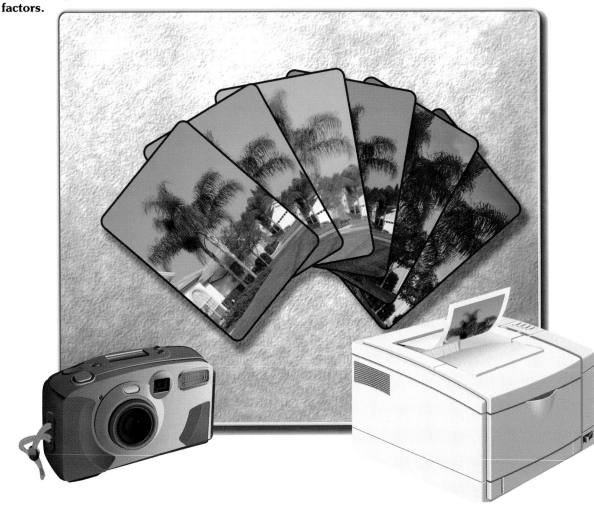

The resolution and quality of the camera lens affects the quality of the image. And, the quality of the printer and the quality of the paper you use to print also affect the quality of the printed image. With a good digital camera, good printer, and good paper, you may have difficulty seeing a great deal of difference between traditional photos and digital photos.

Hewlett Packard 618

Compare this palm tree as seen by the Hewlett Packard 618 digital camera . . .

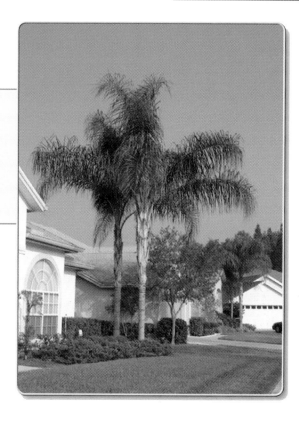

Kodak DC3400

. . . with the same scene shot with the Kodak DC3400 digital camera.

COMPARE PHOTO QUALITY

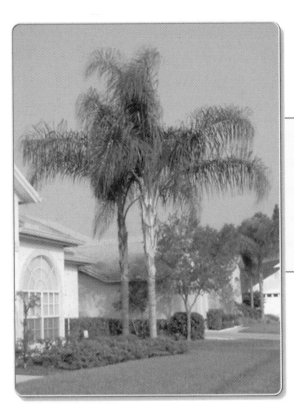

Sony Mavica FD-85

Here you see the palm tree shot with the Sony Mavica FD-85 digital camera.

Olympus C-3000 Zoom

A palm tree shot with the Olympus C-3000 Zoom digital camera.

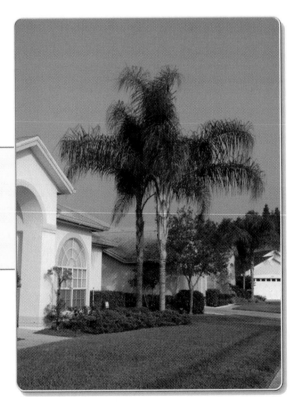

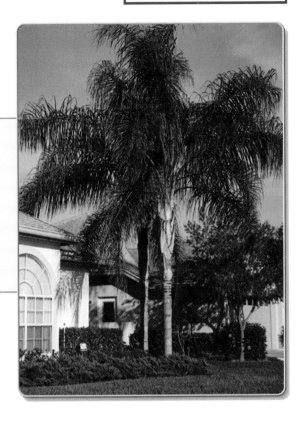

Olympus OM-1

This image was shot on an Olympus OM-1, a fine, older traditional camera that permits both manual and automatic operation. After the image was developed, it was digitized on a high-quality scanner to reproduce it here as true to its original quality as possible.

Olympus Infinity Zoom210

The Olympus Infinity Zoom210 is a point-and-shoot traditional camera that is about seven years old. This image was developed and digitized on a high-quality scanner to reproduce it here as true to its original quality as possible.

Discover How Cameras Record Images

Digital cameras look and feel similar to traditional cameras. In this chapter, you explore how cameras capture and record images.

Digital cameras and traditional cameras create images in similar ways; they simply store the images differently.

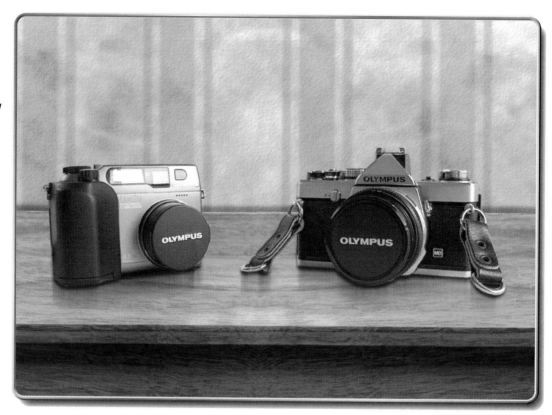

Common Functions

Both traditional cameras and digital cameras use a lens, an aperture, and a shutter. The lens brings light into focus inside the camera. By changing the size of the aperture, you control the amount of light that enters the camera. The speed of the shutter controls how long the aperture remains open.

Store Images on Film

Traditional cameras use film coated with light-sensitive chemicals to capture and store an image; whenever light hits the coated film, a chemical reaction occurs, storing an image on the film.

Store Images on Memory Cards and Disks

The digital camera does not use film to capture an image; instead, it records images onto memory cards or disks in the camera using a silicon chip that records the brightness of the light.

Develop and Download Images

A film image of a traditional image is exposed onto photographic paper and developed with chemicals. The development stage for digital images differs; you download digital images from the camera onto your computer and then, if necessary, use image-editing software to correct and print digital images.

PROCESS OF RECORDING IMAGES

Instead of film, a digital camera records pictures by using image sensor arrays that contain photosites.

Image Sensor Arrays and Photosites

An *image sensor array* is a silicon chip approximately the size of a fingernail. It contains millions of light-sensitive computer chips called *photosites.* Some image sensor arrays arrange photosites in rows and columns, like the one in this drawing. Some designers, like Fujifilm, use a honeycomb layout instead of a grid layout.

Transform an Image to a Picture

When the camera shutter opens, light enters through the lens and falls on the image sensor. Each photosite records the brightness of the light that falls on it by accumulating an electrical charge and stores the information as a set of numbers. Your computer uses the numbers to recreate the image on paper or screen.

Photosites and Pixels

The electrical charge that photosites capture and store is called a *picture element* — or *pixel,* for short. Each photosite captures one pixel. The pixel has no size or shape when it is captured; it is simply an electrical charge assigned a numeric value. The device that displays or prints the pixel gives it a size and shape.

Pixels and Digital Images

Computers display (or print) digital images by dividing the display area into a grid of pixels and then using the values stored in each pixel to specify the brightness and color for that pixel. Think of it as the computer version of painting by number. Your digital images are comprised of millions of pixels.

Digital Images and Pointillist Paintings

You can compare digital photos to post-Impressionist paintings. Georges Seurat created *Sunday Afternoon on the Island of Grand Jatte* by dotting the canvas millions of times instead of using brush strokes. When you stand close to the painting, you can see the dots, but from a distance, the dots run together and seem to disappear; you see the whole picture rather than the individual dots.

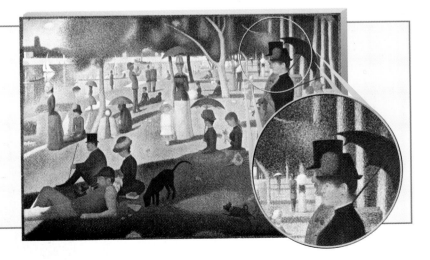

TRANSFORM BRIGHTNESS TO COLOR

Originally, traditional cameras took black-and-white photos only. Similarly, photosites capture brightness, not color, when the lens opens and light enters the camera. Brightness is converted to color in much the same way a camera creates a color image.

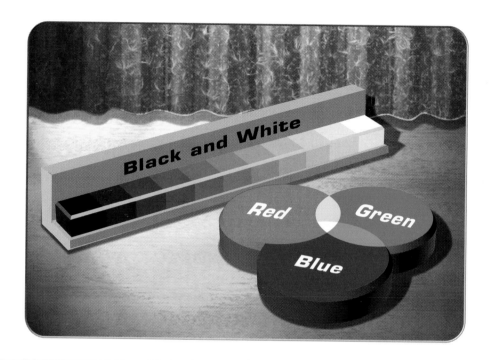

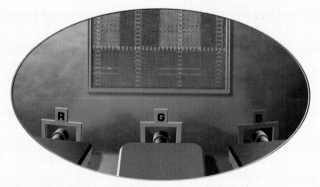

History of Color Photos

James Clerk Maxwell discovered in 1861 that he could create a color photograph using red, green, and blue filters. He had photographer Thomas Sutton photograph a tartan ribbon three times, using a different filter over the lens each time. He then projected the three images on a screen using three projectors, each equipped with a filter the same color as the filter used when the photograph was taken. When the three photos were aligned, a full color image appeared.

Black-and-White

Brightness is measured on a *grayscale*. The lightest tone on the grayscale is pure white, and the grayscale consists of 256 increasingly darker tones, the darkest being pure black.

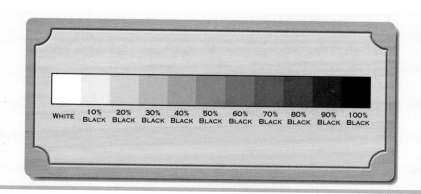

RGB

In most photographs, the colors are based on the three primary colors of red, green, and blue, and using various combinations of these three colors is called the RGB (for red, green, and blue) system. When you combine these colors in equal quantities, they form white. Most digital cameras use the RGB system.

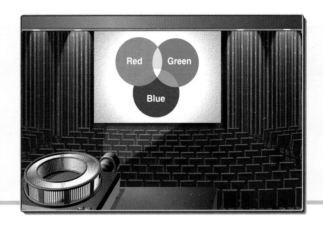

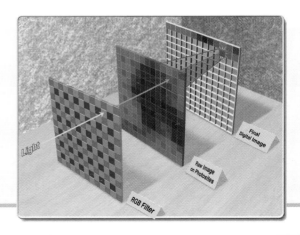

CMYK

A few high-end cameras and all printers use the CMYK system, consisting of three primary colors of cyan, magenta, and yellow (the CMY of CMYK). When you combine cyan, magenta, and yellow in equal quantities, the colors form black. However, the black that the colors form is muddy-looking; therefore, printers, when working in a four-color process, add a separate black (the K) to make the image look much sharper.

You might be wondering why printers use K for black instead of B. While there is some debate, one popular belief states that B stands for blue and therefore cannot be used for black.

Filters Create Color

Placing a red, green, or blue (the colors of daylight) filter on each photosite creates color images in digital cameras just like filters over camera lenses created color photos for Maxwell. To determine the full color of a pixel, the digital camera *interpolates* by using the color captured for the pixel in question and for the pixels that surround it.

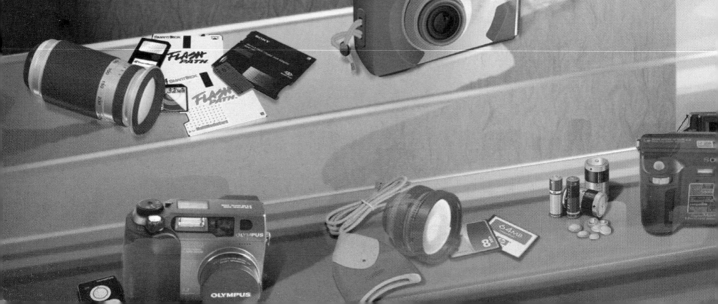

Digital Camera *Display*

Explore Digital Photography

Are you thinking of buying a digital camera? This chapter explores the common features that are available.

You can capture better quality images if you understand the effects of camera resolution. The resolution at which a camera can capture images affects the quality of the image. For more information on resolution and digital images, *see* Chapter 7.

Resolution Measurement

Camera and monitor resolutions are measured in pixels that represent the number of pixels across and down an image. The larger the numbers, the more pixels the camera can capture, producing a higher quality image. For example, 640 x 480 pixels mean that the image contains 640 pixels across and 480 pixels down.

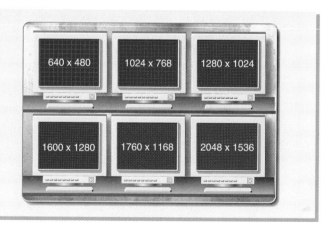

Higher Resolution

In higher-resolution images, the camera captures and stores more pixels of image data. If you intend to print the majority of the digital photos you take, you will want a camera that captures high-resolution images. You need a particularly high resolution to produce prints larger than 5 x 7 inches.

Lower Resolution

On lower resolution images, the camera captures and stores fewer pixels per inch. Lower resolution images will print well only if the image size is very small (less than 3 x 5 inches), but they work very well in an e-mail or on a Web site.

Resolution and File Size

Because higher resolution means capturing and storing more pixels, the file sizes for higher resolution images will be bigger than for lower-resolution images. The file size affects the number of photos you can take before you need to insert a new memory card or download images to your computer. For more information on resolution, see Chapter 7.

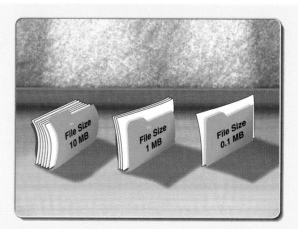

COMPRESS IMAGES

You can produce better photos by having some knowledge of photo compression. Digital cameras often compress images when saving them involves eliminating image data. On digital cameras, compression is most often associated with the JPEG file format. For more information on compression and digital image file formats, see Chapter 8.

Benefits of Compression

Compression makes the size of the file needed to store the image smaller. By compressing images, your camera enables you to store more images before you need to download them to your computer.

Costs of Compression

Because compression sacrifices image data, it is possible that the quality of the image will suffer. While some compression may not make a noticeable difference, a large amount of compression inevitably removes some important image data.

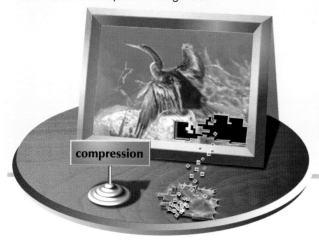

Least Compression

This photo was shot with the HP 618 using a JPEG – Best setting, which involves the least JPEG compression.

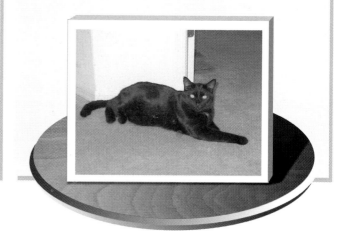

Some Compression

This photo was shot with the HP 618 using a JPEG – Better setting, which involves some JPEG compression. On a print, you might notice some degradation between this image and the preceding image.

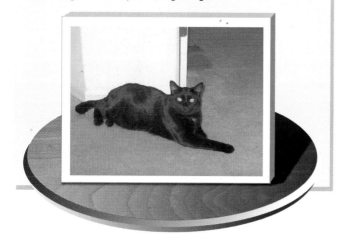

Most Compression

This photo was shot with the HP 618 using a JPEG – Good setting, which involves the most JPEG compression. On a print, the quality of this image would suffer the most, compared to the other two images.

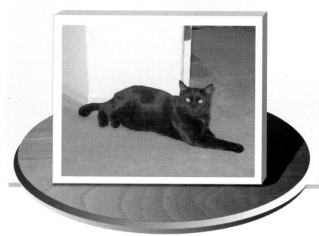

STORE IMAGES

The amount of memory in your camera, along with the compression and resolution you choose, determines the number of images you can store before you must download the images to your computer.

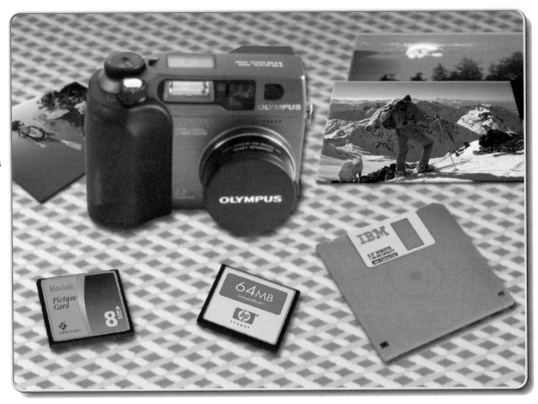

Memory Cards

Many cameras use CompactFlash memory cards like these to store the photos you take. Memory cards, like hard disks, can hold varying amounts of information, based on megabytes (MB). For example, you can buy 8MB cards, 16MB cards, 32MB cards, 96MB cards, and 128MB cards. The higher the number, the more images you can store before you must download them to your computer.

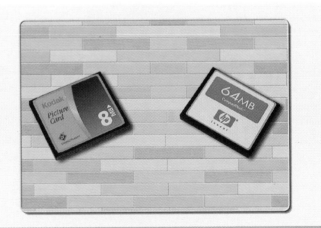

Cameras That Use Memory Cards

Cameras like the Olympus C-3000 (and many Fujifilm cameras) use a SmartMedia memory card and resemble traditional point and shoot cameras.

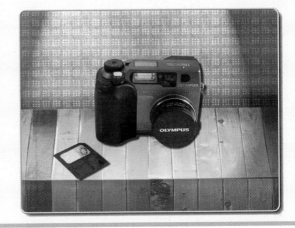

Diskettes

Some cameras store images on floppy diskettes like the ones you use in your computer.

Cameras That Use Diskettes

To accommodate diskettes, cameras like the Sony Mavica FD85 are bigger than other digital cameras.

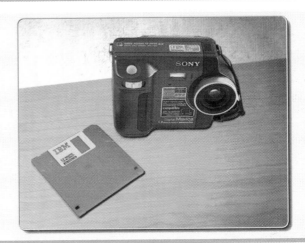

MONITOR BATTERY LIFE

You can monitor available battery life on your digital camera. Digital cameras, like traditional cameras, use batteries to power them. Digital cameras are considered high-drain devices, and you may find that you use the life on the batteries quite quickly. When the batteries are exhausted, you must replace them before you can continue using your camera.

Check Battery Status

Most digital cameras provide an icon on the camera that helps you monitor the life of the battery.

Use Heavy-Duty Batteries

You can purchase special photo lithium batteries that provide longer battery life, for example, the Energizer e² provides about five times the battery life for about twice the cost. You might also consider using rechargeable batteries.

Preserve Battery Life

For most digital cameras, you can purchase an adapter that enables you to plug your camera into electrical current and save battery life.

VIEW IMAGES ON THE LCD MONITOR

Most digital cameras have an Liquid Crystal Display (LCD) monitor that helps you set up an image before you take the picture and then review images after shooting.

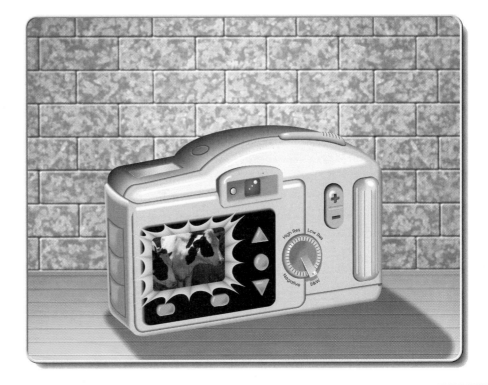

LCDs and Taking a Picture

Most digital cameras contain an LCD monitor in addition to a viewfinder, but some cameras, like the Sony Mavica, use the LCD monitor instead of a viewfinder. You can use the LCD monitor to help you compose your picture. Because LCD monitors are difficult to see under bright, sunny conditions, you may want a camera that has both a viewfinder and an LCD monitor.

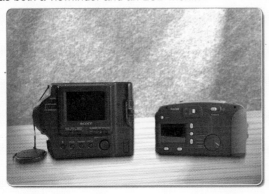

LCDs and Reviewing Pictures

You can use the LCD monitor to review images immediately — and most digital cameras enable you to delete an image you are viewing. This immediate response helps ensure that you capture the image you really want, and you do not waste valuable memory space keeping an image you do not want.

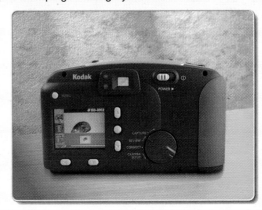

You can transfer digital images to your computer. The transfer method you use depends on the camera you purchase.

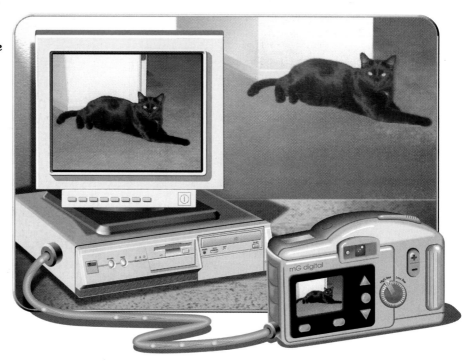

Serial Port

Many older digital cameras use serial ports to transfer image files to the computer. Serial ports carry only one bit of data at a time, so the transfer process is very slow, perhaps as long as 10 minutes per image.

USB Ports

The USB port provides the fastest transfer connection possible. You will often find one or two USB ports on newer computers. The faster and more expensive FireWire ports (IEEE 1394 ports) may or may not appear some day.

Picture Card Readers and the USB Port

If your camera uses a serial connection but your computer has a USB port, you can speed up the transfer process by purchasing a USB Picture Card reader. You connect the picture card reader to your computer, remove the memory card from the camera, and place it in the card reader.

Floppy Disk

When your camera uses floppy disks to store images, you download the images by simply copying them from the floppy disk to your hard drive.

FlashPath Adapters

The FlashPath adapter looks like a floppy disk and fits in your floppy disk drive. You can slide a memory card into the adapter and then slide the adapter into the disk drive to download images to your computer.

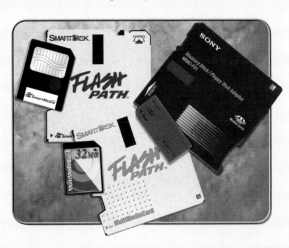

Bypassing the Computer

Many printers are being equipped with card readers and adapters that can read most memory cards directly from the camera without being connected to a computer.

SELECT A LENS

Several factors about the lens of your camera can affect the quality of your image, for example, the material of the lens, its focal length, and its zooming capabilities.

Glass or Plastic Lens

The better the lens of the camera can focus a scene onto the image sensor, the better the picture it produces. Generally, lenses made from glass are sharper and more damage resistant than lenses made from plastic.

Focal Length

A short lens has a wide angle of view; as the focal length gets longer, the angle of view becomes narrower. A short lens captures a wide expanse of a scene. A long lens with its narrower angle of view increases depth by isolating smaller objects in the fore- and background of the scene and making the objects look larger without moving the camera closer.

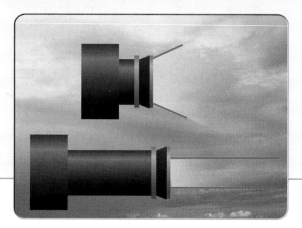

Magnification

Magnification is determined by the view captured by the angle of a lens. Because a short lens includes a wide sweep of the scene, all of the objects in the scene are reduced to fit onto the image sensor. Long lenses have a much narrower angle of view, so objects in a scene appear larger.

Zoom Lenses

Many digital cameras come with optical and digital zoom lenses that let you change the focal length of the lens as you compose a photo. The focal lengths range is usually specified by its magnification. For example, a 3X zoom lens will enlarge the subject in an image by three times compared to the wide-angle setting of the lens.

Optical Zoom

An *optical zoom* lens changes the amount of the scene falling on the image sensor. Every pixel in the image still contains unique data so the final photo is sharp and clear.

Digital Zoom

The *digital zoom* lens captures part of the image falling on the image sensor and then enlarges it to fill the image file by adding new pixels to the image using interpolation. Interpolation typically produces inferior images. Try to avoid digital zoom settings if you want to make prints.

USING A FLASH

Flash capabilities expand your photographic options by helping you take good indoor pictures and even correct some outdoor lighting conditions. Most new digital cameras come with flash capabilities, but not all flashes are the same.

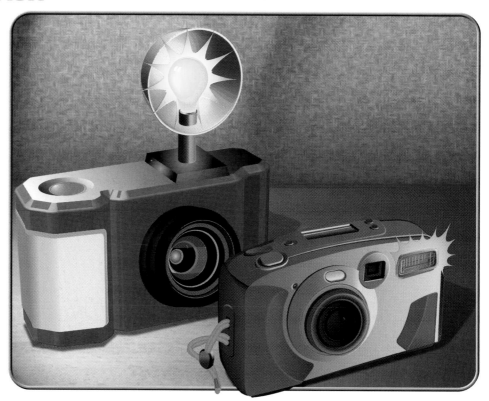

Flash Settings

Many cameras include an *automatic* flash, which fires only when the camera thinks there is not enough light, and a *fill flash*, which means that the flash fires for every shot. Some higher-end cameras include a *slow sync mode* for shooting in very low lighting conditions, and an *external flash mode*, which enables you to attach a separate flash unit to the camera. Fill flash is excellent for portraits in bright sunlight, because it gets rid of shadows around the eyes when the sun is overhead.

Red Eye Reduction

This feature reduces the red glint you often see in a subject's eyes when a flash fires while taking a photo. This feature is not essential to a camera, because you can eliminate red eye in image-editing software. For instructions on eliminating red eye, see Chapter 12.

VIEW PHOTOS ON TELEVISION

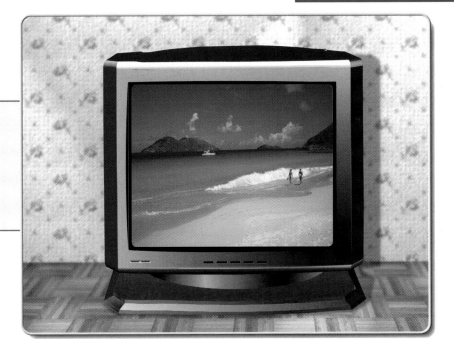

You can connect many digital cameras to televisions and view your photos on your TV set. The setup is simple and uses standard input or video-in terminals that are commonly called RCA jacks.

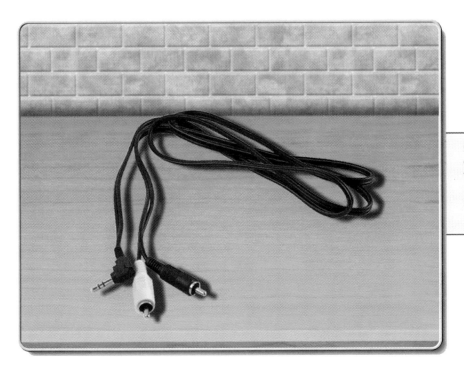

Once hooked up to your TV, you can preview your photos or share them with others. You can even use a VCR to save your slide show on videotape.

SET SELF-TIMERS ON CAMERA

You can use the self-timer that comes on many digital cameras to include yourself in photos. When you use a self-timer, press the shutter; the camera does not record the image immediately. Instead, it waits a short time — usually ten seconds — and then records the image.

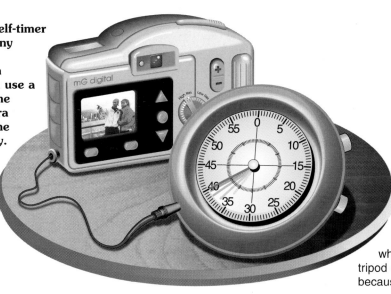

Self-timers also serve as good ways to trigger the shutter for long exposures when the camera is on a tripod or sitting on a solid base, because the camera is steady.

Self-Timer Button

Some cameras, like the Kodak DC3400, have a button on the camera that you push to activate the self-timer. After you activate the self-timer, you have approximately ten seconds to place yourself in the photo.

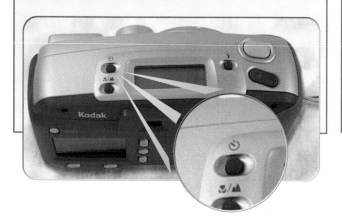

Remote Self-Timer

The Olympus C-3000 comes with a remote control self-timer. With this device, you can place yourself in the photo and then activate the shutter of the camera.

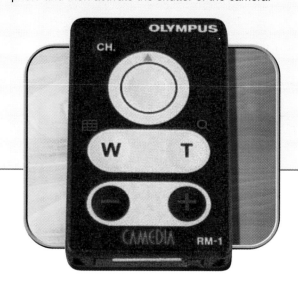

CAPTURE MOVING ACTION

You can only capture moving action with a digital camera that offers features such as continuous capture or mini-movie. With standard digital cameras, shooting action is difficult because the camera needs time between shots to save the image, and, in action situations, you do not want to wait while the camera stores the image.

Continuous Capture

Using this technique, you press and hold the shutter while moving the camera. When you release the shutter, the camera records the image. You actually shoot two or three frames per second.

Mini-Movies

Some cameras, like the Sony Mavica, enable you to capture and store MPEG files, which are movie files. Press and hold the shutter and pan the camera. You can add sound to the movie by simply talking. For more information on mini-movies, see Chapter 15.

Compose Your Shot

This chapter shows you how to create interesting pictures by setting the scene.

POSITION YOUR PHOTOGRAPH

When you compose your picture, compose for interest. For example, you may want to avoid placing the object of interest in the exact center of the photo.

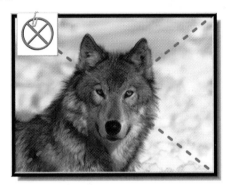

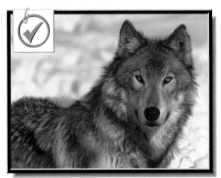

Center the Horizon Line

In this beach scene, the line where the sky meets the beach falls in the center of the photo. This placement provides equal emphasis to both the sky and the sand. This photo would probably be more interesting if it contained less sand in the foreground and drew the eye to the real item of interest — the inlet.

Place Horizon Line Off-Center

In this image, the horizon line appears up higher in the picture, giving less emphasis to the sky. The second line in the photo — the implied line created by the waves in the foreground — helps give more emphasis to the water, and the footprints draw your eye away from the center of the photo.

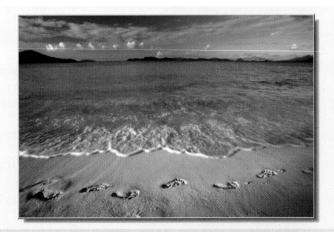

Align Object with a Positioning Grid

As you compose your picture, you might
want to imagine a positioning grid like this
one on top of the scene you are viewing. Try
not to place the object of interest in the
scene in the center box. Instead, align
objects of interest along the lines of the
grid. If possible, place the focal point of an
object of interest on one of the intersection
points on the grids.

Superimpose a Positioning Grid on a Scene

When you superimpose the positioning grid on top of a
photo, you see how the objects of interest in the photo
fall outside the center square of the grid. Lines, like the
skyline, fall on or near a line of the grid.

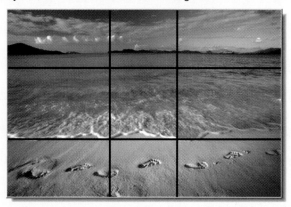

Position a Scene with No Lines

You can use the
rule of the grid
even when the
scene does not
contain lines. In
this portrait-
orientation
picture, your
eyes are drawn
to the eyes of the
gorilla, which fall
at or near one of
the intersection
points of the
positioning grid.

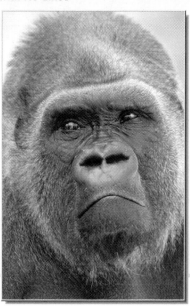

BALANCE THE SHOT

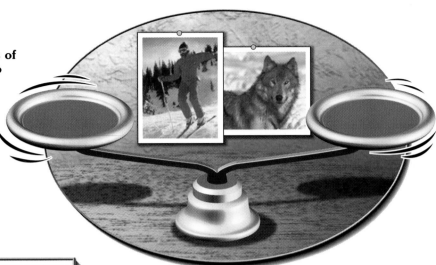

You can balance the subjects of your photo to add interest to your photo. An unbalanced photo distracts the viewer and, in a subtle way, reduces the pleasure the viewer gets from the photo.

Avoid an Unbalanced Scene

This shot is just slightly off balance; the people are off to the right side of the image, placing the man in the center of the photo. You can correct the problem in this photo by cropping.

To learn how to crop, see the "Crop a Photo" section in Chapter 10. Check the Background.

Position People for Balance

In this shot, the positioning of the people balances the shot and adds interest. Neither person appears in the center of the photo.

Use Objects for Balance

In this photo, the tree balances the house, providing more interest than just the house alone.

Balance in Wildlife

These rams very kindly posed for this well-balanced photo. Its seated partner offsets the height of the standing ram.

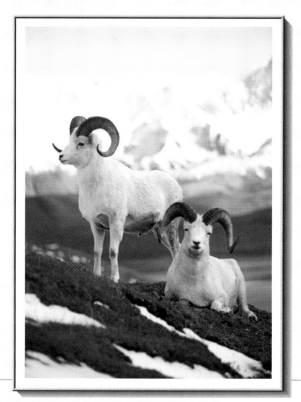

Balance in Nature

This shot could have been very dull with only one flower.

CHECK THE BACKGROUND

You can create better photos by paying attention to the background as well as the subject. When you compose your shot, be sure to check the area surrounding the object you are photographing.

Avoid Extraneous Objects

In this photo, the man looks like a mop is growing out of his head.

Focus on an Object

By simply moving the subject or the photographer, you can create a shot that focuses on the object you intended.

PROVIDE AN ELEMENT OF DIMENSION

You can help your viewer understand the size of objects in your photo by including other objects of known size in the photo.

Landscapes

The viewer gets a better sense of the size of the rocks in this river scene because of the person standing in the foreground of the photo.

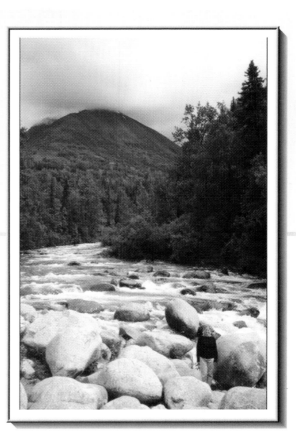

ADD A FRAME FOR INTEREST

You can add impact and interest to your pictures by using a natural frame. Natural frames typically do *not* surround your picture like manufactured frames, and trees most often provide excellent frames.

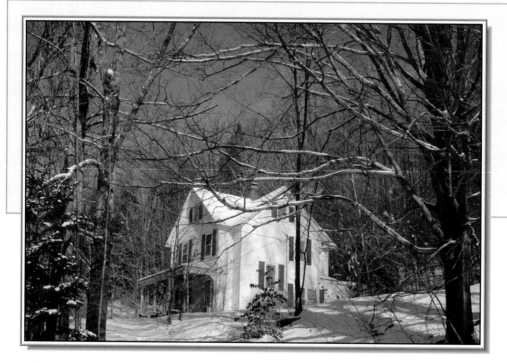

Frame a Photo with Nature

Although the trees could have been eliminated from the shot, they frame the house along both sides and across the top.

Add a Skyline

In this photo, the tree branches frame the top of the photo and quite cooperatively match the shape of the church steeple.

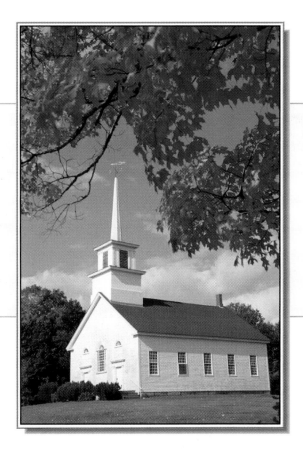

Add Interest Sparingly

The hint of a palm tree in this photo provides a natural frame that adds interest to the image.

ADD A FRAME FOR INTEREST

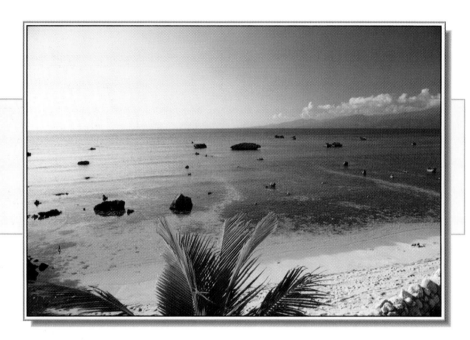

Frame the Foreground

The palm fronds frame the bottom of this beach scene and add interest to it.

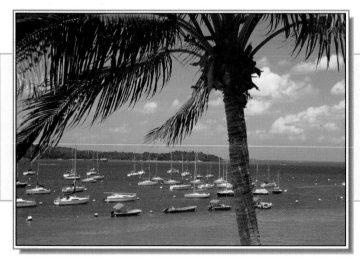

Look for Creative Opportunities

The tree in this photo provided an unusual opportunity for creative natural framing of the boats.

Use Rocks to Form a Natural Frame

Of course, the mountain goat must stand on something, but the line of rocks at the bottom of the photo also provides a natural frame.

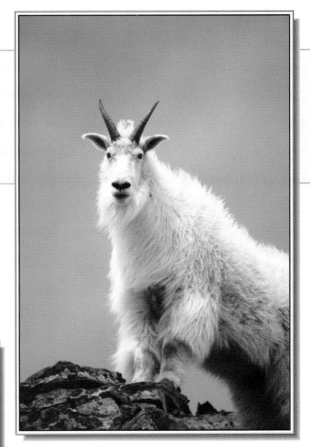

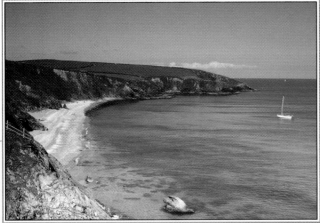

Use Shorelines as Frames

In this photo, the shoreline provides a frame along the majority of the left side of the photo.

CHANGE THE ORIENTATION

You can change the focal point of your photo by your choice of orientation. Do not be afraid to turn your camera.

Landscape Orientation

Landscape orientation produces an image that is wider than it is tall. The outdoors — landscapes — lend themselves well to the wide angle of landscape orientation.

Portrait Orientation

In a portrait orientation, the image is taller than it is wide. Most photos of people work well in portrait orientation.

Appropriate Orientation

Tall buildings work best in portrait orientation.

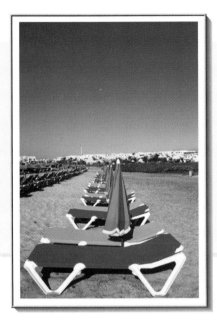

Remain Flexible

Sometimes, the scene you are shooting makes the orientation choice for you, like this photo of beach chairs.

Scene Set the Orientation

If you used a portrait orientation when shooting this photo, you would not have been able to fit the entire inner tube in the photo.

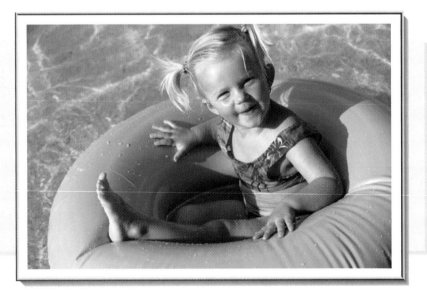

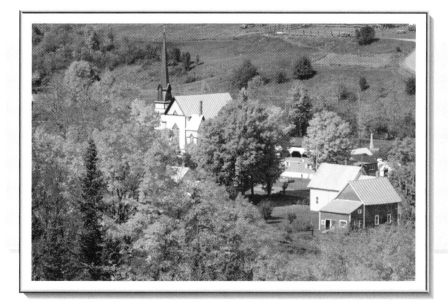

Try Different Approaches

The scene contains no real surprises in its landscape orientation.

Try Different Perspectives

Changing the orientation and stepping back a bit gives you an entirely different perspective.

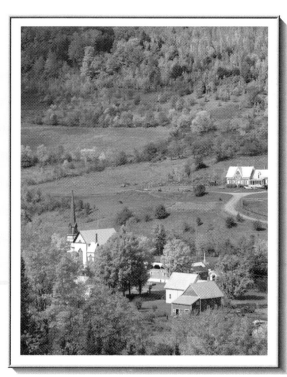

USING COLOR FOR AN EFFECT

You can use color to enhance photos — and you may make color the focal point of a photo by using color as the element of the photo that draws the viewer's attention.

Add a Sunset

The color of the sky at sunrise and sunset has been and continues to be awe inspiring.

Capture the Colors of Autumn

The colors of fall in the northern climates are breathtaking.

Add Flowers for Detail

Plants can be very impressive. Creative use of flowers definitely catches the eye.

USING COLOR FOR AN EFFECT

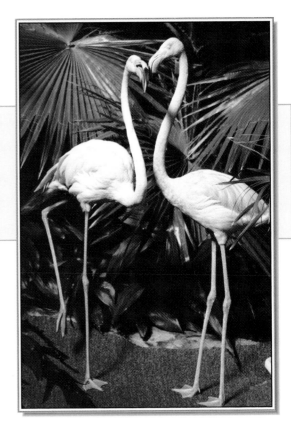

Inspire with Birds

Of all the animals, birds seem to have the most variety of colors. These flamingos provide a wonderful contrast to the world of green around them.

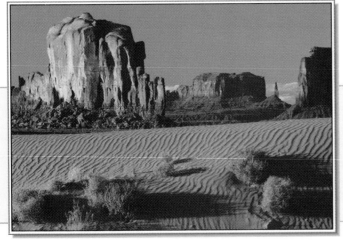

Convey Heat with Color

The colors of a photograph can send subtle messages. For example, the colors in this photograph tell you the climate is hot.

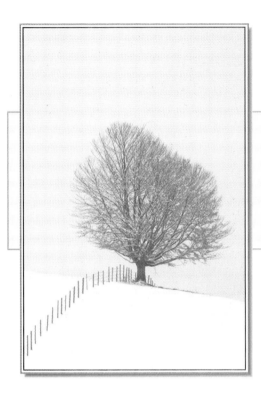

Express Cold with Color

The overwhelming white, representing lack of color, in this photo communicates the message of cold.

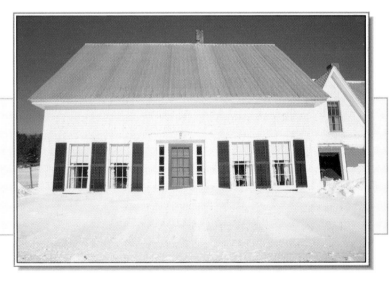

Provide Color Contrast

In this photo, the red door provides an effective color contrast to the black shutters, and white house and snow.

USING COLOR FOR AN EFFECT

Advertise with Color

If people are to buy your product, they must notice it. The owner of this bright red diner understood how to capture the attention of the passerby.

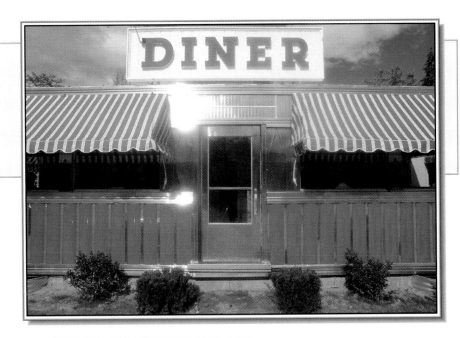

Creatively Decorate with Color

The variety of colors used to paint these chairs makes them far more interesting than they would be if they were all painted one color.

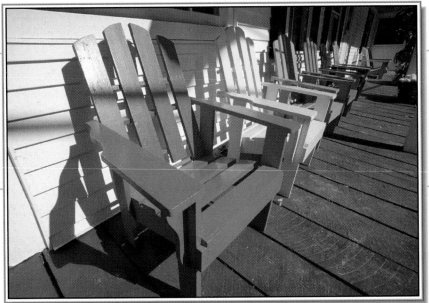

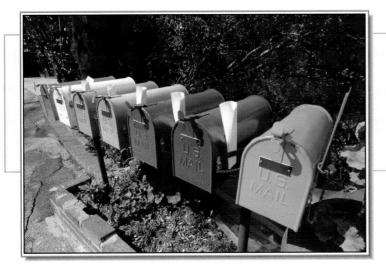

Use Color to Capture Attention

You cannot help but notice and smile at these colorful mailboxes.

Distract with Color

Although the statue is the focus of this photo, you simply cannot miss the rainbow colored car.

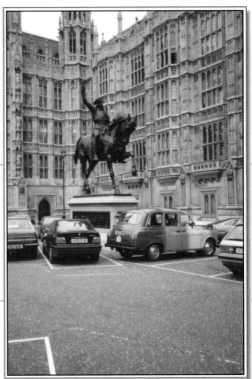

USING LINES FOR PERSPECTIVE

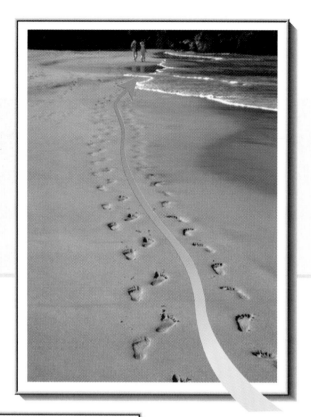

Walk Along a Path

In this photo, the footprints in the sand form an interesting line that your eye follows as you view the picture.

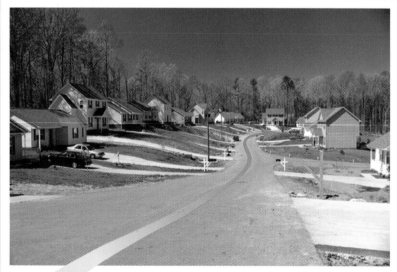

Point Out a Path

Engineered roads form lines quite naturally. In this photo of suburbia, your eye follows the street quite naturally.

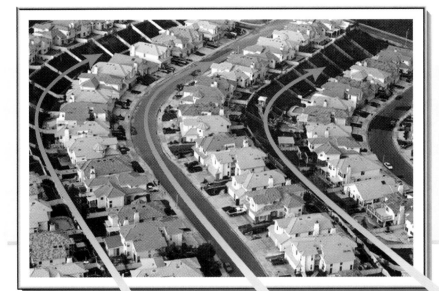

Overview of a Subject

Lines are most apparent from the air.

Attention to Detail

In this photo, the fence rails form lines that draw your eye to the homes between the fence rails.

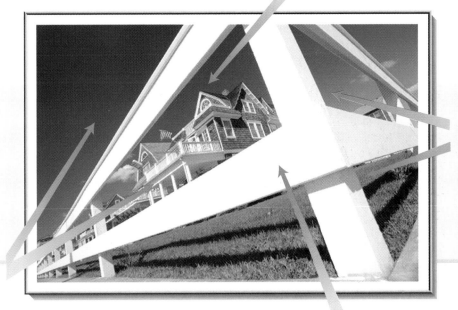

EXPLORE DIFFERENT POINTS OF VIEW

You can add interest to your photos by simply being aware of your surroundings.

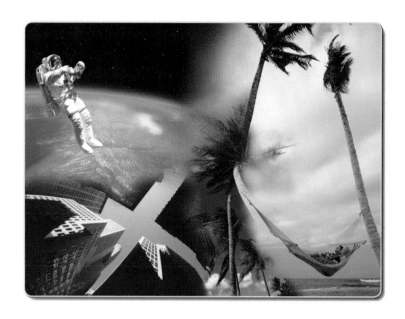

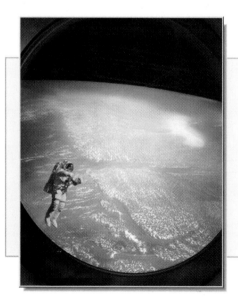

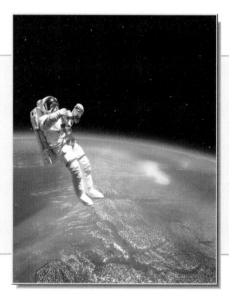

Provide a Point of Reference

When you compare the photo on the left to the photo on the right, you have different reactions to the same scene. Including the edge of the window in the left photo adds a frame to the photo and makes the viewer consciously aware that this photo was taken inside the spaceship.

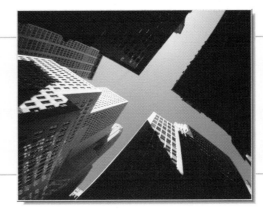

Show Towering Objects

These photos say *tall* without a doubt. Looking up is particularly effective in downtown city centers.

View Height at Different Angles

These photos are basically the same scenes shot from two different angles. You get a sense of height from the photo on the left that you do not get from the photo on the right.

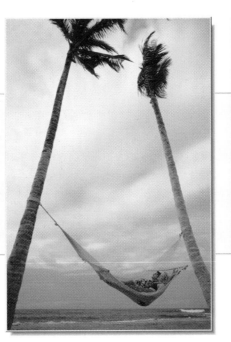

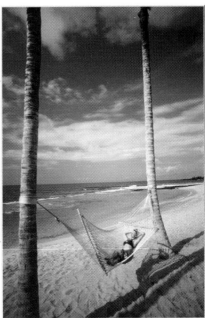

LOOK FOR UNUSUAL THINGS

You can take wonderful photos if you allow your eyes to look for the unusual when you photograph. Both man and Mother Nature provide you with many photo opportunities.

Trees . . .

This interesting tree adds to the beauty of the coastline.

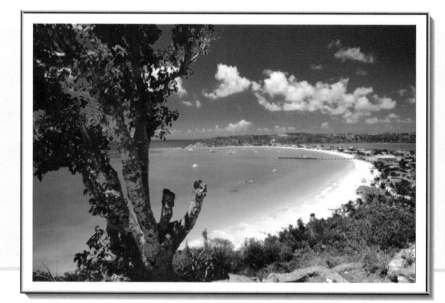

. . . And More Trees

The starkness of this tree adds interest to this water scene.

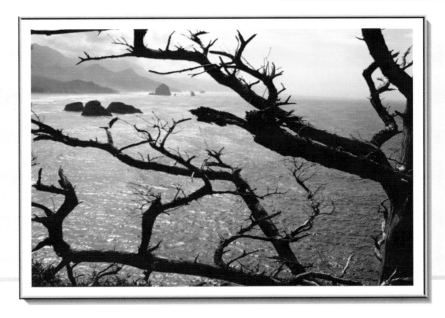

Mailboxes

The mailbox on the left is eye-catching simply because it does not look like a typical mailbox. The colors and reflectors on the mailbox on the right help to catch the eye of the mail carrier in this rural area.

LOOK FOR UNUSUAL THINGS

Beach umbrella

This unusual beach umbrella is definitely an eye-catcher.

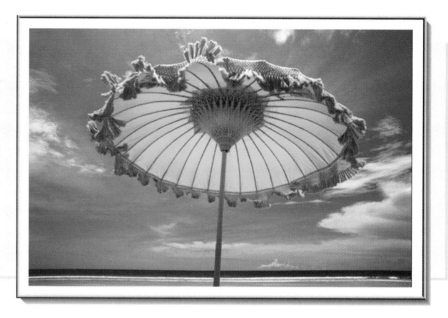

Barbershop

The owner of Larry's Barber Shop cleverly carried the colors of the barber pole to the bench outside the shop — a creative and eye-catching decorating technique.

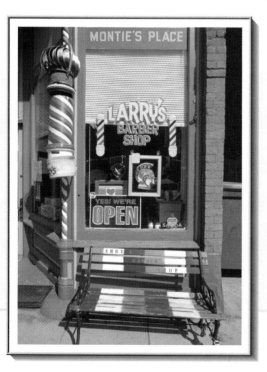

Mountain Carvings

You do not see carvings in a
mountainside every day.

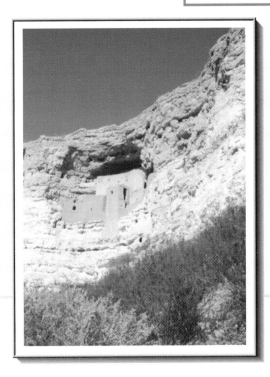

Shapes of Buildings

The shape of this building, with
its oversized roof, catches your
attention.

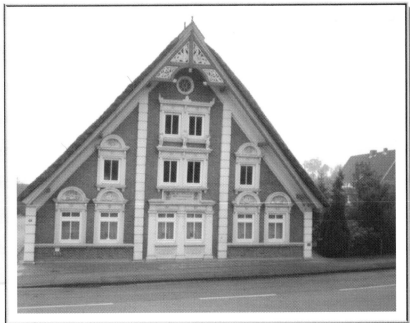

LOOK FOR UNUSUAL THINGS

Mother Nature and Opportunities

Mother Nature's creatures provide some wonderful images . . .

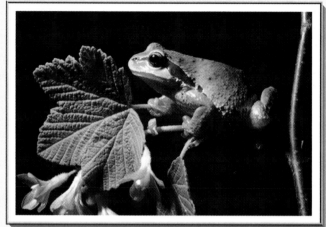

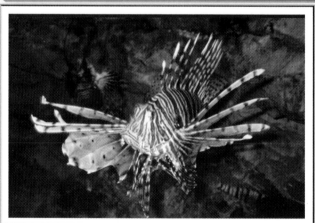

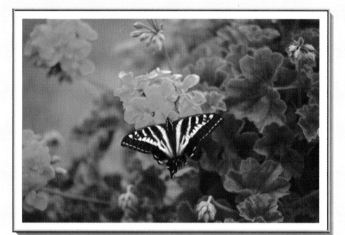

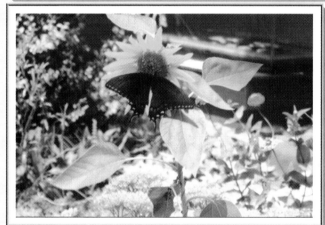

More Mother Nature Opportunities

. . . If you are lucky enough to capture them.

LOOK FOR UNUSUAL THINGS

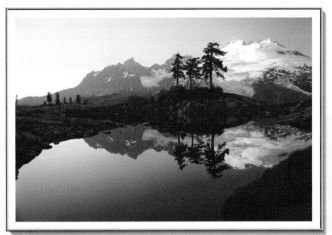

Mirror Images

Reflections in water or glass often provide interesting and beautiful images.

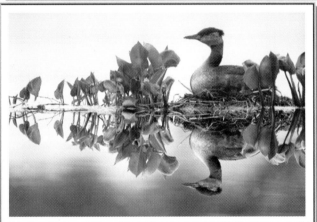

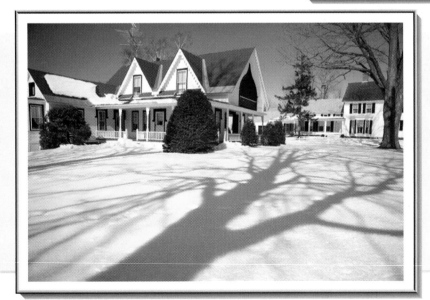

Shadow

Shadows can add interest to photos. Do not overlook them.

Mist, Fog, and Dust

These elements of nature can add an element of mystery to a photo.

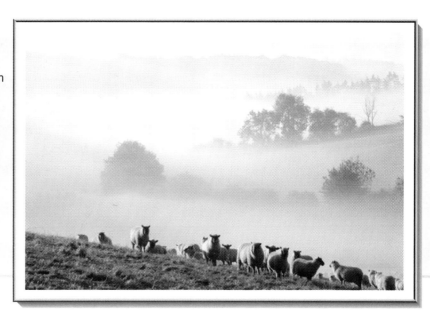

Ice

Frost and ice can add elegance to otherwise everyday bits of nature.

LOOK FOR UNUSUAL THINGS

Sunsets . . .

This scene might have been just as interesting during daylight hours because the trees provide texture.

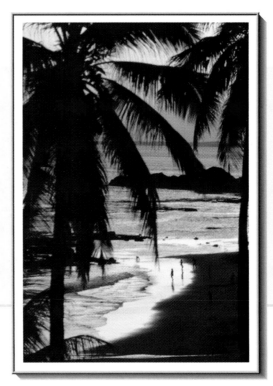

. . . And More Sunsets

You could not have achieved the impact of this scene without the sun providing backlight.

For more information on backlighting, see Chapter 5.

Mother Nature Provides Texture

The flowers in both these photos provide an element of texture and interest.

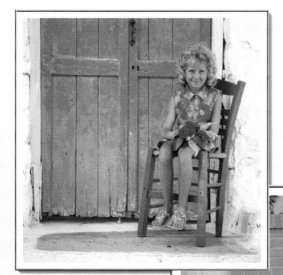

Man Provides Texture

The texture and the color of the doors add interest to both of these photos.

Control Lighting and Exposure

With both digital and traditional cameras, you can control the exposure of a picture in a number of ways. This chapter explores those techniques.

CONTROL EXPOSURE

You can control the lightness or darkness of your image through the exposure setting on your camera. *Exposure* is the amount of light used to capture an image.

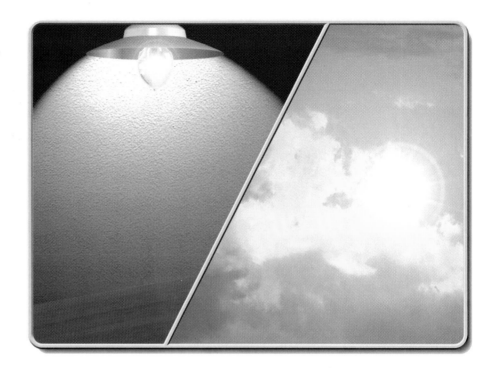

Traditional Cameras

In traditional cameras, exposure is the amount of light that reaches the film.

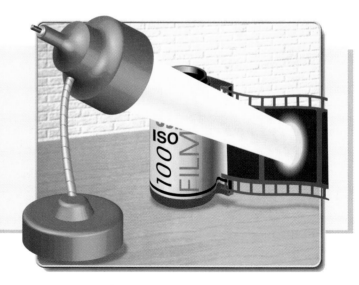

Digital Cameras

In digital cameras, exposure is the amount of light that reaches the image sensor array.

Set the Shutter Speed

When you press the button to take a picture, the shutter opens. You can control how long the shutter stays open by using the settings on your camera.

Adjust the Aperture

The *aperture* is the opening of the camera lens. You can control the aperture by adjusting the settings on your camera.

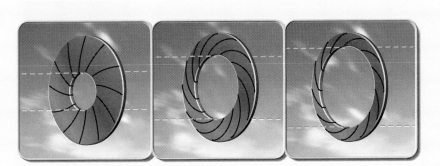

ADJUST THE SHUTTER

You can think of the *shutter* as a window shade that covers the lens of the camera. The shutter opens to expose the lens of the camera and to take a picture. The *shutter speed*, measured in fractions of a second, controls how long the lens remains open.

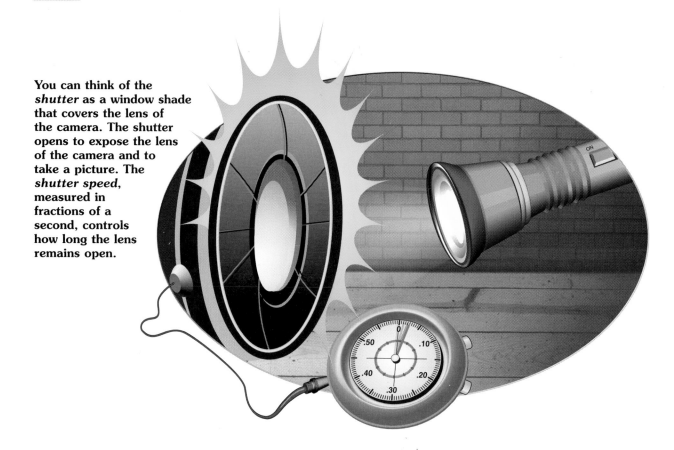

Regulate Light

The shutter speed determines how long the aperture stays open. The longer the shutter is open, the more light reaches the film or image sensor.

Set Shutter Speed

Traditionally, shutter speeds are set in fractions of a second, such as ⅟₁₀₀₀, ⅟₅₀₀, ⅟₂₅₀, ⅟₁₂₅, ⅟₆₀, ⅟₃₀, ⅛, ¼, ½, and 1 second. Traditional cameras that allow you to control shutter speed do not show the numerator of the fraction. Typically, the larger the number for the shutter speed setting, the shorter the time the aperture will remain open.

| 1 | 1/2 | 1/4 | 1/8 | 1/30 |
| 1/60 | 1/125 | 1/250 | 1/500 | 1/1000 |

Lighten Images

A longer shutter speed setting (a lower shutter speed number) produces a lighter image. In the photo on the left, the aperture was set at f/5.6 and the shutter speed at 400. In the photo on the right, the aperture was also set at f/5.6 and the shutter speed at 100.

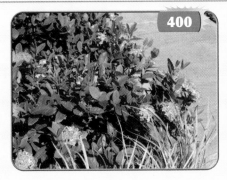
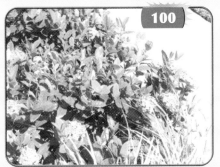

Darken Images

A shorter shutter speed setting (a higher shutter speed number) produces a darker image. In the photo on the left, the aperture was set at f/5.6 and the shutter speed at 400. In the photo on the right, the aperture was also set at f/5.6, but the shutter speed at 800.

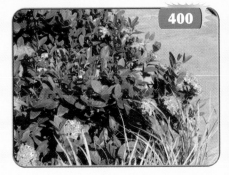
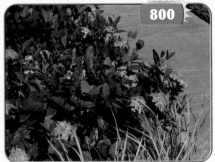

ADJUST THE APERTURE

You can use the *lens iris* to adjust the size of the aperture, which is the opening in the lens. The size of the aperture opening is measured in f-stops, affecting the amount of light used to take your picture.

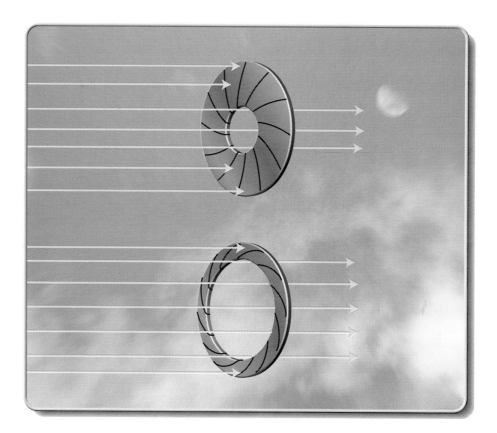

Control Light

The aperture is controlled by a ring, which has overlapping metal plates inside the camera lens that open and close, at varying widths, controlling the amount of light used to create an image.

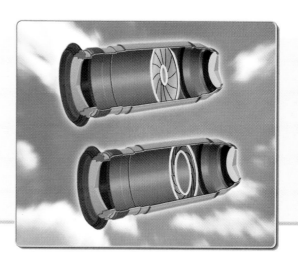

Set f-stop

Traditionally, aperture openings are measured in f-stops such as 1.8, 2.8, 4, 5.6, 8, 11, and 16. The larger the number for the aperture setting, the smaller the aperture opening.

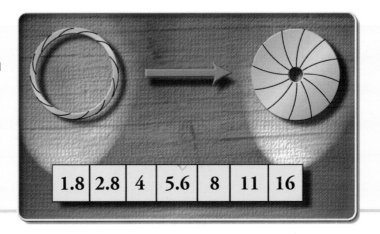

| 1.8 | 2.8 | 4 | 5.6 | 8 | 11 | 16 |

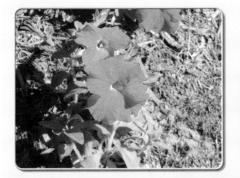

Lighten Images

A larger aperture setting (a lower f/stop number) produces a lighter image. In the photo on the left, the shutter speed was set at 250 and the aperture was set at f/5.6. In the photo on the right, the shutter speed remained at 250, but the aperture was set at f/11.

Darken Images

A smaller aperture setting (a higher f-stop number) produces a darker image. In the photo on the left, the shutter speed was set at 250 and the aperture was set at f/5.6. In the photo on the right, the shutter speed remained at 250, but the aperture was set at f/2.8.

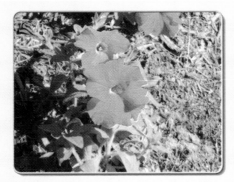

CONTROL SENSITIVITY TO LIGHT

You can use International Standards Organization (ISO) ratings to control the camera's sensitivity to light while you photograph. The film you use in traditional cameras is assigned an ISO rating; on some of the higher-end digital cameras, you can control the ISO rating.

You also may have heard of American Standards Association (ASA) ratings. ASA ratings are rarely used these days; think of them as equivalent to ISO ratings.

Check ISO Ratings

An ISO rating is a number assigned originally to a film — but in the digital world, to a chip — that represents sensitivity to light. Lower ISO ratings, such as 50 or 100, are less sensitive to light. Higher ISO ratings, such as 400 for film and up to 1600 for chips are more sensitive to light.

Lower Ratings on Bright Days

Because lower ISO ratings indicate less sensitivity to light, use lower ISO ratings outdoors on bright, sunny days. Lower ISO ratings are also referred to as slower film or chip speeds.

Higher Ratings on Rainy Days

Because higher ISO ratings indicate more sensitivity to light, use higher ISO ratings indoors, outdoors on overcast days, or when shooting action, such as auto races.

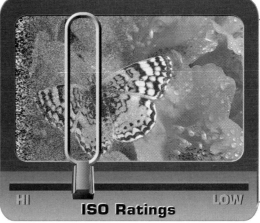

Experiment with Settings

Typically, higher ISO ratings tend to produce lower-quality images that appear grainy. In the world of traditional photography, the difference is not as noticeable as in the world of digital photography. Although you can control the ISO setting on your digital camera, you may want to experiment to determine if you want to make changes from the automatic settings.

ISO Ratings

HI LOW

CONTROL DIGITAL CAMERA EXPOSURE

You can control exposure — the lightness or darkness of your photo — on most digital cameras.

Fully Automatic Mode

In this mode, the camera decides what shutter speed and aperture opening to use. All digital cameras provide this mode.

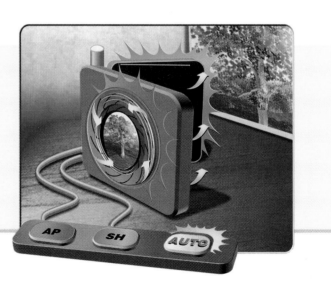

Shutter Priority Mode

In this mode, you select a shutter speed, and the camera then automatically chooses an aperture size. Cameras like the Olympus C-3000 and the HP C618 allow you to choose the shutter priority mode.

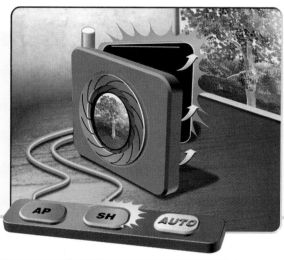

Aperture Priority Mode

In this mode, you select an aperture size, and the camera chooses the shutter speed. Cameras like the Olympus C-3000 and the HP C618 allow you to choose the aperture priority mode.

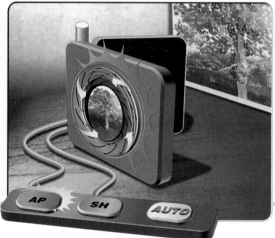

Manual Mode

Some cameras enable you to select both the shutter speed and the size of the aperture. The Olympus C-3000 features this mode.

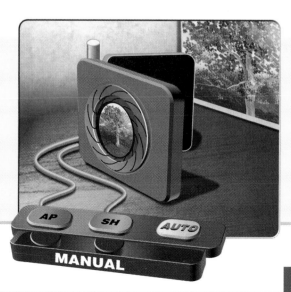

Exposure Compensation Settings

Most digital cameras include an *exposure compensation* setting. This setting uses numbers in increments of 0.5 to increase or decrease the amount of light reaching the image sensor. Typically, a +1.0 setting doubles the amount of light allowed into the camera, and a -1.0 cuts the amount of light in half.

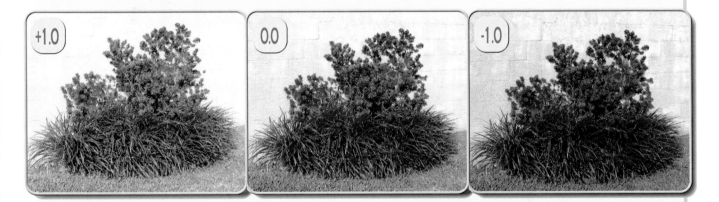

Special Settings

Some cameras provide special situational settings. The HP C618 camera, for example, offers a Landscape, Portrait, and Action setting. In each case, the setting optimizes the camera for that particular type of picture.

Portrait

Landscape

Action

USING AVAILABLE LIGHT

You can use natural light to create the most true-to-life pictures. When you are outdoors, you may notice four kinds of light. The time of day influences the angle of light available to you, as the sun moves across the sky from east to west throughout the course of a day.

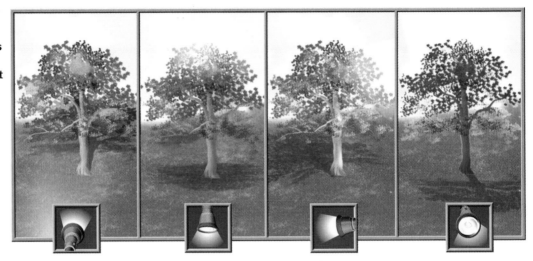

Front Light

Front light falls on the front of the subject. You, the photographer, are standing with your back to the light. Front light provides photos with the least amount of shadow on the subject. You can arrange for front light at almost any time of day.

Be aware, when using front light, that your own shadow may appear in the picture.

Top Light

Top light lights the subject from directly overhead. Outdoors, you may notice that top light is available for only a short time each day, when the sun is directly overhead. Photos of people taken with top light tend to contain shadows on portions of the face.

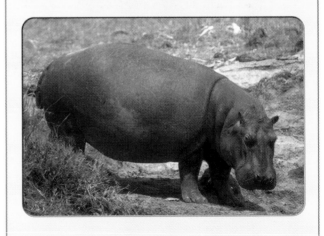

Side Light

When you use side light, light falls mainly on one side of the subject. Side light is common very early in the morning or late in the afternoon and casts shadows on the unlighted side of the subject.

Back Light

A backlit subject has light coming from behind it. Backlit photos cast the front of the subject in shadow and tend to appear too dark. You can compensate by slowing down the shutter or opening the aperture wider or using the exposure compensation features on your camera. Do not overcompensate or you will overexpose the picture. Using fill-flash with back lit subjects can produce attractive portraits. See the section "Using Fill Flash" for more information.

Avoid Overexposing Backlit Scenes

If you have a large white card, you can place it next to you facing the subject to reflect some of the backlit light back onto the subject, or you can use fill flash. See the section "Using Fill Flash" for more information.

BALANCE THE COLORS IN PHOTOS

Using a setting called *white balance,* most digital cameras enable you to balance the colors in a photo to ensure that you accurately reproduce the original scene.

Color of Light

Although light looks white, it is actually made up of the colors of the rainbow which, when combined together, produce white. Different light sources cast different colors of light. For example, mid-day sun casts a more blue tone than early morning light or light from a tungsten lamp.

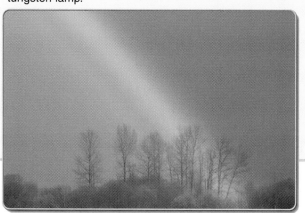

Auto Setting

This default setting works well under many different lighting conditions.

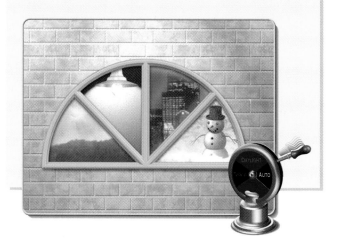

Daylight Setting

This setting works best when photographing outdoors.

Incandescent Lighting

This setting works best when you are photographing indoors in tungsten or incandescent lighting conditions.

Fluorescent Lighting

This setting works best when you are photographing indoors in fluorescent lighting.

ADD LIGHT WITH A FLASH

You can add some light to low-light scenes with a flash. A flash is particularly helpful when shooting indoors.

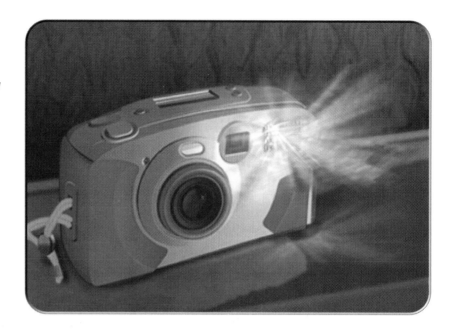

Flash Does Not Travel Far

Light from a flash is not very powerful. To make effective use of it, keep your subjects within 10 to 15 feet of the camera.

Light from the Flash Dims

As it travels, light from the flash gets dimmer — a condition known as *fall off*. To make sure the flash adds light to the subject, keep your subject(s) in an area no wider than 6 to 8 feet.

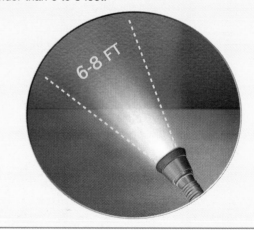

USING FILL FLASH

Sometimes, you can compensate for backlighting or shadows in your photo by using your camera's fill flash to add light to the subject.

Without Fill Flash

In this scene, you cannot see the woman's eyes because of the shadow.

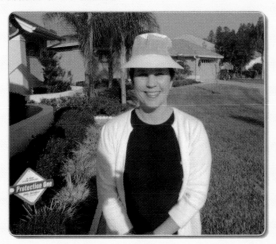

With Fill Flash

In this scene, the camera's flash added light to the front of the woman to eliminate the shadows.

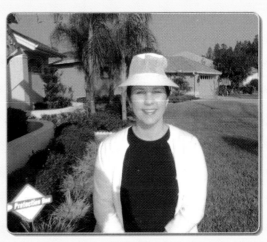

CAPTURE BREATHTAKING IMAGES

You can capture beautiful pictures of sunrises, sunsets, and night scenes, although they present exposure challenges.

Avoid Underexposed Sunsets

Sunsets are most often underexposed, like this photo. Add light to photos like this by slowing down the shutter, opening the aperture wider, or using your camera's exposure compensation features.

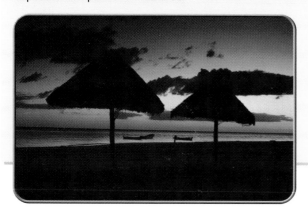

Avoid Unevenly Exposed Photos

Sunrise and sunset photos are also often unevenly exposed, like this photo. Use the following tricks to compensate for uneven exposure.

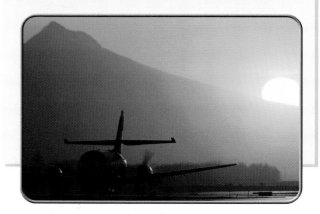

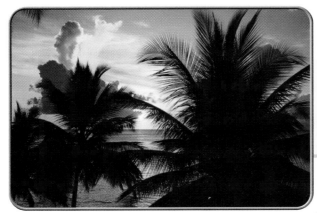

Use Trees

Block the sun with tree branches . . .

Use Objects

. . . or block the sun with the subject of your
photo to create a dramatic backlit scene.

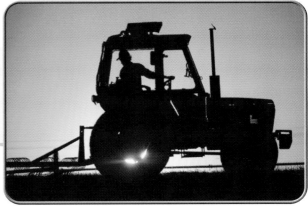

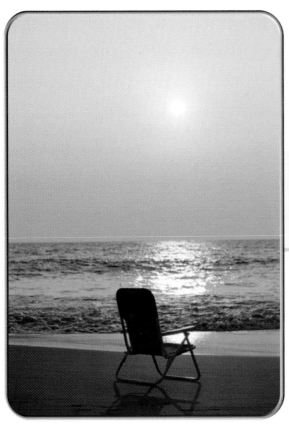

Use the Clouds

On hazy days, the clouds help you include the
sun in your photo.

CAPTURE BREATHTAKING IMAGES

Change Your Position

Move so that you do not include the sun in your photo. In this photo, the sun is just beyond the right edge of the picture.

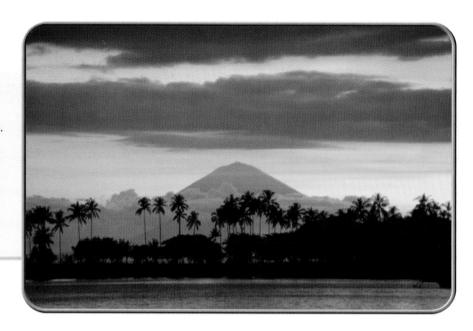

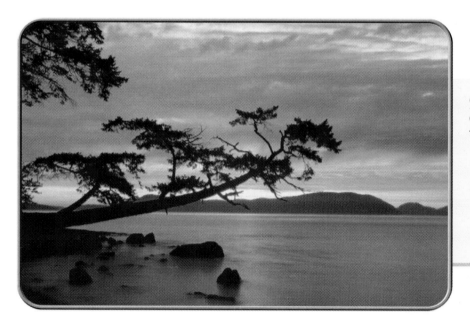

Change Your Timing

Capture the scene before the sun enters.

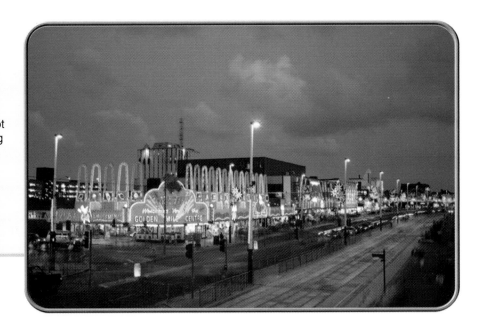

Use Available Light

If the scene contains a lot
of artificial light, you will not
have trouble photographing
at night.

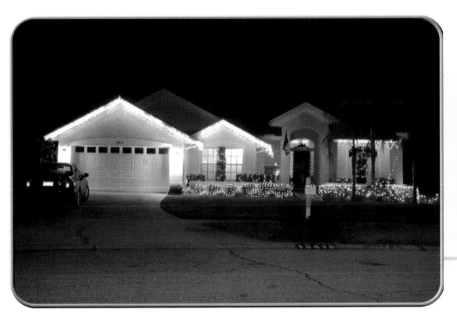

Compensate for Lack of Light

When the scene does
not contain sufficient
artificial light, slow down
the shutter, open the
aperture wider, or use
your camera's exposure
compensation features.

Retain Clarity with an Optical Zoom

The *optical* zoom lens changes the amount of the scene that falls on the image sensor. But every pixel in the image contains unique information, so the image is clear and sharp.

Lose Clarity with a Digital Zoom

In *digital* zooming, the camera makes copies of pixels already in the image and adds them to the image — a process known as *interpolation*. Because the interpolated image does not have as many unique pixels as one taken with an optical zoom, the digitally zoomed image is inferior. If you plan to print your photos, try not to use or rely on the digital zoom.

Align Image with a Viewfinder

Most digital cameras, like most point and shoot traditional cameras, use a viewfinder that is separate from the camera lens. The viewfinder sees the image from a slightly different angle than the lens. If you align your image inside the black lines that you see near the corners of the viewfinder's window, or if you use the camera's LCD panel, you can avoid cutting off a portion of the image.

Sharpen Resolution

The term resolution means different things at different times in the digital imaging community. This chapter discusses image resolution, camera resolution, monitor resolution, and printer or scanner resolution.

CONTROL SHARPNESS WITH RESOLUTION

You can control the sharpness of your final images by shooting at higher resolutions.

Link Pixels to Resolution

Pixels are picture elements containing image information that serve as the basic unit of digital pictures. *Image Resolution* refers to the density of pixels in an image; resolution is expressed as the number of pixels per inch (ppi) or the total number of pixels in an image. You can describe the resolution of a particular image as 1600 x 1200 pixels or 1.92 million pixels (1600 times 1200).

Compose High-Quality Images

You can improve the potential quality of an image by setting the resolution higher. This enables your computer to reproduce the image in a true-to-life manner. The image color and the amount of compression used to store your image also affect your image quality. See Chapter 8 for more information on compression and image quality.

Effects of Color

Each photosite stores a red, green, or blue pixel. The more pixels your image contains, the more likely you are to capture the colors in an image.

Increase File Size

Adding pixels to images increases the size of the file needed to store the image. Consequently, your camera will take fewer pictures before you need to download the images or insert a new memory card.

Print Size

Image size is the linear dimensions of the image. You need a high-resolution image (many pixels) to produce and print a good-quality 8½ x 11-inch photo. If you try to print a low-resolution image as an 8½ x 11 photo, the image will appear blurry.

ADD QUALITY WITH CAMERA RESOLUTION

You can create high-quality pictures by adjusting the resolution of your camera. The resolutions available on your camera ultimately determine the image size and quality you can produce.

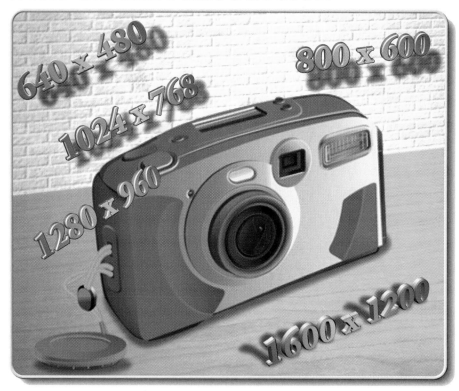

Set Resolution

Your digital camera uses photosites on its image sensor to capture and store pixels. Camera resolutions are stated in pixels, such as 1600 x 1200, or in terms such as Good, Better, and Best. Camera resolutions describe the image resolutions the camera can capture.

Use More Pixels

Each photosite on your camera captures one pixel. To capture more pixels — and potentially produce better quality photos — your camera must be constructed with more photosites. More photosites means higher production costs, so cameras that capture more pixels are more expensive.

Printers and scanners measure resolution in dots per inch (dpi), enabling you to create quality photos. Therefore, you must consider the number of pixels per inch (ppi) of an image to determine the quality of the photo size.

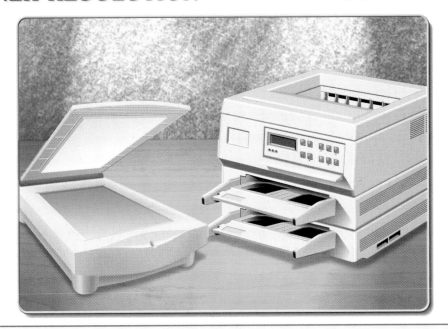

Distinguish between PPI and DPI

A one-to-one correspondence between dots per inch and pixels per inch is not necessary. In fact, inkjet printers print many dots to one pixel. Printers with larger dpi ratings can produce more dots per inch, resulting in a better looking, smoother print because the dots are smaller and harder to see. Beware that 300 dpi on one printer can be better than 600 dpi on another printer. See Chapter 14 for more information.

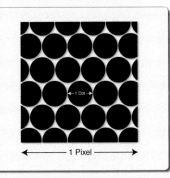

1 Pixel

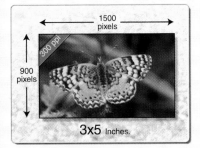

1500 pixels

900 pixels

300 ppi

3x5 Inches.

Set the Photo Size

Most printers can reproduce a maximum of 300 ppi. To print a photo that is 3 x 5 inches, the image file must contain at least 900 (300 ppi x 3 inches) x 1500 (300 ppi x 5 inches) pixels — totaling 1,350,000 pixels. You need a 1.3-megapixel camera to produce an image containing 1,350,000 pixels. The same camera would not produce a good-quality 5 x 7-inch printed photo.

Avoid Too Many Pixels

Using image-editing software, you can size a photo for printing. However, sizing an image to greater than 300 ppi can cause degradation because printers throw away the extra pixels over 300 ppi — and printers are not necessarily very good at selecting the pixels to throw away. See Chapter 10 for more information on sizing a photo.

MONITOR RESOLUTION

Monitors measure resolution in pixels per inch (ppi), but monitors cannot display as many pixels as a camera can capture.

Show Lower Quality

Monitor resolution is limited to the number of pixels per inch that the monitor can display. The size of the pixel plus the space between pixels (called *dot pitch*) determines the number of pixels per inch that a monitor can display. Most monitors display 96 ppi. If an image contains *more* than 96 ppi, the monitor simply will not display the extra pixels.

Check Monitor Resolution

If you have a standard monitor, multiply the width and length of your monitor by 96 ppi to get the *maximum* number of pixels across and down that your monitor can display. The monitor's resolution is expressed in number of pixels being displayed across and down the monitor, for example, 640 x 480 or 800 x 600.

Set Monitor Display

The video card in your computer determines the number of pixels you actually see. You can set the monitor resolution in your operating system. In Windows, you can set your monitor resolution in the Display Properties dialog box. To display this dialog box, right-click the Windows desktop and choose Properties from the resulting pop-up menu.

Affects Display Only

A camera's image resolution of 640 x 480 pixels is *not* the same as a monitor's resolution of 640 x 480 pixels. Camera resolution determines the number of pixels in the image file. Monitor resolution refers to the number of pixels you can see across and down on a monitor; monitor resolution has no effect on the number of pixels in an image file, only on the number of pixels you can display.

Compare Image Resolutions

The space an image fills on a monitor is determined by monitor resolution and image resolution (number of pixels in the image). Changing the resolution of your monitor increases or decreases the space between pixels. An image that fills the screen at a monitor resolution of 640 x 480 pixels will not fill the screen at a monitor resolution of 800 x 600 pixels due to the reduction in space between the pixels.

Working with Images

In this chapter, you learn about managing photo files and the effects of various photo file formats.

TRANSFER IMAGES TO A COMPUTER

To use your digital images, you must move the images from the camera to the computer.

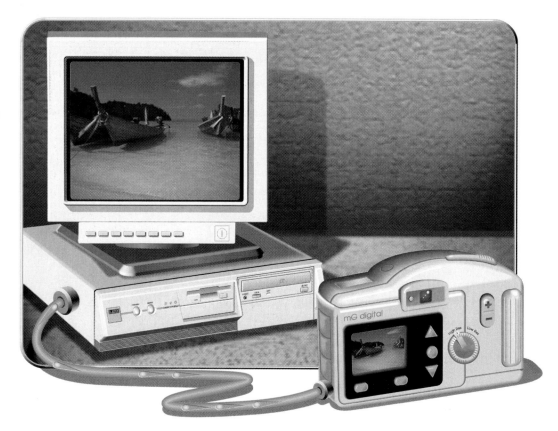

USB Connection

Most digital cameras today use USB connections. You attach one end of the cord to the camera and the other to the USB port on your computer.

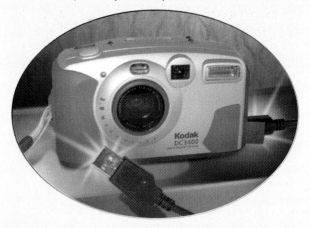

Serial Connection

Older digital cameras connect to computers using a serial port connection. The concept is the same as for a USB connection; the connector simply looks different.

Floppy Disk Connection

Some cameras, like the Sony Mavica, use a floppy disk to store images. To use them on your computer, you remove the disk from the camera and place it in your computer's floppy disk drive. Some camera memory cards can be used in a floppy disk adapter and be placed in the same drive.

Transfer Software

Many cameras come with software that helps you unload images from your camera when the camera is connected to the computer. Check your camera manual for instructions on using the software specific to your camera.

Drag and Drop to Computer

For cameras that use floppy disks to store images, you typically use regular operating system techniques to copy images from the floppy disk to your computer's hard drive. Some cameras that connect to your computer, like the Kodak DC3400, use your computer's operating system to allow you to drag and drop images from the camera to the computer.

COMPRESS FILE SIZE

You can select a file format for your images that reduces the size of the file, while preserving quality and detail in the original image.

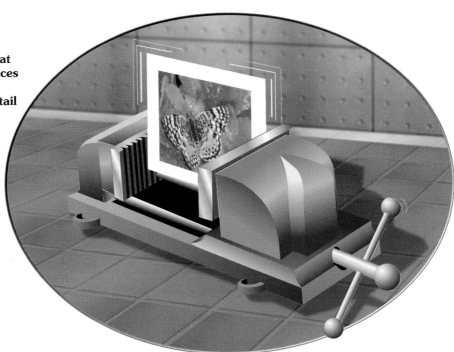

COMPRESSION

Compression is a process used when storing files to make the files smaller. Camera manufacturers use compression to help you store more images before you need to download to your computer or insert a new memory card. If no compression is used, cameras store image information pixel by pixel, and files can be very large. Your camera can store only a few large files.

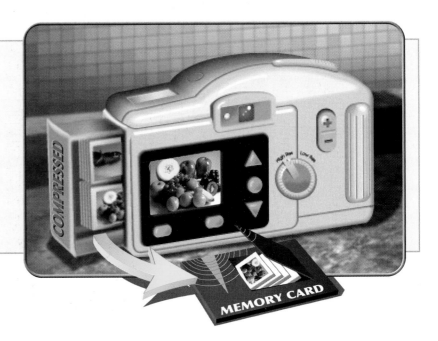

TWO TYPES OF COMPRESSION

Lossy Compression

Lossy compression discards pixel information as it compresses the file, relying on your eye to fill in the missing information when you view the image. Each time you edit and resave the image, more information is lost.

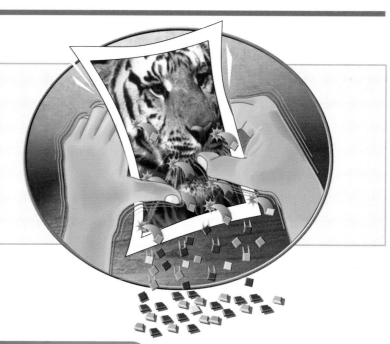

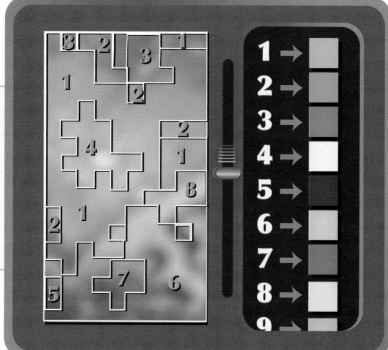

Lossless Compression

Lossless compression maps the location of each pixel's color. It then saves only one pixel for each color — and a list of *where* each color belongs in the photo so that it can recreate the image. Your image retains its quality, but because this technique results in less compression, files often are not significantly smaller than uncompressed files.

STORE PHOTO IMAGES

You can free up the disk space that digital images use by storing them on places other than your hard drive.

Use Zip, Jaz, and PocketZip

Zip, Jaz, and PocketZip are removable media that look like floppy disks, but they hold large quantities of files. Zip disks can hold 100MB or 250MB of information, and Jaz disks can hold 1GB or 2GB of information. PocketZip disks hold up to 40MB of information and can connect directly to a digital camera through the USB port of the camera.

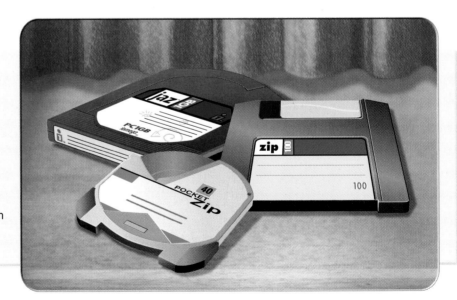

Take Advantage of CD Writers

CD-ROM drives that can both read and create CDs have come down in price significantly, and external ones like the HP 8220e connect to your computer through a USB port. You can store up to 650MB of information on a CD. CD-R disks are permanent archives for images that cannot be erased, while CD-RW disks are rewritable and can be reused.

Photo Web Sites

You can store your images on Web sites such as www.photopix.com, www.photopoint.com, and www.clubphoto.com. Some charge a nominal fee of 25–75 cents per picture. Others are free.

SELECT FILE FORMATS

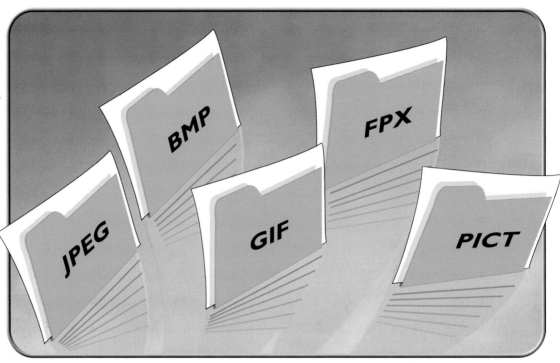

Digital cameras and image-editing software offer you several different file formats for storing your digital image files.

CHOOSE FILE FORMATS CAREFULLY

File formats do matter. Some work only on Macs or only on PCs. Some file formats use compression while others do not. Some file formats are more appropriate for on line use on Web pages and in e-mail, while other file formats are more appropriate for printing. Some file formats are *proprietary*; that is, only certain cameras or image-editing software uses them.

TYPES OF FILE FORMATS

JPEG

JPEG files can be opened and saved on both the Mac and PC platforms and are commonly used for images on Web pages or in e-mail. JPEG uses a lossy compression scheme, so original image information is lost when you save a file in JPEG format. Most image-editing software allows you to choose the amount of compression when saving JPEG files. See "Compress File Size" earlier in this chapter.

TIFF

Like JPEG images, TIFF images can be opened on both Macs and PCs and are a widely used image format. Although TIFF files use a compression scheme, it is a lossless compression scheme, so TIFF files are usually large — and not appropriate for use on Web pages or in e-mail.

GIF

GIF files are most appropriate for use on Web pages or in e-mail. While they use a lossless compression scheme and retain image information, they store only 256 colors. Prints can look rough or blotchy, simply because they do not display enough shades of color to accurately reproduce an image. Using GIF89a, a variation of GIF, you can make portions of your image transparent and see a Web page background through the image.

BMP

Originally developed for use in Windows, this file type is used primarily for desktop wallpapers. The BMP file type does not resize well, so try not to use it with photographs.

EPS

This file format is widely used in high-end desktop publishing and EPS files are very large — usually bigger than TIFF files. EPS files are not desirable on Web pages.

PICT

Only Mac computers can read PICT files. If you intend to share files between a PC and a Mac, use TIFF or JPEG.

FPX

The FlashPix (FPX) format was developed by a group of software companies. In an FPX file, you will find several versions of an image, ranging from a large high-resolution image to a small low-resolution image. On Web pages, FPX files can be downloaded at low resolution with a more detailed version available if needed.

PCD

PCD stands for PhotoCD, a format designed by Eastman Kodak for transferring slides and film negatives onto CD-ROM. Consumer image-editing software may be able to open these files, but they will not be able to save in PCD format.

You can enjoy digital images on your computer without ever printing them.

Use Images on Web Pages

Many people post photographs on personal Web pages, and businesses can advertise products using photos of the products. See Chapter 15 for more information on using photos on Web pages and in e-mail.

Consider File Size

If you intend to use images on a Web page or in e-mail, make sure you use low-resolution images because the files are much smaller. On a monitor, the lower resolution does not present the negatives associated with printing a low resolution, because the lower resolution is virtually undetectable on a monitor. And, smaller files load much faster than larger files.

Exchange Digital Images

Share photos with family and friends via e-mail. Simply attach a digital image to an e-mail message and send it. In the business world, you can send forms via e-mail by scanning them to create digital images and attaching them to e-mail.

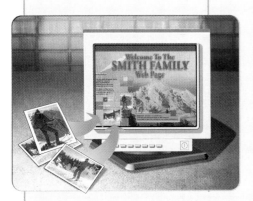

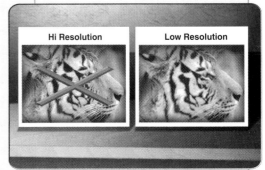

Get Familiar with Image Editors

Are you wondering about the tools available to edit images? This chapter helps you understand how to use image editors.

DISCOVER IMAGE EDITORS

You can use image editors to change the appearance of photos.

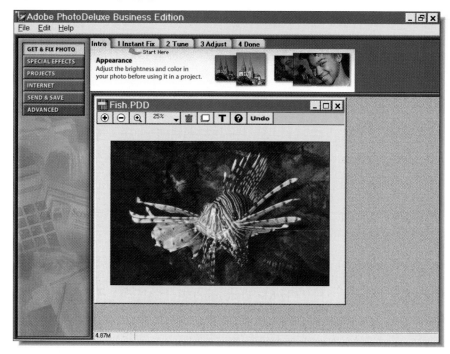

Enhance Images

You can enhance your photos by changing the orientation of a photo; resizing it; adding special effects, such as drop shadows; or changing from color to black and white. You also can improve the quality of a photo by changing the brightness and contrast or removing red eye.

Image-Editing Software

Most digital cameras come with image-editing software that you can use to modify images. If digital photography is more than a hobby for you, you can buy image editors such as Adobe Photoshop, Jasc PaintShop Pro, or Corel Photo-Paint, which all have more advanced capabilities.

TOUR THE ADOBE PHOTODELUXE WINDOW

Adobe PhotoDeluxe ships with many different digital cameras; therefore it is used throughout this book in examples. The Business Edition works on PCs, and the Home Edition works on Macs. You can download a free trial version of Adobe PhotoDeluxe at www.adobe.com.

MENU BAR

Contains commands available in Adobe PhotoDeluxe.

TABS

Describe what you can do in a guided tab or section. Numbered tabs walk you through the process in numerical order.

ZOOM IN BUTTON

Enlarges the view of your photo so you can see more detail.

BUTTONS

Click any of the first five buttons to view tabs that walk you through activities. Click the Advanced button to use tabs or menus to edit photos without walking through a guided process.

ZOOM OUT BUTTON

Reduces the view of your photo so that you can see more of the entire image instead of just a portion of the image.

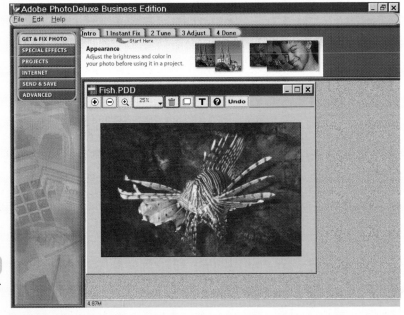

HELP BUTTON

Get help on Adobe PhotoDeluxe.

UNDO BUTTON

Reverse the effect of the last action you performed.

ZOOM TOOL

Enlarge a particular part of a photo.

ZOOM MENU

Enables you to choose a percentage of magnification.

TRASH CAN BUTTON

Deletes portions of a photo.

OBJECT-ORDER MENU

Enables you to move selected objects forward or backward.

TEXT BUTTON

Add text to your photo.

OPEN YOUR IMAGE EDITOR

You can open most Windows-based image-editing software packages by using the Windows Start menu.

If you did not receive Adobe PhotoDeluxe with your camera, you can download a free trial version from Adobe's Web site at www.adobe.com.

OPEN YOUR IMAGE EDITOR

1 Click **Start**.

2 Click **Programs**.

3 Click **Adobe**.

4 Click **PhotoDeluxe Business Edition 1.1**.

5 Click **Adobe PhotoDeluxe Business Edition 1.1**.

■ The Adobe PhotoDeluxe image-editing window appears.

Note: You may have an icon for Adobe PhotoDeluxe on your Windows Desktop. If so, you can double-click the icon to start the program.

You can close most
Windows-based image-
editing software packages
by using standard
Windows techniques.

CLOSE YOUR IMAGE EDITOR

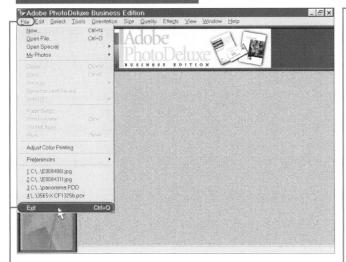

CLOSE USING MENUS

1 Click **File**.

2 Click **Exit**.

■ Adobe PhotoDeluxe
closes, redisplaying your
Windows Desktop.

CLOSE USING SHORTCUTS

1 Click the ⊠ button in the
upper-right corner of the
Adobe PhotoDeluxe window.

■ Adobe PhotoDeluxe
closes, redisplaying your
Windows Desktop.

■ You can also press
`Ctrl` + `Q` to close your
image-editing window.

OPEN AN IMAGE

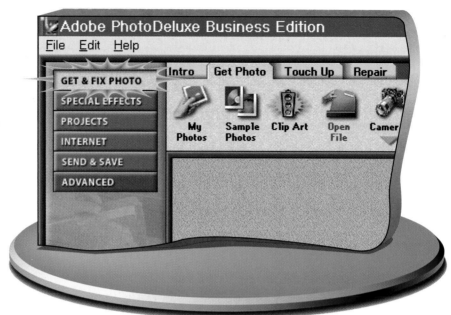

You can display your photos in image-editing software to make changes to them. To display a photo in Adobe PhotoDeluxe, you must open the photo.

OPEN AN IMAGE

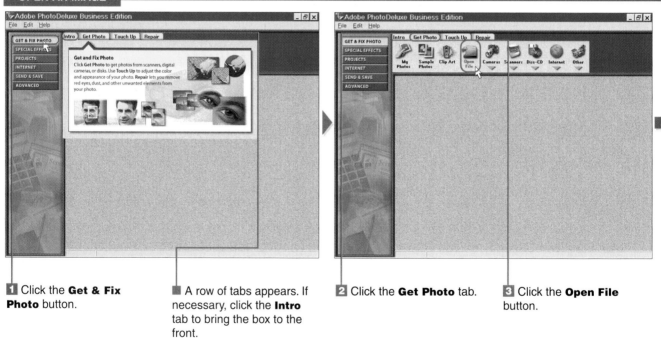

■1 Click the **Get & Fix Photo** button.

■ A row of tabs appears. If necessary, click the **Intro** tab to bring the box to the front.

■2 Click the **Get Photo** tab.

■3 Click the **Open File** button.

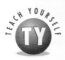

Is there a faster way to open a photo?

Yes. You can avoid using the Guided
tabs to open a photo. Instead, click
File and then click **Open File**. The
Open box appears.

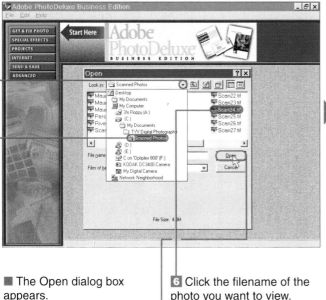

■ The Open dialog box
appears.

4 Click ▾ to view the folder
listing.

5 Click the folder that
contains the photo you want
to open.

6 Click the filename of the
photo you want to view.

7 Click **Open**.

■ Your photo appears in an
untitled window.

*Note: If you intend to print photos,
do not rely on the on-screen
appearance of the image. See
Chapter 14 to run a test print.*

SAVE AN IMAGE

You can save changes
you make to a photo.
However, to preserve the
original photo, save
using a different name
before making changes.

SAVE AN IMAGE

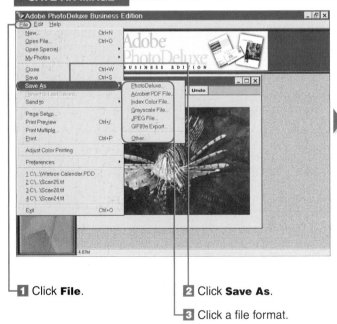

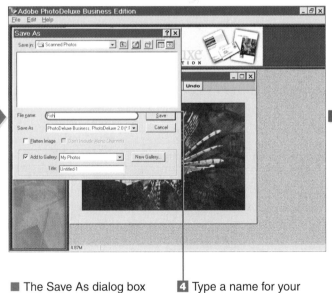

1 Click **File**.

2 Click **Save As**.

3 Click a file format.

■ The Save As dialog box
appears.

4 Type a name for your
image.

When should I save my file as a
PhotoDeluxe file (PDD) and when
should I choose another file
format?

Save your file as a PhotoDeluxe
file if you want the full editing
capabilities available in
PhotoDeluxe. Because PDD is a
proprietary file format, only
PhotoDeluxe can read PDD files.
Save your file using some other
format if you intend to share the
file with others and want them to
be able to edit the file.

5 Click 🔽 to open the Save
As menu and click a file
format.

*Note: See Chapter 8 for details on
selecting the appropriate file format.*

6 Click **Save**.

*Note: Some file formats you choose
may require additional options. The
safest route is to accept the defaults
suggested by the program.*

■ Your photo reappears.

SELECT TO MAKE CHANGES

You can change the appearance of a photo by selecting the portion of the photo that you want to change and then apply the changes.

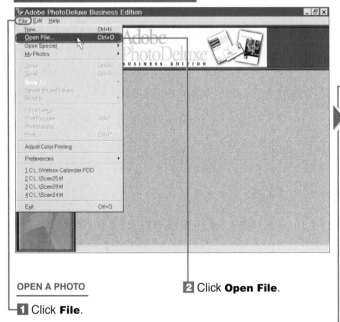

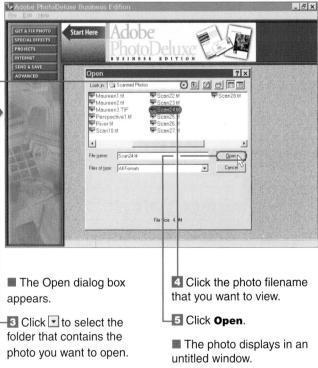

OPEN A PHOTO

1 Click **File**.

2 Click **Open File**.

■ The Open dialog box appears.

3 Click ⬇ to select the folder that contains the photo you want to open.

4 Click the photo filename that you want to view.

5 Click **Open**.

■ The photo displays in an untitled window.

148

Can I turn off the Clue cards that keep popping up?

Yes. Right-click a blank area of the PhotoDeluxe screen and click **Turn Off All Clue Cards**.

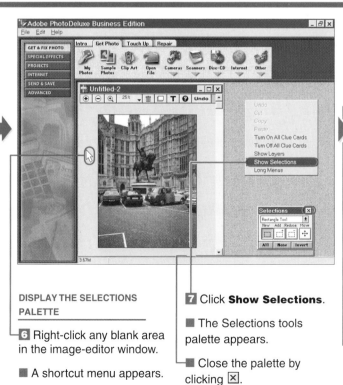

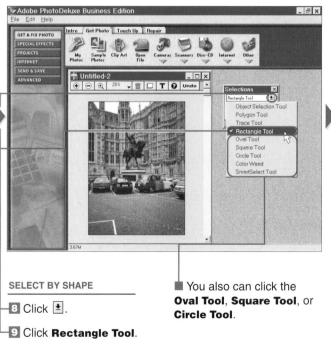

DISPLAY THE SELECTIONS PALETTE

🖼 6 Right-click any blank area in the image-editor window.

■ A shortcut menu appears.

7 Click **Show Selections**.

■ The Selections tools palette appears.

■ Close the palette by clicking ⊠.

SELECT BY SHAPE

8 Click ⊞.

9 Click **Rectangle Tool**.

■ You also can click the **Oval Tool**, **Square Tool**, or **Circle Tool**.

CONTINUED

SELECT TO MAKE CHANGES

You can select areas of a
photo using standard
shapes, such as
rectangles. You also can
select areas of a photo
by the colors in that
area.

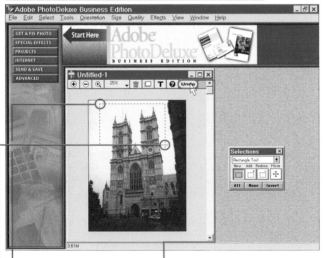

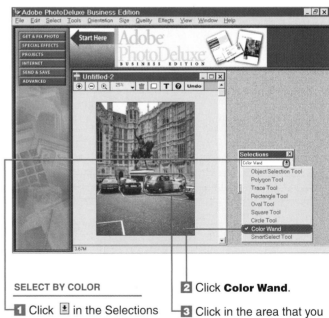

10 Position the mouse **+** at
the upper-left corner of the
area you want to select.

11 Click and drag the pointer
down diagonally to the right.

■ When you release the
mouse button, an animated
selection rectangle appears.

■ Click **Undo** to cancel the
selection.

SELECT BY COLOR

1 Click ⬆ in the Selections
tools palette.

2 Click **Color Wand**.

3 Click in the area that you
want to select by color.

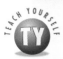

I find the Selections tools palette annoying. Is there another way to get to these tools?

Yes. Right-click any blank area on-screen and choose **Long Menus**. Then, click **Select** and click **Selection Tools**. Note that keyboard shortcuts exist for some tools and that you cannot adjust a selection from this menu.

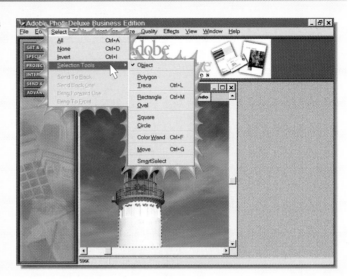

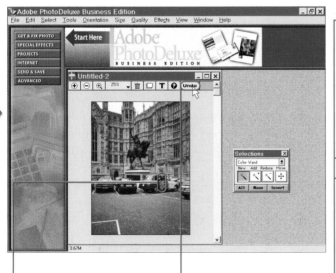

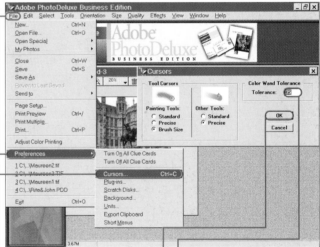

■ PhotoDeluxe selects all pixels of similar color to the one you clicked.

■ Click **Undo** to cancel the selection.

CONTROL COLOR TOLERANCE

■1 Click **File**.

■2 Click **Preferences**.

■3 Click **Cursors**.

■ The Cursors dialog box appears.

■4 Type a number between 1 and 100 in the Tolerance field.

■ Select higher numbers for more pixels.

■5 Click **OK**.

OUTLINE TOOLS

You can select an area of an image by tracing with the Trace or Polygon tool. The Trace tool enables you to draw freehand, while the Polygon tool enables you to selection straight segments as well as curved segments.

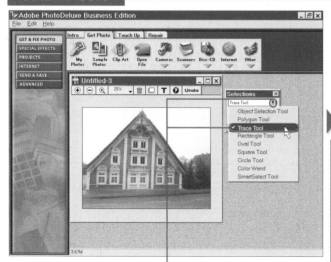

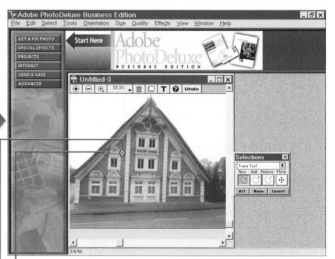

USE THE TRACE TOOL

1 Open the Selections tools palette.

Note: See "Select to Make Changes" for instructions.

2 Click 🔽.

3 Click **Trace Tool**.

4 Position the mouse + at one edge of the area you want to select.

5 Click and drag the pointer to the other edge.

6 Release the mouse button.

■ PhotoDeluxe connects the point you initially selected with the point where you released the mouse button.

■ Click **Undo** to cancel the selection.

What does the Invert button do?

The Invert button selects the outside of your selection instead of the inside. In this figure, the man and woman are traced, but the inverted selection causes the sky and sand (that is, everything *except* the man and woman) to be selected.

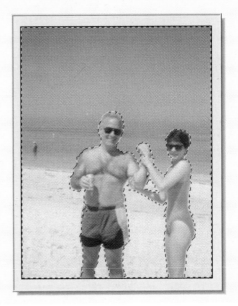

USE THE POLYGON TOOL

1 Open the Selections tools palette.

Note: See "Select to Make Changes" for instructions.

2 Click ⬇.

3 Click **Polygon Tool**.

4 Position the mouse + at one edge of the area you want to select.

5 Click and drag the mouse +.

■ To draw a straight segment, release the mouse button while moving the mouse.

6 Double-click to complete the polygon.

USE SMARTSELECT TRACING

You can use the SmartSelect tool to select areas of uniform color that are hard to trace. The SmartSelect tool guesses at what you want to trace by including similar colors in the selection as you trace. You can set the Brush width, Sensitivity, and Feather of the SmartSelect tool.

USE SMARTSELECT TRACING

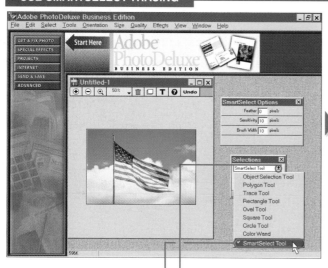

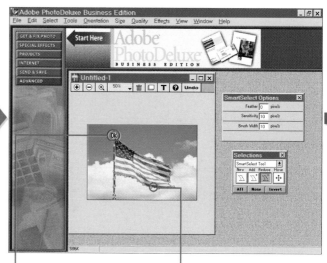

1 Open the Selections tools palette.

Note: See "Select to Make Changes" for instructions.

2 Click ⊡.

3 Click **SmartSelect Tool**.

■ The SmartSelect Options dialog box appears.

4 Click the mouse + at the place you want to start selecting.

■ The word OK appears at the starting point.

5 Drag to trace around the edge of the area you want to select until you reach the beginning point.

■ Small square handles appear as you trace.

The software is not including everything I am tracing. Is there a way to force Adobe PhotoDeluxe to include an area I am tracing?

Yes. Click as you trace to force the inclusion of a handle. PhotoDeluxe ultimately selects the area inside the handles.

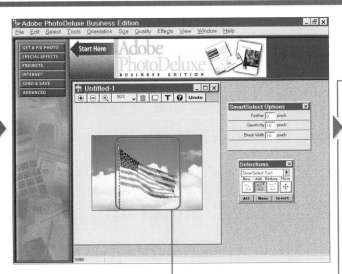

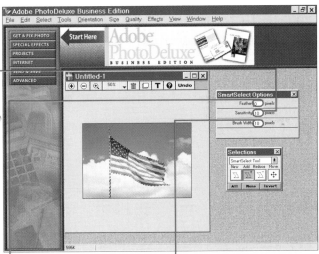

■ PhotoDeluxe displays OK when you reach the beginning point.

6 Click the mouse button to complete the selection.

■ You can also end the selection at any point by double-clicking.

■ The selected area appears inside the dotted lines.

■ You can set the Feather value between 0 and 250. Higher numbers cause you to lose detail at the edges.

■ You can set the Sensitivity value between 1 and 100. Higher numbers make the tool more sensitive to color differences.

■ You can set the Brush Width value between 1 and 20. Higher numbers make the tool search a larger area for color differences.

CHANGE THE SELECTION OF PIXELS

You can both add and
remove pixels to a
selection. You may find,
after selecting an area,
that you did not select
everything you wanted,
or that you selected
more than you wanted.

CHANGE THE SELECTION OF PIXELS

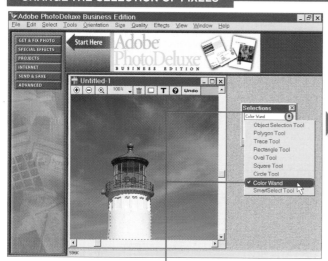

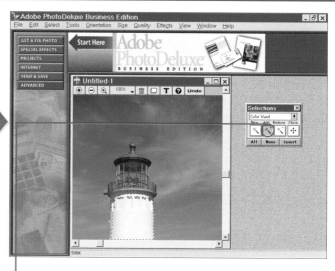

ADD PIXELS

1 Open the Selections tools
palette.

*Note: See "Select to Make Changes"
for instructions.*

2 Click ⊡.

3 Click a tool to add to the
selection (example: **Color
Wand**.)

4 Click the **Add** button.

■ Use the same method to
add to the selection that you
use to make a new selection
with the appropriate tool
(example: click and drag
using the **Rectangle** tool).

*Note: See "Select to Make Changes"
for instructions.*

Can I select two different portions of the same photo at the same time?

Yes. Just make your first selection using the tool of your choice. When you finish making the first selection, make the second selection as if nothing on the photo were selected.

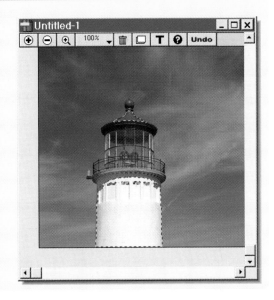

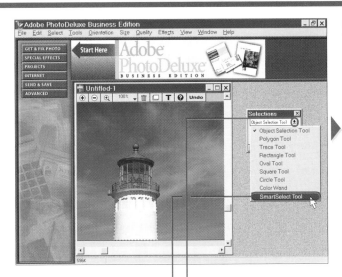

REMOVE PIXELS

1 Open the Selections tools palette.

Note: See "Select to Make Changes" for instructions.

2 Click 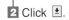.

3 Click a tool to remove pixels from the selection (example: **SmartSelect Tool**).

4 Click the Reduce button for the tool.

■ Use the same method to remove pixels from the selection that you use to make a new selection with the appropriate tool (example: click and trace with the **SmartSelect** tool.

Note: See "Select to Make Changes" for instructions.

ENHANCE IMAGES AUTOMATICALLY

You can correct the brightness, color saturation, contrast, and sharpness of an image automatically. Typically, correcting an image yields a broader range of colors and a crisper image.

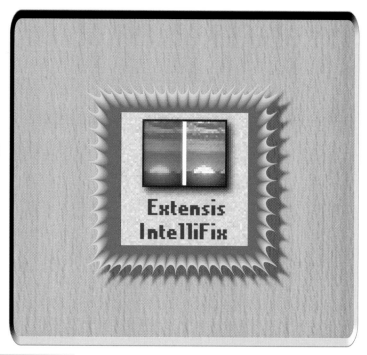

The Extensis IntelliFix tool is used on images that require some correction. Use it before applying corrections.

ENHANCE IMAGES AUTOMATICALLY

■1 Click **File**.

■2 Click **Open File**.

■ The Open dialog box appears.

■3 Click ▾ to select the folder that contains the photo you want to open.

■4 Click the file name of the photo you want to view.

■5 Click **Open**.

■ Your photo appears.

Can I adjust only one part of an image?

Yes. Select the portion you want to adjust before you click the **Extensis IntelliFix** button.

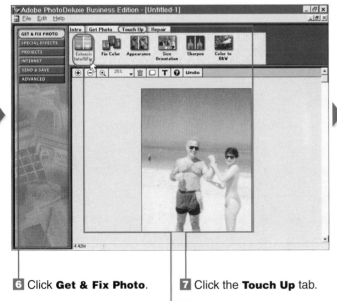

6 Click **Get & Fix Photo**.

7 Click the **Touch Up** tab.

8 Click the **Extensis IntelliFix** button.

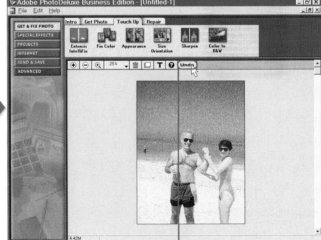

■ The image adjusts automatically, appearing crisper and more vivid but also dusty.

Note: See Chapter 12 for instructions on removing dust.

■ Click **Undo** to cancel the effects of the Extensis IntelliFix.

Note: If you intend to print photos, do not rely on the on-screen appearance of images. See Chapter 14 to run a test print.

Fine-Tuning Images

Did you know that you can change the size and shape of your digital photographs? This chapter shows you how.

DISPLAY LONG MENUS

You can display more
menus than just the
default File, Edit, and
Help menus. By using
Long Menus, you can
have more control and
freedom to act
because you have
direct access to more
commands. Using
Long Menus displays
additional menus on
the Menu bar.

DISPLAY LONG MENUS

1 Click **File**.

2 Click **Preferences**.

3 Click **Long Menus**.

■ Additional menu choices
appear.

PRESERVE YOUR ORIGINAL IMAGE

You can preserve your original images to safeguard them from the possible damaging effects of excessive editing.

Edit Process

When you edit an image, your software remaps the image, guessing what you mean. The guesswork is actually a process called *interpolating*. During the editing process, the software moves pixels around in an image, which redefines the values of the pixels. By continuously moving pixels or redefining their values, you can end up with a very ugly photo.

Copy Before Editing

You may want to make a copy of the photo for editing, instead of using the original. That way, if you create a poor-quality image, you can always start over by reopening the original and saving it under a new name.

Undo Changes

The Undo button in the image window enables you to undo the last action you took. After each change you make, evaluate the photo. Click Undo if you do not like what you see. And remember, the Undo button only lets you undo your last action; so, evaluate after each change you make.

RESIZE BY DRAGGING

You can resize images by dragging using the Free Resize tool or the Resize tool. The Resize tool maintains proportions, but the Free Resize tool does not. Neither tool is precise, and if you do not need precision, they will serve the purpose of resizing your photo. If you need to resize a photo, see "Adjust Photo Size" in this chapter.

USE THE FREE RESIZE TOOL

1 Open an Image and save under another name.

Note: See Chapter 9 for instructions.

2 Click **Size**.

3 Click **Free Resize**.

■ Small handles appear around the sides of the image.

4 Position the mouse over any handle.

■ The pointer appears as a two-headed arrow ().

■ As you drag a handle toward the center of the image, the image becomes smaller.

■ As you drag a handle away from the center of the image, the image becomes larger.

How do I get rid of the handles after I choose Size, Free Resize or Size, Resize?

You can press Enter to eliminate the handles if you change your mind after you start the resizing process.

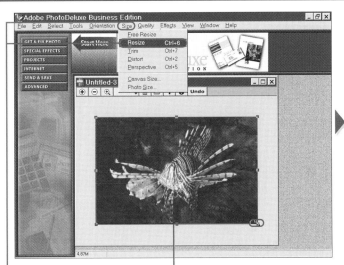

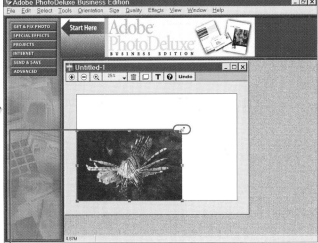

USE THE RESIZE TOOL

1 Open an Image and save under another name.

Note: See Chapter 9 for instructions.

2 Click **Size**.

3 Click **Resize**.

■ Small handles appear around the sides of the image.

4 Position the mouse over any handle and drag.

■ The pointer appears as a two-headed arrow (↗).

■ As you drag a handle toward the center of the image, the image becomes smaller.

■ As you drag a handle away from the center of the image, the image becomes larger.

ADJUST PHOTO SIZE

You can adjust the size of a photo if you need to make it fit in a particular space. The Photo Size box adjusts the size of a photo more precisely than Free Resize or Resize tools do because you can specify photo dimensions.

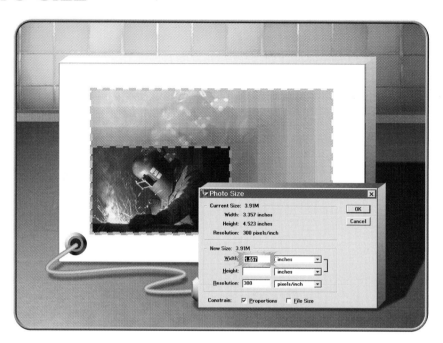

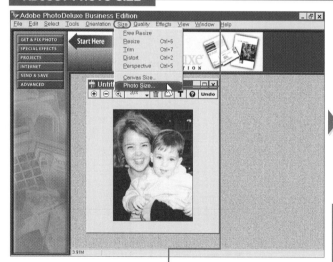

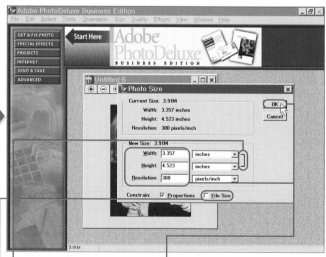

1 Open an Image and save as another name.

Note: See Chapter 9 for instructions.

2 Click **Size**.

3 Click **Photo Size**.

■ The Photo Size dialog box appears.

■ This line indicates that the proportions are retained. Changing one dimension proportionally changes the other.

■ You can click **File Size** (☐ changes to ☑) to change the dimension, which affects image resolution.

4 Type numbers to change the photo's Width, Height, or Resolution.

5 Click **OK** to accept any changes made.

Changing the size of your photo can affect the quality of the image. Compare the Current Size to the New Size in the Photo Size box.

Reduce Image Size

You may not notice a change in quality in a printed image if you reduce the size of a photo by 10 percent or more without checking the File Size box. To avoid losing original information from a photo, work from a copy.

Increase Image Size

You should find the quality acceptable to you if you increase the size of the image by 10 percent without checking the File Size box. However, if you increase the size more than 10 percent, you may notice blurring from the adding of more pixels.

Effect of the File Size Box

When you check the File Size box and make changes, PhotoDeluxe adjusts both the dimensions and the resolution (density of pixels per inch) of the image.

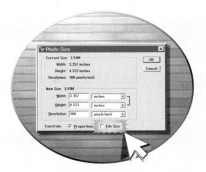

Effects on Resolution

When you reduce the size of a photo, PhotoDeluxe increases resolution. The image will have more pixels than the size requires, reducing both printing and online transfer speed. When you enlarge a photo, PhotoDeluxe reduces resolution. The photo may appear blurred, or you may even be able to see individual pixels on-screen or when you print because the photo has fewer pixels than the size requires.

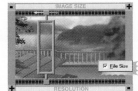

CROP A PHOTO

You can trim away unwanted portions of a photo. For example, you can crop a photo to rebalance it or to make it fit into a particular frame.

CROP A PHOTO

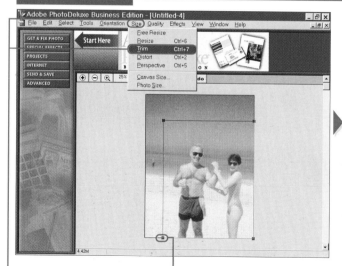

-1 Click **Size**.

-2 Click **Trim**.

■ The mouse ▷ changes to a plus sign (+).

-3 Click and drag to outline the portion of the image you want to keep.

■ Handles appear at the corners of the image.

-4 Click outside the photo to accept the crop marks.

■ The edited photo appears.

■ You can press Esc to cancel the crop changes.

■ You can click the **Undo** button to undo the effects of the cropping.

ADJUST ORIENTATION

You can adjust the orientation of an image to switch from a landscape to a portrait orientation or vice versa. Some digital cameras store all images in landscape orientation, even if you hold the camera in portrait orientation.

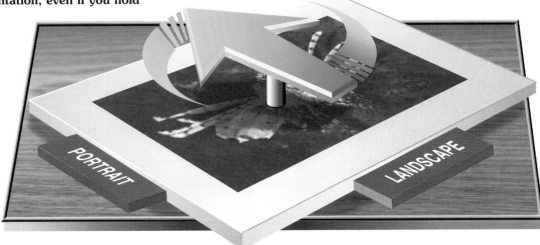

ADJUST ORIENTATION

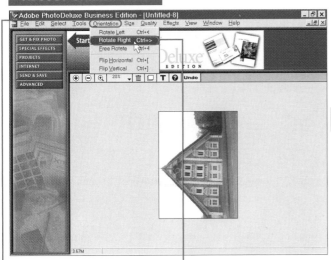

1 Click **Orientation**.

2 Click a preference (example: **Rotate Right)**.

■ The image appears in the orientation of your choice.

ADJUST AN IMAGE FOR PERSPECTIVE

You can adjust the perspective of a photo. Photographing tall buildings or roads from a great distance typically makes the top of the building or the furthest point of the road look smaller. You can control this effect.

ADJUST AN IMAGE FOR PERSPECTIVE

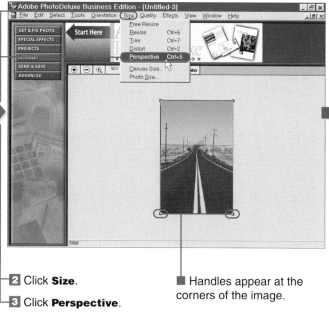

1 Click 🗗 to maximize the image in the window.

2 Click **Size**.

3 Click **Perspective**.

■ Handles appear at the corners of the image.

How far can I drag a Perspective handle?

You can drag the Perspective handle as far as you like. But be aware of the distortion you can create. In this figure, the telephone poles do not appear to be straight due to overcompensating for perspective.

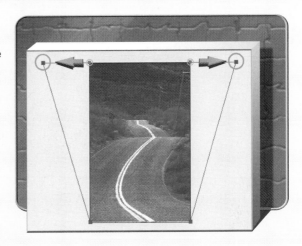

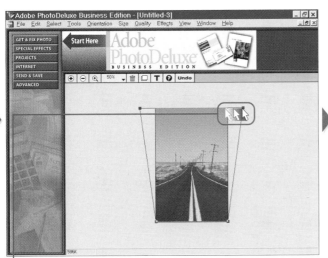

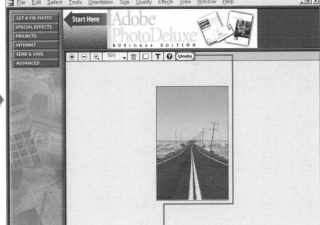

4 Click and drag a handle outward.

■ Dragging one handle expands both sides of the photo.

5 Release the mouse.

■ The side of the image that you dragged appears wider.

6 Press **Enter** to accept the perspective correction.

■ The image-editing program removes the handles and stores the change.

■ You can press **Esc** to cancel the perspective correction.

■ You can click the **Undo** button to reverse the perspective correction.

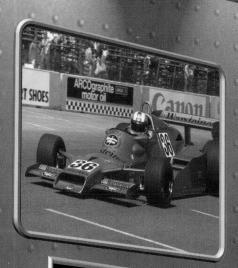

Create Negative

Convert to
Black-and-White

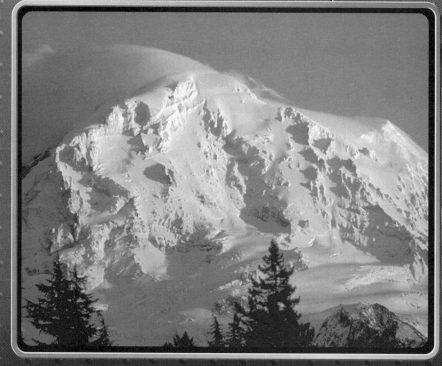

Hue/Saturation

Sharpen Image Color

Do you want to enhance or even change the colors of a photo? This chapter shows you how.

CONTROL BRIGHTNESS AND CONTRAST

You can adjust the brightness and contrast of all or part of a digital image. *Brightness* is the amount of white added to a color, and *contrast* is the difference between adjacent colors or shades of gray.

If you intend to print photos, do not rely on the on-screen appearance of an image. See Chapter 14 to run a print test.

CONTROL BRIGHTNESS AND CONTRAST

1 Open an image.

Note: See "Open an Image" in Chapter 9 for instructions.

■ To modify part of a photo, select that portion.

Note: See "Select to Make Changes" in Chapter 9 for instructions.

2 Click **Quality**.

3 Click **Brightness/Contrast**.

■ The Brightness/Contrast dialog box appears.

4 Type a positive number to increase brightness or contrast.

■ Typing a negative number decreases brightness or contrast.

5 Click to preview your changes (☐ changes to ☑).

■ You can also click and drag a slider to the right to increase brightness or contrast, or to the left to decrease brightness or contrast.

6 Click **OK** to accept the changes.

CHANGE HUE, SATURATION, OR LIGHTNESS

By adjusting hue, saturation, and lightness, you can change the overall color of any or all elements in a photo. *Hue* is the color and saturation of the vibrancy or dullness of the color. When you change lightness, you affect the brightness or darkness of the tint. Changes made to lightness can make changes to contrast necessary.

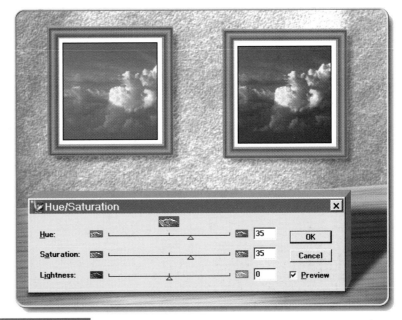

CHANGE HUE, SATURATION, OR LIGHTNESS

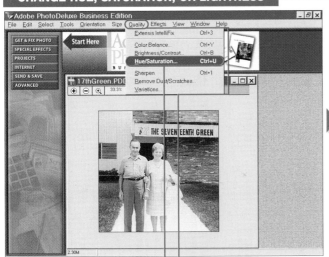

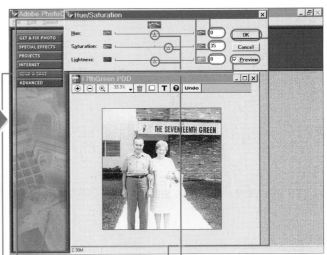

■ Open an image.

Note: See "Open an Image" in Chapter 9 for instructions.

■ To modify part of a photo, select that portion.

Note: See "Select to Make Changes" in Chapter 9 for instructions.

■ Click **Quality**.

■ Click **Hue/Saturation**.

■ The Hue/Saturation dialog box appears.

■ Type a positive number to increase hue, saturation, or lightness.

■ Typing a negative number decreases hue, saturation, or lightness.

■ Click to preview your changes (□ changes to ☑).

■ You can also click and drag a slider to the right to increase hue, saturation, or lightness, or to the left to decrease hue, saturation, or lightness.

■ Click **OK** to accept the changes.

BALANCE COLORS

You can control the amount of cyan, red, magenta, green, yellow, and blue in all or part of a photo.

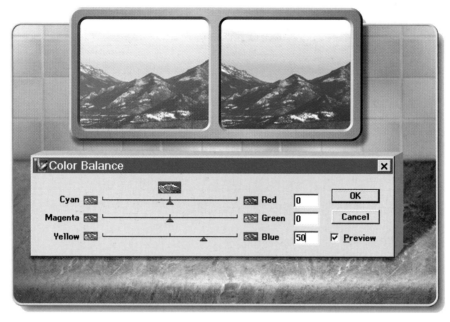

If you intend to print photos, do not rely on the on-screen appearance of the image. See Chapter 14 to run a print test.

BALANCE COLORS

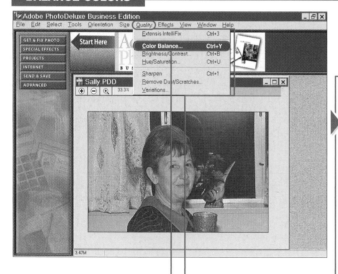

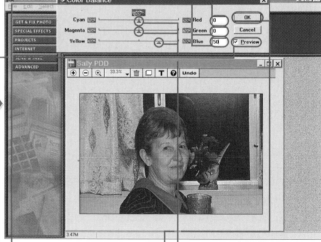

1 Open an image.

Note: See "Open an Image" in Chapter 9 for instructions.

■ To modify part of a photo, select that portion.

Note: See "Select to Make Changes" in Chapter 9 for instructions.

2 Click **Quality**.

3 Click **Color Balance**.

■ The Color Balance dialog box appears.

4 Type a positive number to add red, green, or blue.

■ Typing a negative number adds cyan, magenta, or yellow.

5 Click to preview your changes (☐ changes to ☑).

■ You can also click and drag a slider to the right to add red, green, or blue, or to the left to add cyan, magenta, or yellow.

6 Click **OK** to accept the changes.

You can
simultaneously adjust
color balance,
contrast, and
saturation of all or
part of an image
using the Variations
command.

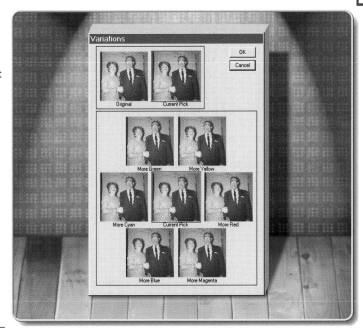

CHANGE COLORS

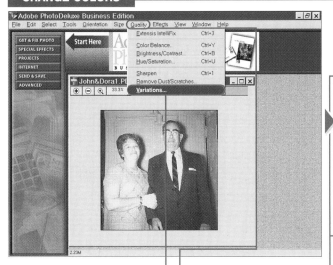

1 Open an image.

Note: See "Open an Image" in Chapter 9 for instructions.

■ To modify part of a photo, select that portion.

Note: See "Select to Make Changes" in Chapter 9 for instructions.

2 Click **Quality**.

3 Click **Variations**.

■ The Variations box appears.

■ Your original and current choices appear at the top.

4 Click a sample picture to add more of the color to the Current Pick.

5 Compare the Current Pick and the Original.

6 Click **Cancel** to cancel the changes.

■ The Cancel button changes to a Reset button that you can click.

CONTINUED ►

CHANGE COLORS

PhotoDeluxe offers you two other ways to change colors. Use the Color Change tool if the object you want to change does not contain many shades of color. Use the Hue Control if the object contains many different color shades.

If you intend to print photos, do not rely on the on screen appearance of an image. See Chapter 14 to run a print test.

CHANGE COLORS (CONTINUED)

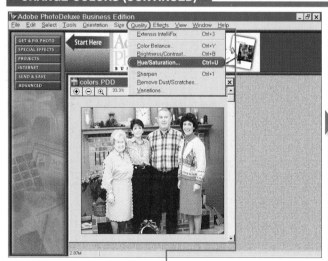

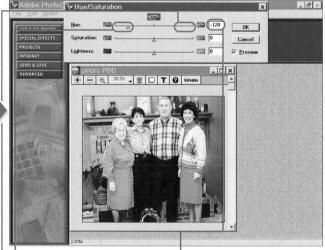

USE THE HUE CONTROL

1 Open an image.

Note: See "Open an Image" in Chapter 9 for instructions.

■ To modify part of a photo, select that portion.

Note: See "Select to Make Changes" in Chapter 9 for instructions.

2 Click **Quality**.

3 Click **Hue/Saturation**.

■ The Hue/Saturation dialog box appears.

4 Click and drag the slider to the left to change the colors to shades of red, yellow, and green.

5 Click and drag to the right to change the colors to shades of magenta, purple, and blue.

6 Type a number from 0 to -180 to change the colors to shades of red, yellow, and green.

7 Type a number from 0 to 180 to change the colors to shades of magenta, purple, and blue.

CREATE A NEGATIVE

You can use the Negative command to make your photo look like a negative of the photo. When building a collage, negatives can provide an artistic effect especially, if you fade the art into the background of the image.

CREATE A NEGATIVE

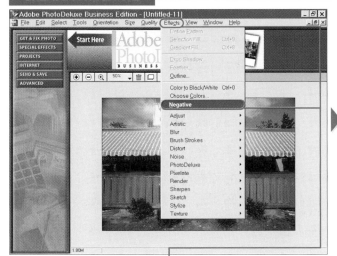

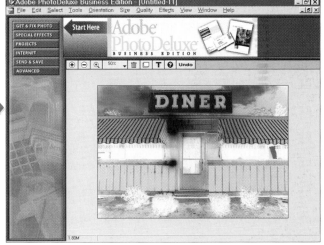

1 Open an image.

Note: See "Open an Image" in Chapter 9 for instructions.

■ To modify part of a photo, select that portion.

Note: See "Select to Make Changes" in Chapter 9 for instructions.

2 Click **Effects**.

3 Click **Negative**.

■ A negative version of your image displays.

■ You also can use the Negative command to create a positive image from a scanned black-and-white negative.

Retouch Images

Were you wondering if you could improve the appearance of photos? This chapter shows you how use some image editor tools to fix photo problems.

CLEAN UP A JPEG IMAGE

You can smooth the blocks, often called *jaggies*, which may appear on JPEG images. Typically, these blocks appear on JPEG images that have been compressed a great deal or on JPEG images that have been enlarged.

CLEAN UP A JPEG IMAGE

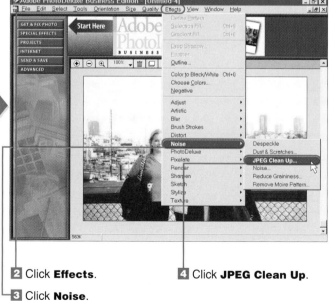

1 Open an image.

Note: See "Open an Image" in Chapter 9 for instructions.

■ To modify a specific area of a photo, select that portion.

Note: See "Select to Make Changes" in Chapter 9 for instructions.

2 Click **Effects**.

3 Click **Noise**.

4 Click **JPEG Clean Up**.

What effect do the values between 1 and 128 have on my photo?

Larger numbers provide more smoothing. You will find that higher numbers make the image appear blurry.

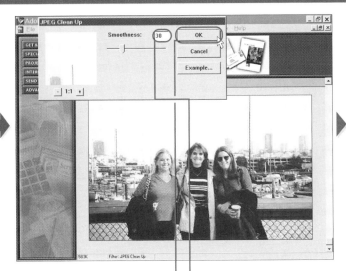

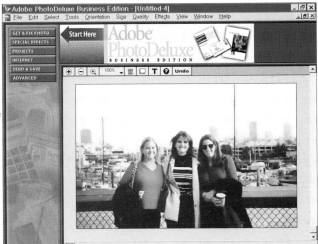

■ The JPEG Clean Up dialog box appears

5 Type a value from 1 to 128 in the Smoothness field.

6 Click **OK**.

■ The photo appears clearer after the cleanup.

USING THE CLONE TOOL

You can copy the pixels from one portion of a photo to another portion of the same photo or to a different photo. Use the Clone tool to cover up portions of a photo that you do not really want in the image.

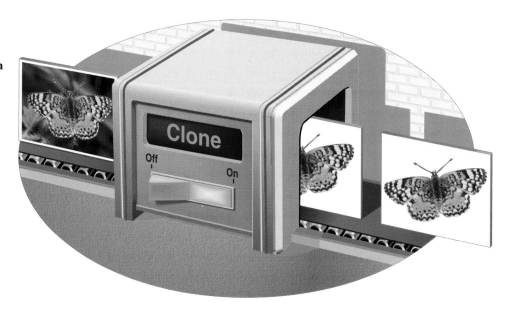

USING THE CLONE TOOL

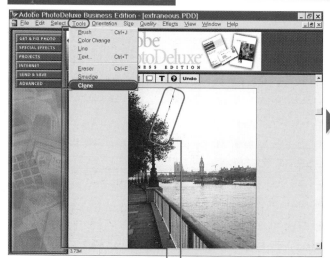

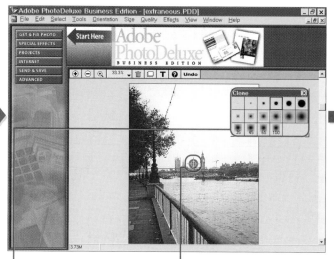

1 Open an image.

Note: See "Open an Image" in Chapter 9 for instructions.

2 Click the Zoom Tool button 🔍.

3 Click the area of the photo you need to fix.

4 Click **Tools**.

5 Click **Clone**.

■ The Clone palette appears.

■ The source point (⊕) appears in the center of the image.

188

What are the smudge marks that appear when I drag the Clone tool?

The smudges appear when you do not zoom in on the area that you want to clone. To eliminate the smudge marks, you can click the **Zoom** tool (🔍) or you can minimize the Adobe PhotoDeluxe window and maximize it again to make the smudges disappear.

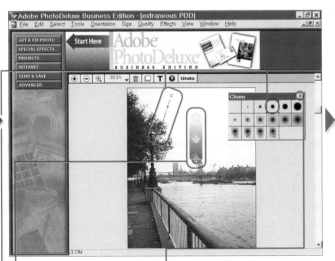

6 Click and drag the ⊕ to an area containing pixels you want to copy.

Note: This example clones sky pixels to cover the string of bulbs that detracts from the rest of the image.

7 Click a brush.

8 Click and drag the circle pointer ○ over the pixels you want to cover.

■ Repeat steps **6** to **8** as needed.

9 Click ⊠ to close the Clone palette box.

■ Your modified image appears.

Notice that the light bulbs no longer appear; instead, you see only sky and trees.

WORK WITH THE SMUDGE TOOL

You can use the Smudge tool to blur areas of a photo for artistic effect. Think of smudging as if you were running a paper towel across a wet paint canvas. The tool can help you draw attention to an important part of a photo by blurring the unimportant part.

WORK WITH THE SMUDGE TOOL

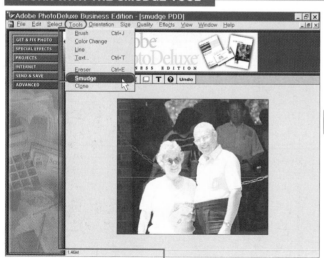

■ **1** Open an image.

Note: See "Open an Image" in Chapter 9 for instructions.

■ To modify a specific area in a photo, select that portion.

Note: See "Select to Make Changes" in Chapter 9 for instructions.

■ You can also invert the selection to smudge outside instead of inside the selection.

2 Click **Tools**.

3 Click **Smudge**.

■ The Smudges palette appears with available brushes.

■ The mouse pointer changes from ▷ to ○.

4 Click a brush in the Smudges palette.

5 Type a number to control the strength of the smudging.

190

How do the keyboard numbers control the strength of the smudge?

The number 1 provides the least smudging and 0 provides the most smudging, the other numbers change the strength of the smudging relative to their proximity to 1 or 0. A setting of 5, for example, provides a smudging strength halfway between the weakest and the strongest smudging.

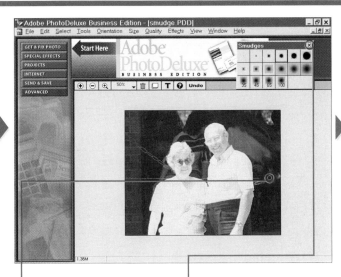

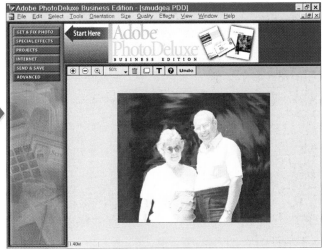

6 Click and drag the ○ over the pixels you want to smear.

7 Repeat steps **4** to **6** as needed to smear the parts of the picture that you want to blur.

8 Click ⊠ to close the Smudges palette box.

■ The modified image appears.

CORRECT GRAININESS

You can remove spots and speckles from digital images. Often you will see spots and speckles if you use Extensis IntelliFix to adjust automatically an image. The Reduce Graininess command blurs your image to remove the graininess.

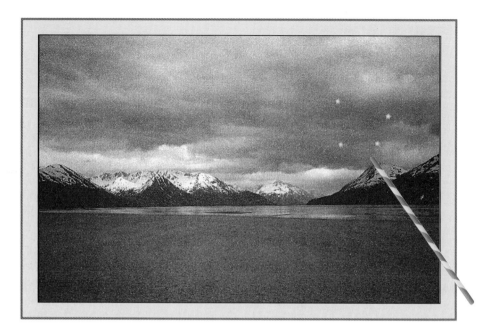

CORRECT GRAININESS

1 Open an image.

Note: See "Open an Image" in Chapter 9 for instructions.

■ To modify part of a photo, select that portion.

Note: See "Select to Make Changes" in Chapter 9 for instructions.

2 Click **Effects**.

3 Click **Noise**.

4 Click **Reduce Graininess**.

■ The Reduce Graininess dialog box appears.

What does the Despeckle command do?

The Despeckle command looks for the areas where significant color changes occur — known as *edges* — and blurs everything *except* those edges, leaving you with a crisper but less grainy photo than you get when you reduce graininess because detail is preserved. You do not have any control over the amount of despeckling that occurs. When you choose the command, PhotoDeluxe corrects the image without displaying a dialog box.

■5 Type a value between 1 and 128 in the field.

■ Higher values blur the image more, reducing graininess.

■6 Click **OK**.

■ A smoother, spot-free image appears.

REMOVE DUST OR SCRATCHES

You can remove flaws from photos using the Remove Dust/Scratches tool. Artifacts appear on photos perhaps from scanning or due to dust on a negative. The Remove Dust/Scratches tool looks for dissimilar colors and blurs the area surrounding them to eliminate them.

You will see spots and speckles if you use Extensis IntelliFix to adjust automatically an image.

REMOVE DUST OR SCRATCHES

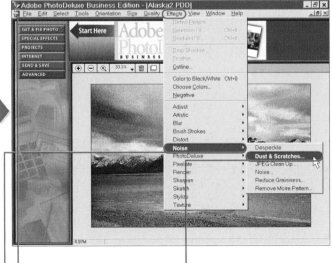

1 Open an image.

Note: See "Open an Image" in Chapter 9 for instructions.

■ To modify part of a photo, select that portion.

Note: See "Select to Make Changes" in Chapter 9 for instructions.

2 Click **Effects**.

3 Click **Noise**.

4 Click **Dust & Scratches**.

■ The Dust & Scratches dialog box appears.

How do I know what values to type in the Radius and Threshold fields?

You need to experiment and be patient as PhotoDeluxe redraws your image after each change. If you do not like the results of one set of choices, you can change them. The changes you make are not cumulative. If you click **OK** to close the Dust & Scratches dialog box and then reopen it, you can see your last settings in the Radius and Threshold fields.

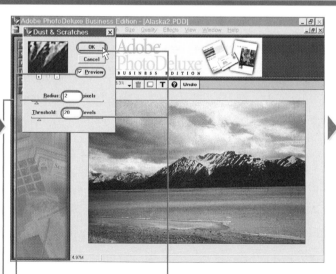

■ Checking this box enable you to see the effects of your changes.

5 Type a number between 1 and 16 to specify the size of the search area.

■ A higher number increases the search area.

6 Type a number from 0 to 128 to enlarge the detail.

■ Higher values blur the image more.

7 Click **OK**.

■ The image appears dust and scratch free.

REMOVE RED EYE

You can correct photos that contain glowing red eyes. This phenomenon occurs when the flash of the camera reflects off the red blood vessels in the back of the eye. Although many digital cameras today have features that can prevent red eye, you may scan photos that contain red eye or your camera may not control red eye.

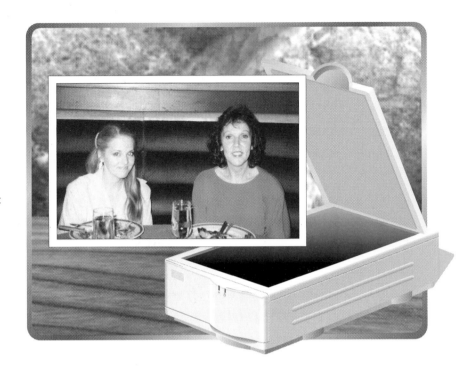

REMOVE RED EYE

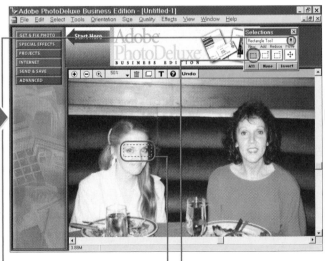

1 Open an image.

Note: See "Open an Image" in Chapter 9 for instructions.

2 Right-click the image to display a shortcut menu.

3 Click **Show Selections**.

■ The Selections palette appears.

4 Click ⬇.

5 Click **Rectangle Tool**.

6 Draw a rectangle around the red eyes in the photo.

Do I need to display the Selection palette?

No. You can select the Rectangle tool by pressing `Ctrl` + `M`.

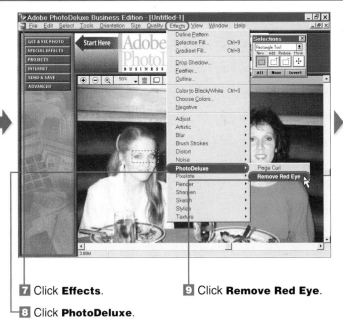

7 Click **Effects**.

8 Click **PhotoDeluxe**.

9 Click **Remove Red Eye**.

■ The glowing red disappears from the eyes.

10 Repeat steps **6** to **9** for each pair of red eyes in the photo.

Note: Because the glare of red eye can distort eye color, you may want to correct eye color after removing red eye. See the section "Change Eye Color" later in this chapter.

CHANGE EYE COLOR

You can change the color of a person's eyes in a photo. Consider this an opportunity to find out what you would look like if you had different colored eyes. Or, if you removed Red Eye (see the preceding task), you may need to touch up eye color.

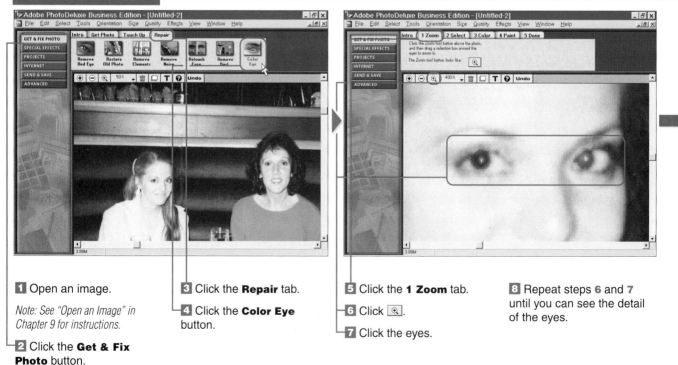

1 Open an image.

Note: See "Open an Image" in Chapter 9 for instructions.

2 Click the **Get & Fix Photo** button.

3 Click the **Repair** tab.

4 Click the **Color Eye** button.

5 Click the **1 Zoom** tab.

6 Click 🔍.

7 Click the eyes.

8 Repeat steps **6** and **7** until you can see the detail of the eyes.

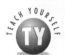

What if I did not get the eye entirely the way I want it? Can I fix it?

Yes. Click the **4 Paint** tab. Then click the **Paint** button to display the Brushes palette. Select a touch-up brush by clicking the icon on the palette. If necessary, click the Color square at the lower-right edge of the palette to change the color for touch-up purposes (see steps **13** to **16**). Click the individual pixels to change their color.

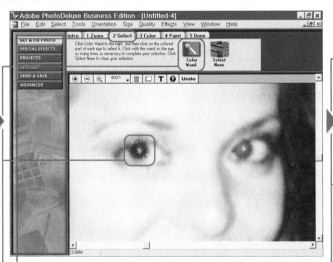

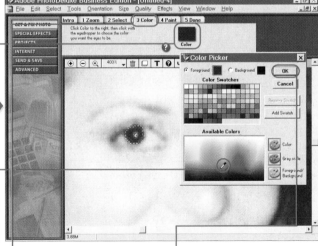

9 Click the **2 Select** tab.

10 Click the **Color Wand** button.

11 Click an eye area.

12 Repeat step **11** to select additional pixels to change.

Note: You can control the number of pixels the Color Wand selects in the Cursors box. Press **Ctrl** + **K** *and reduce the Color Wand Tolerance number.*

13 Click the **3 Color** tab.

14 Click the **Color** button.

■ The Color Picker dialog box appears.

15 Click the eyedropper (🖊) on a color.

16 Click **OK**.

■ The selected pixels color changes.

17 Click the **5 Done** tab.

■ The correct image remains.

ADD TEXT
COLORED PENCIL
POSTERIZE
SPONGE
LIGHTING
TRACE
NOTEPAPER
FEATHER
COMPOSITE
PANORAMA

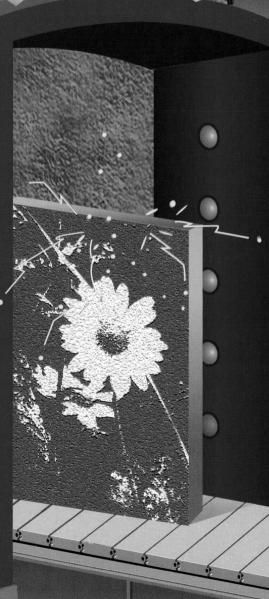

Create Effects

Feeling creative? Image editors contain tools that enable you to indulge your artistic yearnings.

ADD TEXT TO A PHOTO

You can add text to any
photo and use the text
as an artistic effect or an
identifier.

ADD TEXT TO A PHOTO

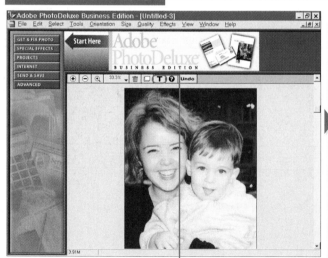

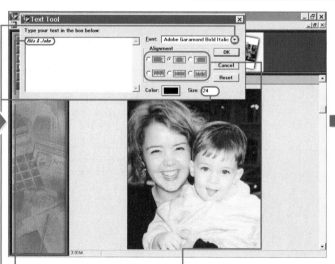

CREATE TEXT

1 Open an image.

*Note: See "Open an Image" in
Chapter 9 for instructions.*

2 Click **T**.

■ The Text Tool dialog box
appears.

3 Type your text in the field.

4 Click ▼ to select a font.

5 Type a font size.

6 Click to select an
alignment (○ changes
to ◉).

7 Click the **Color** box to
select a font color.

8 Click **OK** to save the
changes.

Is there some way to make the text more visible?

Yes. You can erase the area of the photo behind the text. Use the Rectangle tool to select the area you want to erase — selecting the area makes sure that you erase *only* that area. Click **Tools** and then **Eraser** from the menu. The Erasers palette appears. Click a tool and then drag the mouse back and forth over the selected area to erase it. If the area already contains text, PhotoDeluxe will erase the area behind the text and leave the text.

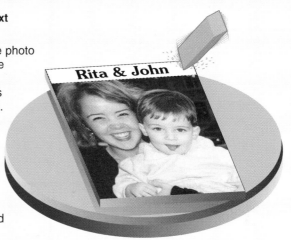

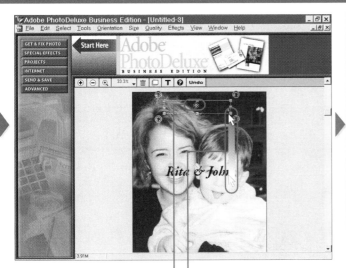

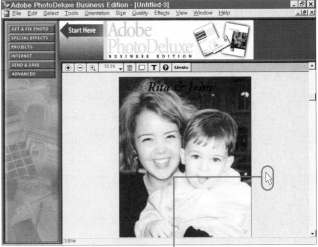

POSITION TEXT

■ Your text appears in a box in the center of your photo.

9 Click and drag the text box to the location where you want it to appear.

■ The mouse ▷ changes to four arrows.

■ When you release the mouse ▷, the text appears in the new location.

10 Click any gray area to remove the handles.

APPLY THE COLORED PENCIL EFFECT

You can make a photograph appear as if it were a colored pencil drawing. PhotoDeluxe applies a rough crosshatch pattern to important edges in the photo and a solid background color to the smoother areas.

APPLY THE COLORED PENCIL EFFECT

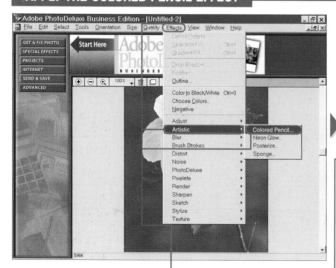

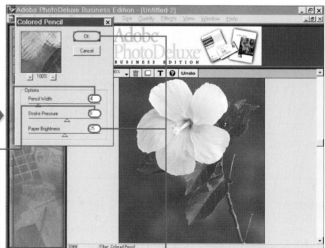

1 Open an image.

Note: See "Open an Image" in Chapter 9 for instructions.

■ To modify part of a photo, select that portion.

Note: See "Select to Make Changes" in Chapter 9 for instructions.

2 Click **Effects**.

3 Click **Artistic**.

4 Click **Colored Pencil**.

■ The Colored Pencil dialog box appears.

5 Type a number from 1 to 24 to set the Pencil Width for crosshatching.

■ Smaller numbers show less crosshatching.

6 Type a number from 0 to 15 to set the Stroke Pressure.

■ Lower numbers show more background and less image.

7 Type a number from 0 to 50 to set the Paper Brightness.

8 Click **OK** to apply the effect.

POSTERIZE A PHOTO

You can posterize an image to reduce the number of colors included in a photo by setting the brightness level. PhotoDeluxe changes each color in the photo to the closest match for the brightness level you chose. Posterizing creates flat areas of color, producing an interesting effect.

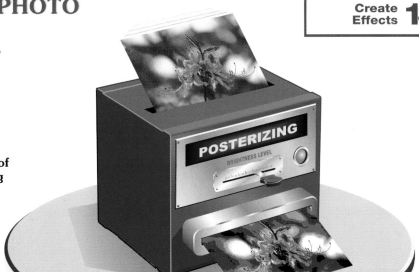

POSTERIZE A PHOTO

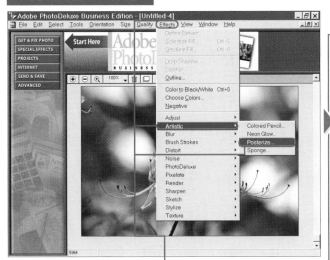 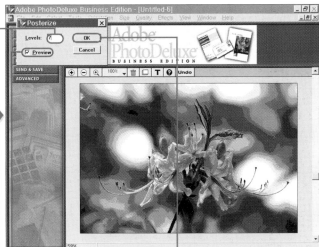

1 Open an image.

Note: See "Open an Image" in Chapter 9 for instructions.

■ To modify part of a photo, select that portion.

Note: See "Select to Make Changes" in Chapter 9.

2 Click **Effects**.

3 Click **Artistic**.

4 Click **Posterize**.

■ The Posterize dialog box appears.

■ This check allows you to see the effects of changes you make.

5 Type a number from 2 to 255 to set the level.

■ Higher numbers have less effect.

6 Click **OK** to apply the effect.

USING THE SPONGE EFFECT

You can make a photo look as if you painted it using a sponge. Applying the Sponge effect creates images with highly textured areas.

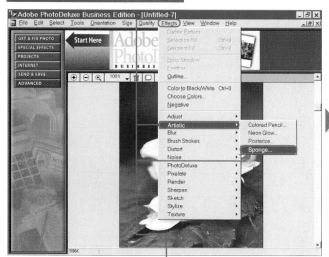

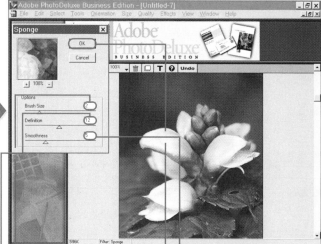

1 Open an image.

Note: See "Open an Image" in Chapter 9 for instructions.

■ To modify part of a photo, select that portion.

Note: See "Select to Make Changes" in Chapter 9.

2 Click **Effects**.

3 Click **Artistic**.

4 Click **Sponge**.

■ The Sponge dialog box appears.

5 Type a number from 0 to 10 to set a Brush Size.

■ Use smaller numbers for more detail.

6 Type a number from 0 to 25 to set a Definition.

■ Lower numbers produce more blending of colors.

7 Type a number from 1 to 15 to set a Smoothness to control the strength.

■ Lower numbers produce more sponging and less smoothness.

8 Click **OK** to apply the effect.

CRYSTALLIZE A PHOTO

You can use the Crystallize effect to clump pixels into a polygon shape of solid color.

CRYSTALLIZE A PHOTO

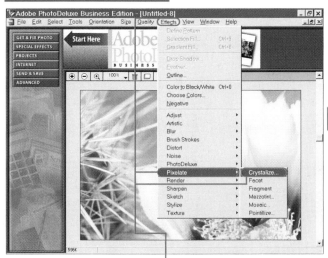

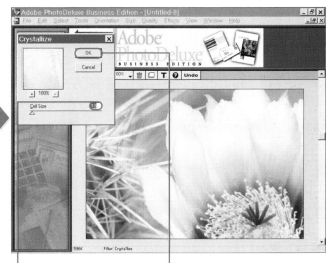

1 Open an image.

Note: See "Open an Image" in Chapter 9 for instructions.

■ To modify part of a photo, select that portion.

Note: See "Select to Make Changes" in Chapter 9.

2 Click **Effects**.

3 Click **Pixelate**.

4 Click **Crystalize**.

■ The Crystalize dialog box appears.

5 Type a number from 3 to 300 to set a Cell Size that specifies how big an area PhotoDeluxe bunches into one polygon.

■ Larger numbers produce bigger polygons and less definition in the photo.

6 Click **OK** to apply the effect.

USING LIGHTING EFFECTS

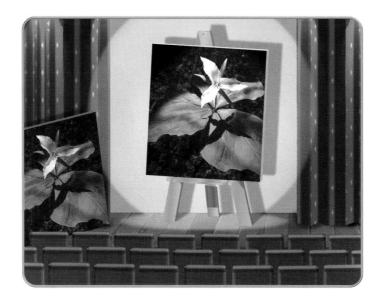

You can use
lighting effects to
add floodlights,
spotlights, and
even colored
lights to a photo.

USING LIGHTING EFFECTS

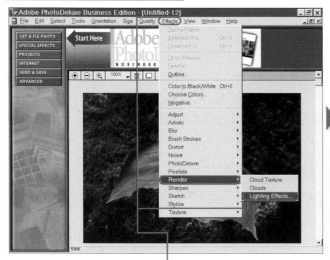

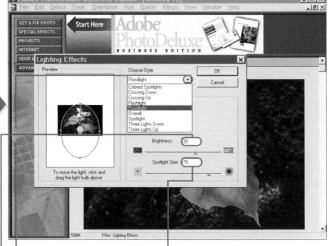

1 Open an image.

*Note: See "Open an Image" in
Chapter 9 for instructions.*

■ To modify part of a photo,
select that portion.

*Note: See "Select to Make Changes"
in Chapter 9.*

2 Click **Effects**.

3 Click **Render**.

4 Click **Lighting Effects**.

■ The Lighting Effects
dialog box appears.

5 Click ⏷ to select a
lighting style.

6 Type a number from −100
to +100 to set Brightness.

■ Higher numbers apply
brighter light.

7 Type a number from −100
to +100 to set a Spotlight
Size.

■ Higher numbers widen the
lighted area.

Why do I see a bulb and handles in the Lighting Effects box around the sample image?

You can drag the bulb to adjust the angle of the light, and you can drag the handles to adjust the shape of the light.

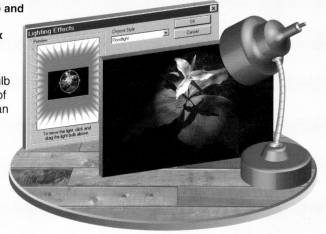

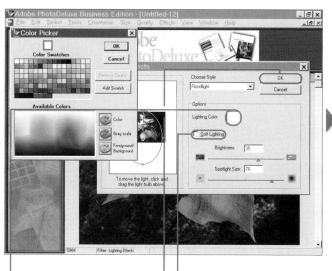

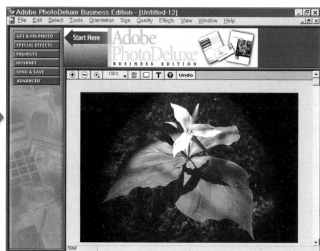

■ You can click **Lighting Color** to change the light color.

■ The Color Picker box dialog appears where you click to select a color and then click **OK** to redisplay the Lighting Effects dialog box.

■ You can click **Soft Lighting** (☐ changes to ☑) to soften the light.

■ **8** Click **OK** to apply the effect.

■ PhotoDeluxe displays the photo with the lighting effect.

USING A TRACE CONTOUR

You can use the Trace Contour effect to find the major changes in brightness and outline them, like the lines in a contour map.

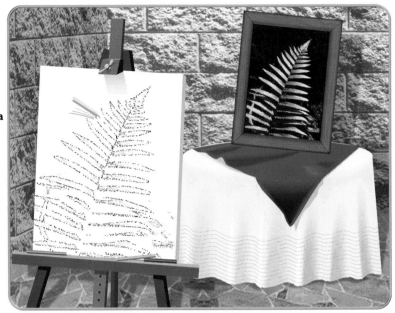

USING A TRACE CONTOUR

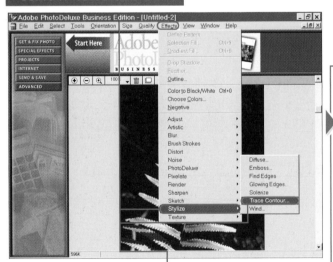

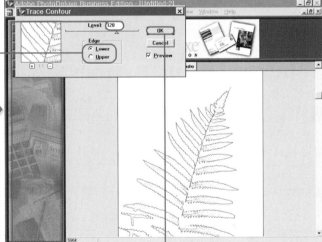

1 Open an image.

Note: See "Open an Image" in Chapter 9 for instructions.

■ To modify part of a photo, select that portion.

Note: See "Select to Make Changes" in Chapter 9.

2 Click **Effects**.

3 Click **Stylize**.

4 Click **Trace Contour**.

■ The Trace Contour dialog box appears.

5 Type a number to set a Level between 0 to 255.

■ Experiment to find the setting that produces the detail you want.

6 Click an edge (○ changes to ●).

■ Lower outlines pixels with color value below the Level, and Upper outlines pixels with color value above the Level.

7 Click **OK** to apply the effect.

APPLY GLOWING EDGES

You can use the Glowing Edges effect to darken all parts of a photo except the edges. With this effect, the edges of the photo appear to glow.

APPLY GLOWING EDGES

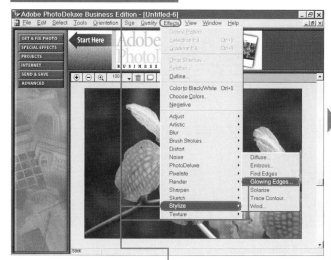

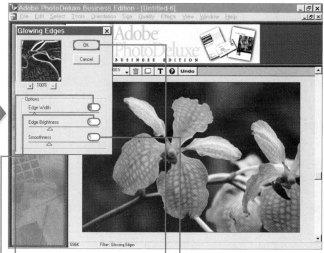

1 Open an image.

Note: See "Open an Image" in Chapter 9 for instructions.

■ To modify part of a photo, select that portion.

Note: See "Select to Make Changes" in Chapter 9.

2 Click **Effects**.

3 Click **Stylize**.

4 Click **Glowing Edges**.

■ The Glowing Edges dialog box appears.

5 Type a number from 1 to 14 to set an Edge Width.

6 Type a number from 0 to 20 to set an Edge Brightness.

7 Type a number from 1 to 15 to set a Smoothness level.

■ Lower numbers show more edges and detail.

8 Click **OK** to apply the effect.

FIND THE EDGES

You can use the Find Edges command to emphasize the edges in a photo and make the photo look like a drawing. Like the Trace Contour effect, the Find Edges effect locates areas in the photo where significant changes in brightness occur and outlines them with dark lines against a white background. Unlike the Trace Contour effect, you have no control over the behavior of the Find Edges effect.

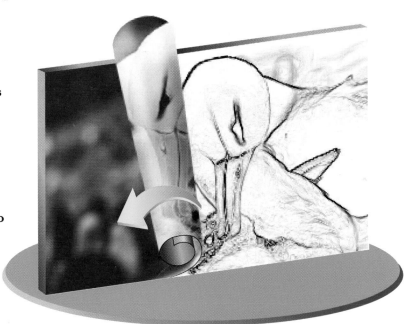

FIND THE EDGES

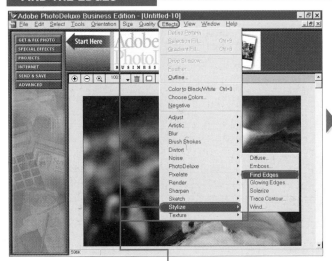

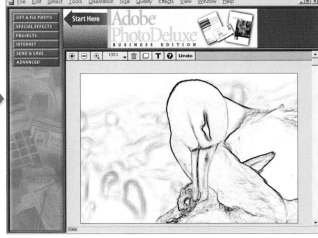

1 Open an image.

Note: See "Open an Image" in Chapter 9 for instructions.

■ To modify part of a photo, select that portion.

Note: See "Select to Make Changes" in Chapter 9.

2 Click **Effects**.

3 Click **Stylize**.

4 Click **Find Edges**.

■ PhotoDeluxe applies the effect to your photo.

You can use the Diffuse effect to make a photo look less focused. When you apply the Diffuse effect, PhotoDeluxe rearranges pixels in the photo.

DIFFUSE A PHOTO

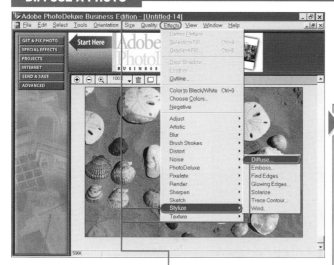

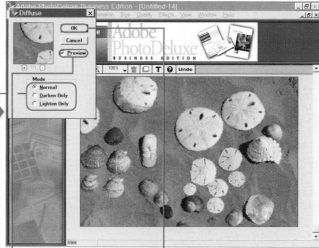

1 Open an image.

Note: See "Open an Image" in Chapter 9 for instructions.

■ To modify part of a photo, select that portion.

Note: See "Select to Make Changes" in Chapter 9.

2 Click **Effects**.

3 Click **Stylize**.

4 Click **Diffuse**.

■ The Diffuse dialog box appears.

■ This check allows you to preview the effects of changes you make.

5 Click a mode (○ changes to ◉).

■ Normal ignores color values and moves pixels randomly. Darken Only replaces light pixels with darker pixels. Lighten Only replaces dark pixels with lighter pixels.

6 Click **OK**.

APPLY THE NOTE PAPER EFFECT

You can apply the Note Paper effect to produce an image with the three-dimensional look that you see on images constructed of handmade paper. PhotoDeluxe uses the foreground and background colors you set using the Change Color tool to color dark areas in the photo with the foreground color and light areas with the background color.

To change the foreground and background colors, see "Change Colors" in Chapter 11.

APPLY THE NOTE PAPER EFFECT

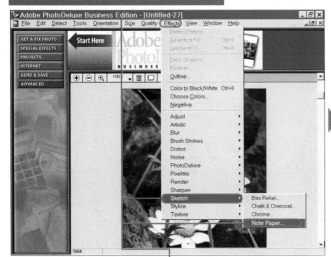

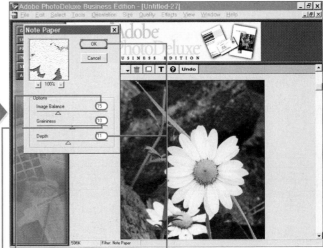

■1 Open an image.

Note: See "Open an Image" in Chapter 9 for instructions.

■ To modify part of a photo, select that portion.

Note: See "Select to Make Changes" in Chapter 9.

■2 Click **Effects**.

■3 Click **Sketch**.

■4 Click **Note Paper**.

■ The Note Paper dialog box appears.

■5 Type a number from 0 to 50 to set an Image Balance.

■ Smaller numbers add more foreground color.

■6 Type a number from 0 to 20 to set a Graininess.

■ Higher numbers add more texture.

■7 Type a number from 0 to 25 to set a Depth.

■8 Click **OK** to apply the effect.

You can apply the Crackle effect to make a photo look like it was painted onto a plaster surface, adding fine cracks to the image.

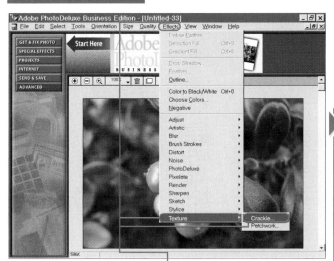

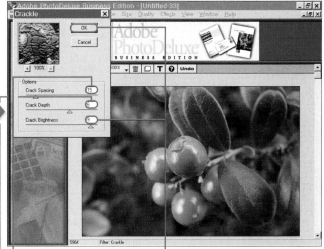

1 Open an image.

Note: See "Open an Image" in Chapter 9 for instructions.

■ To modify part of a photo, select that portion.

Note: See "Select to Make Changes" in Chapter 9.

2 Click **Effects**.

3 Click **Texture**.

4 Click **Crackle**.

■ The Crackle dialog box appears.

5 Type a number from 2 to 100 to set a Crack Spacing.

■ Larger numbers add more distance between cracks.

6 Type a number from 0 to 10 to set a Crack Depth.

■ Higher numbers add deeper cracks.

7 Type a number from 0 to 10 to set a Crack Brightness.

8 Click **OK** to apply the effect.

FEATHER AN IMAGE

You can use the Feather effect to fade the edges of a selection. When you apply the Feather effect, PhotoDeluxe gradually fades pixels between the selection and the area surrounding it, drawing the viewer's attention to the unfeathered portion of the image.

FEATHER AN IMAGE

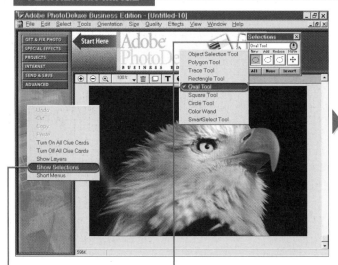

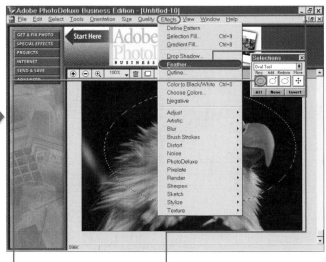

1 Open an image.

Note: See "Open an Image" in Chapter 9 for instructions.

2 Right-click to display a shortcut menu.

3 Click **Show Selections**.

■ The Selections palette appears.

4 Click ⊡ to display a list of tools.

5 Click the **Oval Tool**.

6 Click and drag to select the part of the photo that you want to keep.

7 Click **Effects**.

8 Click **Feather**.

Can you show me the effect of using smaller and larger numbers of pixels and deleting the background?

The figure on the left was created using 10 pixels and deleting the background. The figure on the right was created using 25 pixels and deleting the background.

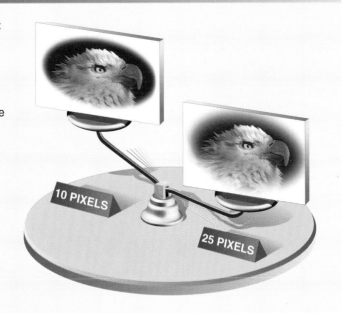

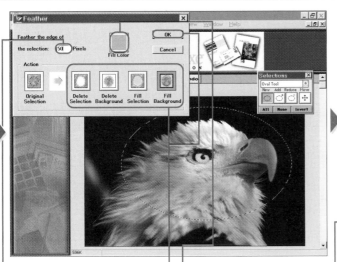

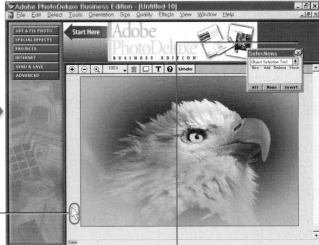

■ The Feather dialog box appears.

9 Type a number of pixels from 1 to 250.

■ Larger numbers produce a more gradual fading effect.

■ You can click **Fill Color** to select a foreground or background color.

10 Click an action.

■ Both fill choices apply the Fill Color.

11 Click **OK** to apply the effect.

■ PhotoDeluxe applies the Feather effect.

12 Click a gray area outside the photo to cancel the selection.

■ You can close the Selection Palette by clicking ☒.

COMBINE PHOTOS

By combining two photos into one, you can make a family picture out of two separate portrait-oriented photos of two different family members.

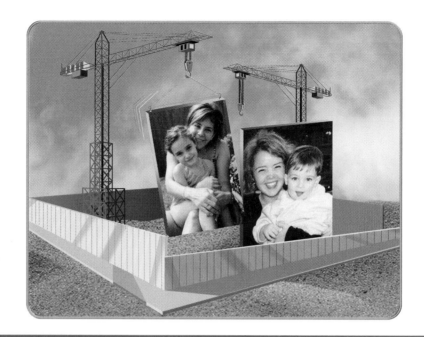

COMBINE PHOTOS

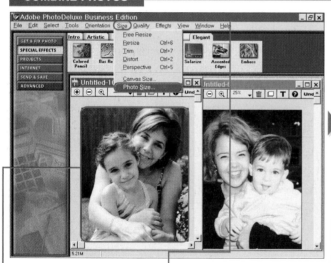

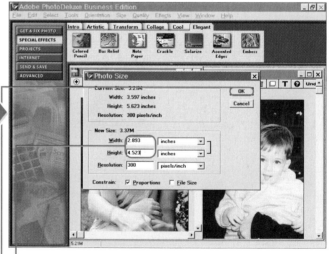

ADJUST THE HEIGHTS

1 Open an image.

Note: See "Open an Image" in Chapter 9 for instructions.

2 Click the left photo.

3 Click **Size**.

4 Click **Photo Size**.

■ The Photo Size dialog box appears.

5 Write down the width and height of the photo.

6 Click **OK**.

7 Repeat steps **2** to **5** for the photo on the right.

8 Repeat steps **3** and **4** to change its height to match the shorter photo.

9 Note the new width and click **OK**.

■ Changing the height from 5.623 to 4.523 changes the width to 2.893.

Why must I shorten the taller photo to match the height of the shorter photo?

If you do not match heights, your combined photo will look strange and out of proportion. If you try to lengthen the shorter photo, you rely on PhotoDeluxe to add pixels — an experience that may not leave you happy.

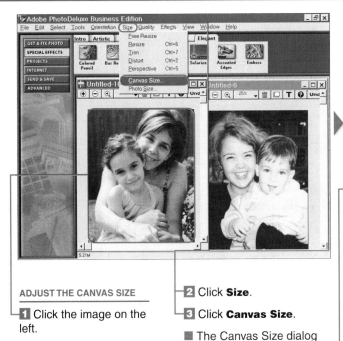

ADJUST THE CANVAS SIZE

■1 Click the image on the left.

■2 Click **Size**.

■3 Click **Canvas Size**.

■ The Canvas Size dialog box appears.

■4 In the Width field box, type the sum of the two photos' widths (for example: **2.893 + 3.357 = 6.25**).

■5 Click the left-center Placement box to place the photo in the middle of the left of the canvas.

■6 Click **OK**.

■ A large white space appears to the left photo.

CONTINUED

COMBINE PHOTOS

You can merge the two photos into one by copying one image and pasting it into the other image.

COMBINE PHOTOS (CONTINUED)

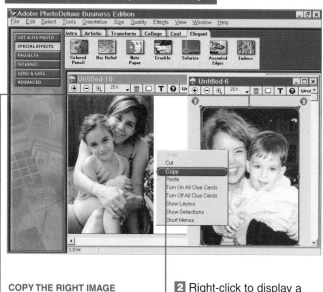

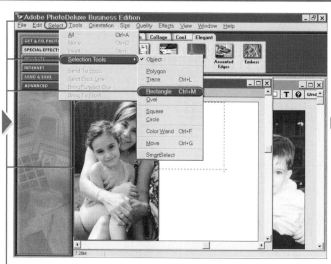

COPY THE RIGHT IMAGE

1 Click the right photo twice.

2 Right-click to display a shortcut menu.

3 Click **Copy**.

PASTE THE LEFT IMAGE

4 Click the left photo to make it active.

5 Click **Select**.

6 Click **Selection Tools**.

7 Click **Rectangle**.

■ The mouse ⊾ becomes a plus sign **+**.

8 Drag to outline the white space.

Is there another way to choose the Rectangle tool?

Yes. You can press `Ctrl` + `M` or display the Selections palette and click the Rectangle Tool. Right-click and click **Show Selections,** click ▼, and then click **Rectangle Tool.**

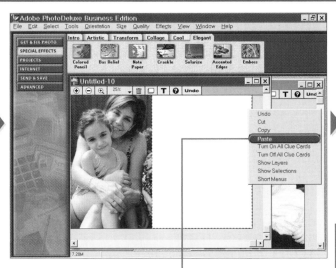

9 Right-click to display a shortcut menu.

10 Click **Paste**.

■ The right image appears selected next to the left image in the white space of the canvas.

11 Click any gray area to remove the selection handles.

12 Save the image.

Note: See "Save an Image" in Chapter 9 for instructions.

COMPOSITE PHOTOS

You can create a *composite photo*, where you combine two photos by superimposing all or part of one photo onto another photo. In this task, you take advantage of the Layers feature in PhotoDeluxe to superimpose one entire photo onto another.

Think of Layers as images stacked one on top of the other. Using layers, you can easily combine images, text, and graphics and remove elements that you do not like.

COMPOSITE PHOTOS

OPEN IMAGES TO COMPOSITE

1 Open an image.

Note: See "Open an Image" in Chapter 9 for instructions.

2 Open the other image that you want to use in the composite.

■ Repeat step **2** for any other images that you want to use in the composite.

■ While you can create up to 99 layers, the size of the file will be the combined size of all layers. In addition to slowing PhotoDeluxe, the images will not be attractive.

Can I decide not to include a particular layer? Do I need to start all over?

No, you can delete the layer. Click the layer in the Layers palette. Then, click ▶ to display the Layers palette menu. Click **Delete Layer.**

COPY AN IMAGE

■3 Click the image to select it.

■ A selection box with handles appears around the image.

■4 Click **Edit**.

■5 Click **Copy**.

SWITCH IMAGES

■6 Click **Window**.

■7 Click the name of the other image.

■ The other image appears.

CONTINUED

COMPOSITE PHOTOS

Each time you create a layer, you increase the size of the file. The size of any image file is the sum of the sizes of the layers it contains. You can reduce the size of a file that contains many images by merging the layers.

COMPOSITE PHOTOS (CONTINUED)

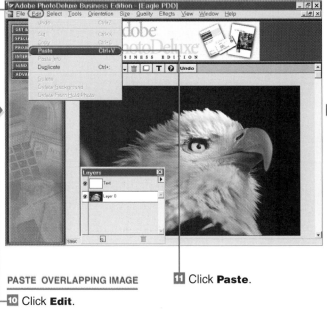

DISPLAY THE LAYERS PALETTE

■ 8 Right-click to display a shortcut menu.

■ 9 Click **Show Layers**.

■ The Layers palette appears, including thumbnail images for each layer.

PASTE OVERLAPPING IMAGE

■ 10 Click **Edit**.

■ 11 Click **Paste**.

What effect do the various Blend choices have on a layered image?

When you blend, you combine colors from the original photo (called *base colors*) with colors from the layers you are blending (called *blend colors*). **Darken** combines the base and blend colors to produce a darker image. **Lighten** combines the base and blend colors to produce a lighter image. **Overlay** mixes the base and blend colors evenly. **Difference** subtracts the less bright pixels in each layer from the brighter pixels in other layers, reducing the overall brightness of the combined layers. **Color** combines the lightness of the base colors with the hue and saturation of the blend colors.

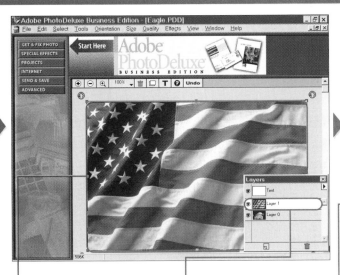

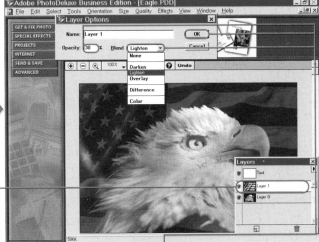

■ PhotoDeluxe superimposes the image you copied onto the current image (example: the flag appears on top of the eagle).

■ A thumbnail appears in the Layers palette for the copied image.

EDIT A LAYER

⏣ Double-click the thumbnail of the layer you just copied.

■ The Layer Options dialog box appears.

⏥ Lower the Opacity number to make the layer more transparent.

■ You can click ▾ to select a Blend option such as Lighten.

⏦ Click **OK**.

CREATE A PANORAMA

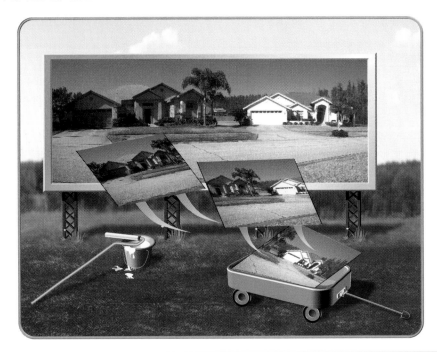

You can create a *panorama photo,* a very wide-angle picture, when the expanse you are photographing will not fit into an individual photo. You will have the best success at creating a panorama if you use the same lighting, shutter, and aperture settings for all of the photos and use a tripod when you take the photos.

CREATE A PANORAMA

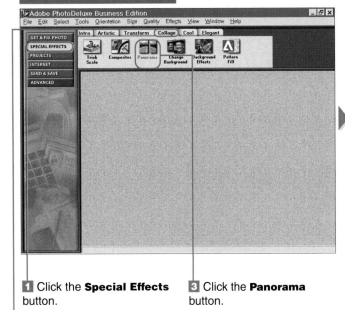

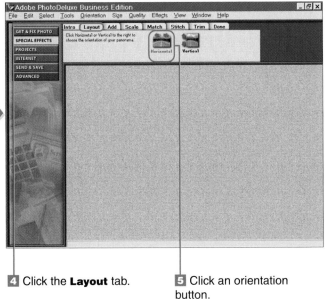

1 Click the **Special Effects** button.

2 Click the **Collage** tab.

3 Click the **Panorama** button.

4 Click the **Layout** tab.

5 Click an orientation button.

How many photos can I combine into a panorama?

You can combine up to three photos into one panorama picture.

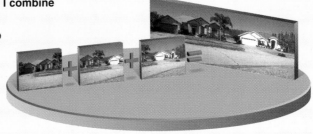

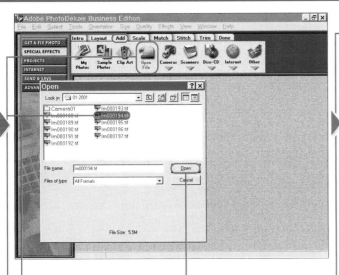

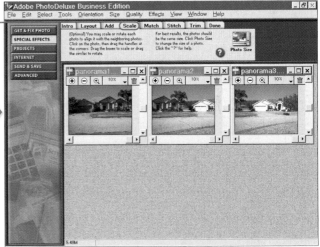

6 Click **Add**.

7 Click **Open File**.

■ The Open dialog box appears.

8 Click the filename of the photo you want to place on the left side of the panorama.

9 Click **Open**.

Note: See "Open an Image" in Chapter 9 for instructions.

■ Repeat steps **6** to **9**, opening each photo in the order in which they should appear in the panorama.

■ Your photo appears in an untitled window.

10 Click **Scale**.

■ If needed, scale or rotate photos, or adjust sizes.

Note: See "Adjust Orientation" and "Adjust the Photo Size" in Chapter 10 for more information.

CONTINUED

CREATE A PANORAMA

You can complete the creation of a panorama by matching, as closely as possible, the colors, brightness, contrast, and hue of individual photos that you include in the panorama.

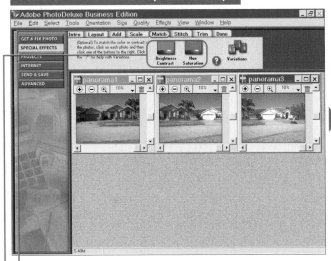

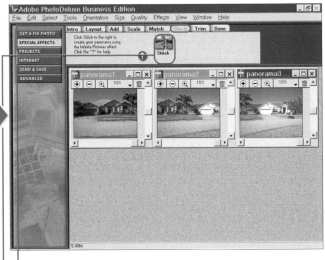

11 Click the **Match** tab.

12 Click the **Brightness Contrast** or **Hue Saturation** button to match the color or contrast of the photos.

Note: See Chapter 11 for more information on controlling brightness and contrast, and changing hue saturation and color.

13 Click the **Stitch** tab.

14 Click the **Stitch** button.

How does PhotoDeluxe know where to stitch the photographs together?

You can help. When you take the photos, include about 50% of the same information in each photo that will be part of a panorama shot. PhotoDeluxe will compare the photos and stitch based on common information in the photos.

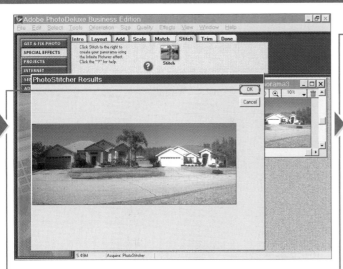

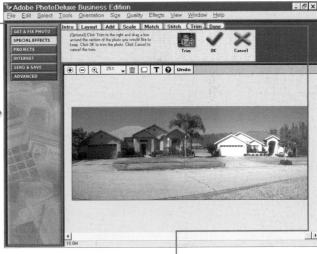

■ The proposed panorama appears.

15 Click **OK**.

■ If you want to make changes, you can click **Cancel** and then repeat steps **10** to **14**.

■ PhotoDeluxe converts individual photos into one panorama photo.

■ You can click **Trim** to crop the panorama.

Note: See Chapter 10 for more information on cropping photos.

16 Click **Done**.

■ PhotoDeluxe redisplays the choices available on the Special Effects tab along with your panorama shot.

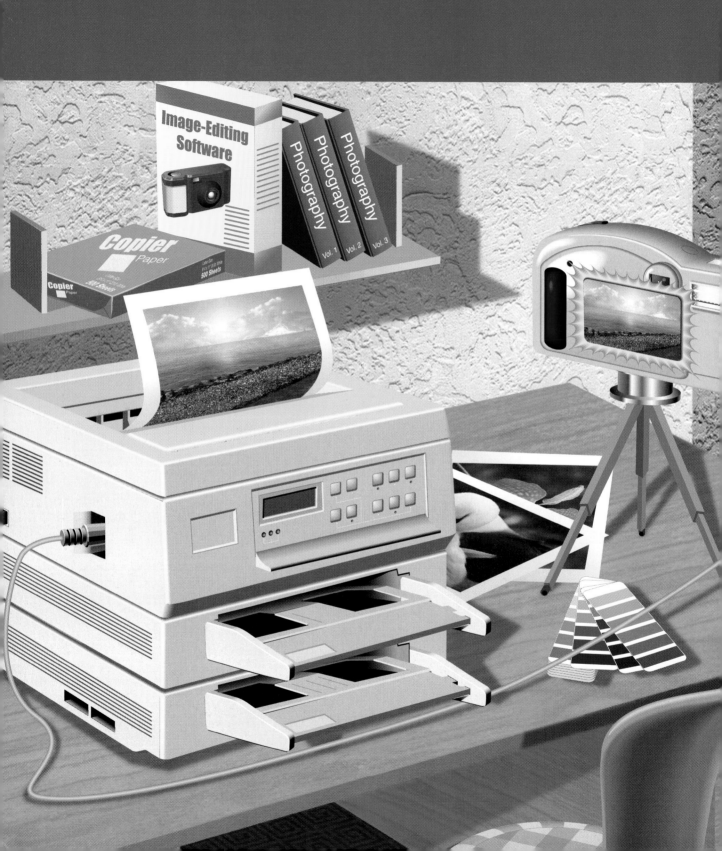

Print Photos

Are you looking forward to seeing your digital images on paper? This chapter shows you how to print quality photos.

GET THE FACTS ABOUT PRINTING

You can create high-quality prints by understanding some basics about printing images, such as the factors that determine print quality.

Print Quality

The quality of a printed image depends on the type of printer and paper that you use, and the quality — number of pixels — of the image. See "Purchase a Quality Printer" and "Print Paper" later in this chapter for more information. Images that contain larger numbers of pixels give you the best results when printing.

Calibration

The colors on your monitor may not match the colors printed by your printer, and colors vary from one monitor to another. Image editors such as Adobe Photoshop and Corel PHOTO-PAINT enable you to calibrate your printer and monitor. See "Calibrate Your Printer" later in this chapter.

You can print your photos even if you do not own a printer, or if you are not satisfied with the image quality of your printer.

Get Prints Over the Internet

You can upload image files to the Kodak Web site at www.kodak.com or to the Fujifilm Web site at www.fujifilm.com and receive your prints by mail.

Visit Your Local Photo Lab

You can take digital images to many photo labs that will print and enlarge your images on a variety of photo papers.

Enlarging a digital image can reduce the quality of the print if you do not have enough pixels for the print size.

CHOOSE A PRINTER

You can purchase a variety of printers that can print your digital images near photo quality.

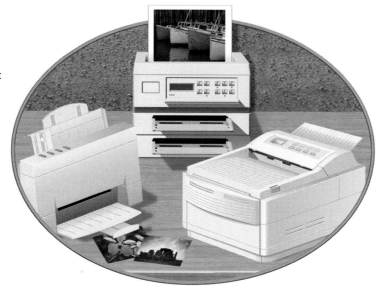

THE COST OF PRINTING

When you look at printers, consider the cost of printing photos. You incur more than the cost of the printer; you must also buy ink and paper. Be sure to ask about the cost of the ink for the printer, and find out if the printer requires that you use photo paper. The cost of printing a photo could run $1 per photo or more.

TYPES OF PRINTERS

Color Inkjet Printers

Inkjet printers are physically small and spray ink dots onto paper. Inkjet printers are very affordable at $100 to $700, but can be slow. Also, the spraying process tends to make ink spread out on the paper, providing less definition to the print and reducing quality. Glossy paper reduces the effect, but be careful not to smear a wet print when you handle it.

Color Laser Printers

Laser printers use a laser beam to produce static electricity on a drum inside the printer. The drum places toner — the ink — onto paper and the printer uses heat to bind the ink to the paper. Color laser printers can produce near-photographic quality and are speedy. They also tend to be large and expensive, starting at around $1000.

Dye-Sublimation Printers

Also called *thermal dye printers*, dye-sublimation printers use heat to transfer colored dyes to paper. The dye sinks into (sublimates) the paper. Dye-sublimation printers produce the closest to photo-quality prints you will see. These printers range in cost from $300 to $10,000, and require that you use special paper. The less-expensive models produce only snapshot-size prints, so you cannot use them to print full pages (invoices, letters, and so on).

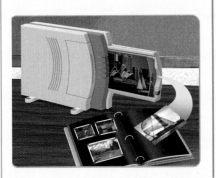

Micro Dry Printers

Micro Dry printers transfer resin-based ink onto paper using heat. Micro Dry printers cost about the same as inkjet printers, and, because the ink is almost dry when it hits the paper, it does not produce the bleeding and page warping that sometimes happens with inkjets. Also because the ink is almost dry, you also sometimes see banding in solid color areas of the photo. You can use any paper in a Micro Dry printer.

Print from the Camera

All of the printers discussed so far connect to and print from your computer. Printers like the Lexmark PM200, the Hewlett Packard PhotoSmart series, and the Epson 875DC, however, print directly from the camera. In some cases, you connect your camera directly to the printer using the same cable that connects the camera to your computer. In other cases, you can insert the removable memory card of the camera into a slot on the printer.

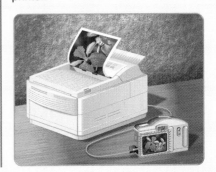

OPTIMIZE CAMERA AND PRINTER RESOLUTION

You are more likely to print a top-quality photo if you set both the number of pixels in your image and the resolution setting of your printer according to its manual.

PPI and DPI

You measure the *resolution* of an image by the number of pixels it contains per inch — called pixels per inch (ppi). You measure the resolution of a printer by the number of dots it prints in one inch — called dots per inch (dpi). DPI and PPI are *not* the same. Many printers print multiple dots for each pixel in an image.

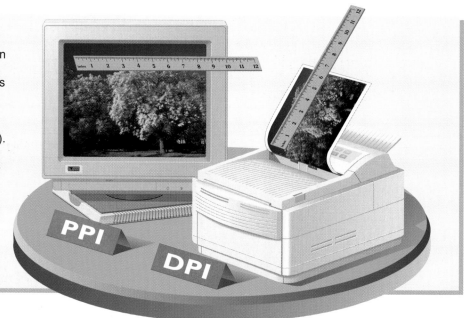

PPI and Photo Size

The number of pixels in your image determines the maximum size photo you can print. If you try to print too large a photo from a file that does not contain enough pixels, your printed image will be pixelated, like the image on the right. For most photos printed on consumer printers, use images with an image resolution of 300 ppi to produce the best quality print.

Set Printer Resolution

You need to check your printer's manual to identify the ideal dpi setting for printing photos. On some printers, you want set a one-to-one by setting your image resolution to 300 ppi and the printer resolution to 300 dpi. Some printers, however, print multiple dots for each pixel in your image, so check your printer manual.

Determine Optimal Photo Print Size

The number of pixels in an image is linked to the print size. Use the Photo Size option box in PhotoDeluxe to determine the size you can print at a desired resolution. Typing 300 in the resolution field will give you the ideal print size of a photo. Be sure to constrain both Proportions and File Size.

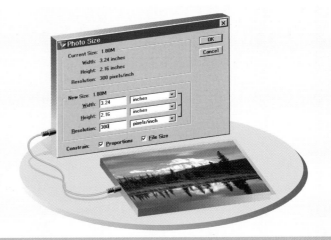

CHOOSE A PAPER TYPE

You can use an assortment of paper to print images with most printers. The quality of paper will affect your print.

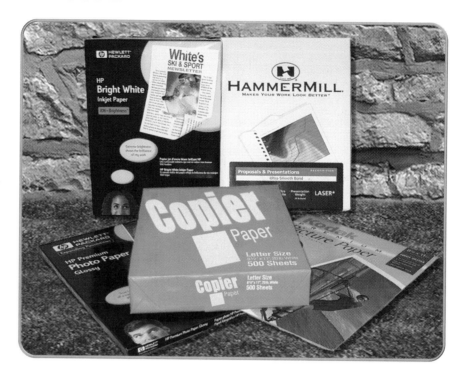

TYPES OF PAPER

Photocopy Paper

This multipurpose paper is lightweight and inexpensive ($.01-$.02 per sheet) and does not produce particularly good quality prints.

Inkjet Paper

Higher-quality inkjet paper costs relatively little ($.10 per sheet). The special coating on inkjet paper enables it to dry more quickly, reducing the smearing and page curl you see on inkjet prints produced on lower quality or non-inkjet paper.

Laser Paper

Laser paper comes in a variety of qualities, and the higher quality paper is brighter, smoother, heavier, and runs about $.04 per page. The brighter color makes images look like they have higher contrast, and the smoother surface works with laser printer toners to make images appear sharper.

Photo Paper

Photo paper is thick and glossy, and it produces prints closest in quality to traditional photographs. It is also the most expensive of the papers you can use, running between $.50-$3.00 per sheet.

PAPER TIPS

Acid Content

The acids in paper can cause a print to discolor over time, reducing the life of a print. If possible, use acid-free papers. You may find acid-free papers in your local office supply store, if not, look in art supply stores.

CALIBRATE YOUR PRINTER

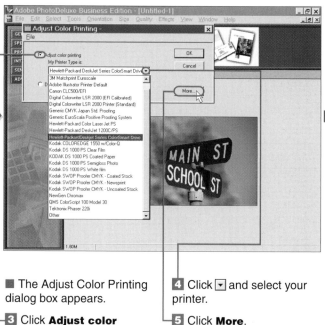

You can calibrate your printer to adjust its colors if you find that colors of the printed photo do not match the colors of the on-screen photo.

1 Click **File**.

2 Click **Adjust Color Printing**.

■ The Adjust Color Printing dialog box appears.

3 Click **Adjust color printing** (○ changes to ⊙).

4 Click ▼ and select your printer.

5 Click **More**.

My printer does not appear in the list. What should I do?

If you do not see your printer, select a similar printer from the same manufacturer or select Generic Color Printer.

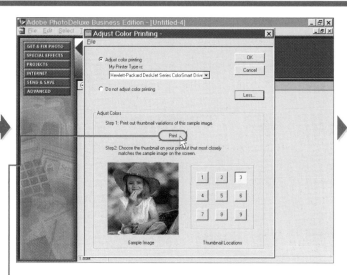

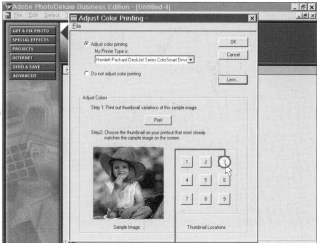

■ The dialog box expands, showing more features.

6 Click **Print**.

■ Your printer prints a page with nine variations of the same image on it.

7 Compare the thumbnail printout to the image on your screen.

8 Click the number representing the image that most closely matches the screen image.

PRINT FROM PHOTODELUXE

The File menu in PhotoDeluxe contains three commands that can help you print: the Print Preview command, the Print command, and the Print Multiple command.

PRINT FROM PHOTODELUXE

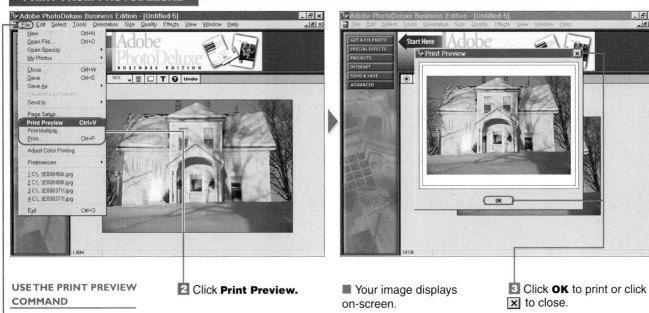

USE THE PRINT PREVIEW COMMAND

1 Click **File**.

2 Click **Print Preview.**

■ Your image displays on-screen.

3 Click **OK** to print or click ⊠ to close.

When I preview my photo, portions of it appear outside the lines in the Print Preview box. What does that mean?

Your photo is larger than the paper size you have chosen, and if you print, trimming will occur. You can control the trimming rather than allow the software and printer to control it by using the Photo Size box (click **Size** and then **Photo Size**) to set a size that falls within the margins of the paper size you chose. For more information on setting the size of a photo, see "Adjust the Photo Size" in Chapter 10.

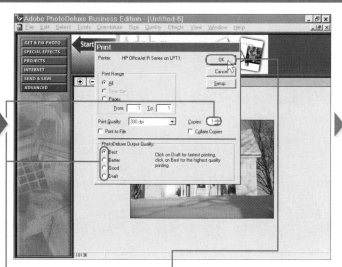

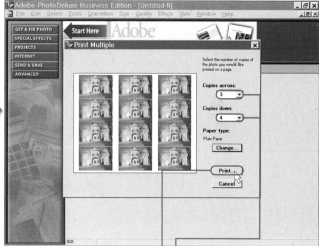

USE THE PRINT COMMAND

■ If you click **Print**, the Print dialog box appears.

■ You can set options such as the number of copies and the print quality.

Note: The options you see in this dialog box change, depending on the printer you use.

■ Click **OK**.

USE THE PRINT MULTIPLE COMMAND

■ If you click **Print Multiple**, the Print Multiple dialog box appears.

■ You can choose to print as many copies of an image that will fit on a page.

■ Click ▾ to set the Copies Across and the Copies Down.

■ Click **Print**.

Explore Other Output Options

Have you been looking for nontraditional ways to display your photos? This chapter suggests some.

E-MAIL A PHOTO

You can e-mail digital photos to friends and family with any e-mail program. This task shows you how to use Outlook Express to e-mail a photo.

Say hello to your first grandchild, Mark Allen. This adorable little angel weighs 7lbs., 2oz., and has his mother's red hair.

E-MAIL A PHOTO

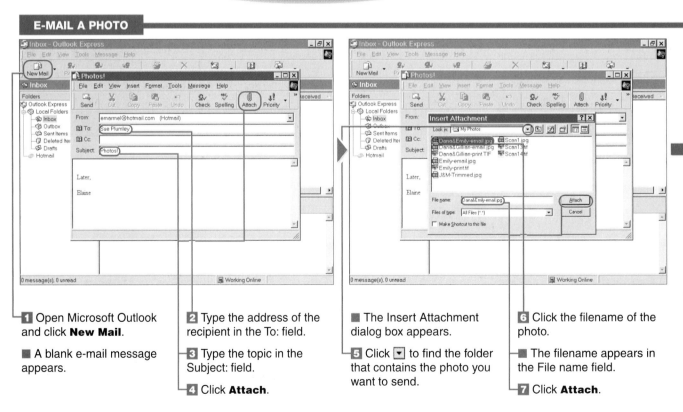

1 Open Microsoft Outlook and click **New Mail**.

■ A blank e-mail message appears.

2 Type the address of the recipient in the To: field.

3 Type the topic in the Subject: field.

4 Click **Attach**.

■ The Insert Attachment dialog box appears.

5 Click ▼ to find the folder that contains the photo you want to send.

6 Click the filename of the photo.

■ The filename appears in the File name field.

7 Click **Attach**.

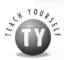

Can I send more than one photo at a time?

Yes. Repeat steps **4** through **7** for each photo you want to attach. If you are sending multiple attachments via AOL, your attachment will zip multiple attachments to help speed uploading and downloading.

Zipping is a technique used by programs like WinZip or Drag and Zip to reduce the size of a file by compressing it. The zip files that these programs create can contain more than one file. If you e-mail three images to a friend who uses AOL, your friend will receive one ZIP file that contains all three images — and will need a utility like WinZip or Drag and Zip to restore and view the images. You can get a copy of WinZip at www.winzip.com and a copy of Drag and Zip at www.canyonsw.com. Both programs are shareware.

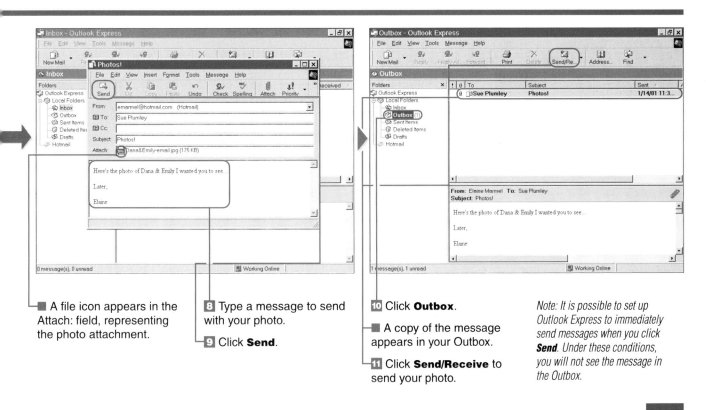

■ A file icon appears in the Attach: field, representing the photo attachment.

8 Type a message to send with your photo.

9 Click **Send**.

10 Click **Outbox**.

■ A copy of the message appears in your Outbox.

11 Click **Send/Receive** to send your photo.

Note: It is possible to set up Outlook Express to immediately send messages when you click Send. Under these conditions, you will not see the message in the Outbox.

VIEW PHOTOS ON TELEVISION

You can view your photos on your television if you have a newer camera.

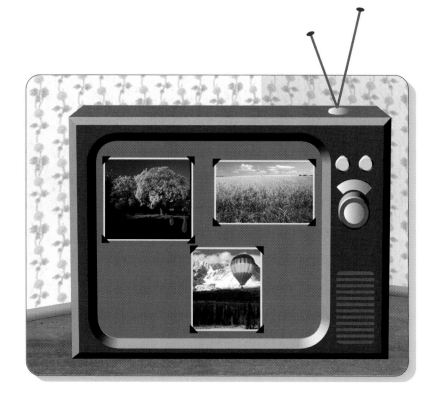

Connect a Camera to a TV

Newer cameras can send video signals. Using a video cable, you can connect your camera to a TV to display your photos on your TV instead of your computer monitor.

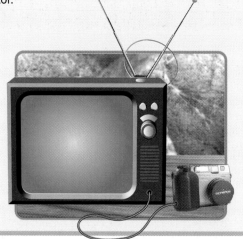

Use Your Camera in a Slide Show

New cameras can hook up to devices other than a TV. For example, you can connect some cameras to video projectors or a LCD screen and show pictures from your camera on a movie screen or a LCD screen. This connection enables you to use your camera for business and educational presentations.

You can make small
movies if you have a
newer camera. If you
have an older camera,
you can use technology
to animate a photo and
simulate a movie.

Use Still Pictures

Cameras like the Sony Mavica enable you to take
both still pictures and make a movie (video and audio)
up to one minute long by using the camera's movie
setting and move the camera to capture subjects.

Animating Still Pictures

QuickTime Virtual Reality (QTVR) was developed by Apple
Computer and works on both Macs and PCs. The
technology animates a still image by rotating it in front of a
camera while photos are taken. All of the photos are played
back rapidly to simulate movement. You can download the
QTVR plug-in from the Apple Web site at
www.apple.com/quicktime/download.

POST PHOTOS ON THE WEB

You can show your photos to the world by displaying them on a variety of Web sites.

www.ebay.com

www.imagestation.com

www.photopoint.com

www.pixhost.com

www.yahoo.com

www.zing.com

Showcase Photos on the Web

Web sites such as www.photopoint.com let you upload your photos to share with the world. Most auction sites, such as www.ebay.com, enable you to upload pictures of things you intend to auction. And, many ISPs provide you, as part of their service, with personal Web server space where you can create a Web page that contains your photos.

Store Photos on the Web

Uploading photos to a Web site is a good way to store images when you are low on disk space and have no alternative storage medium. For example, www.yahoo.com permits you to upload and store up to 25 megabytes (MB) free, and www. honesty.com, while primarily an auction site, offers free image hosting. Other Web sites, like www. pixhost.com, charge a nominal fee for storing your photos.

Get Creative with Your Photos

Looking for some interesting uses for your photos? Browse through this chapter.

DISPLAY A PHOTO ON YOUR DESKTOP

You can make one of your favorite digital photos appear as the background on your computer so that you can look at it all the time.

DISPLAY A PHOTO ON YOUR DESKTOP

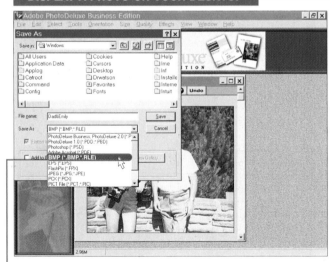

1 Open an image and save as a BMP file.

Note: See Chapter 9 for instructions on opening and saving an image.

2 Go to your computer's Desktop.

Note: To display the desktop, you can minimize all open programs or, if you use Windows 98, click the Desktop icon.

3 Right-click in the open area of the Desktop.

■ A shortcut menu appears.

4 Click **Properties**.

My photo does not really fit on my monitor to fill the screen. Can I improve the fit?

You can resize the photo to match the dimensions of the screen area of your monitor. Because monitors are wider than they are tall, monitors display landscape photos better than portrait photos. Use the Photo Size dialog box (click **Size**, then **Photo Size**) to get a better fit for your photo on your monitor.

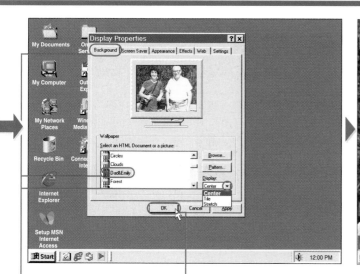

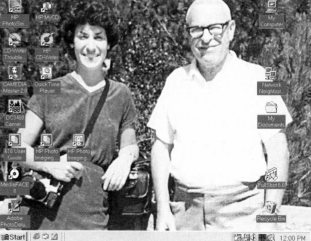

■ The Display Properties dialog box appears.

5 Click **Background**.

6 Click the filename of the photo.

7 Click ▾ to select a display method.

■ Stretch makes your photo fill the screen. Tile displays multiple copies of your image to fill the screen. Center displays your image in the center of the screen.

8 Click **OK**.

■ Your photo appears as the background on your computer's Desktop.

ADD PHOTOS TO YOUR WEB SITE USING FRONTPAGE

You can add photos to your Web site to share them with the world. You can size your photos to make viewing them faster and easier for your visitors.

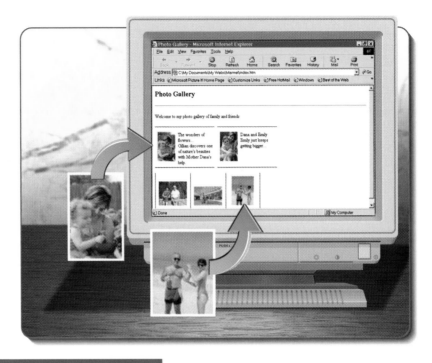

ADD PHOTOS TO YOUR WEB SITE USING FRONTPAGE

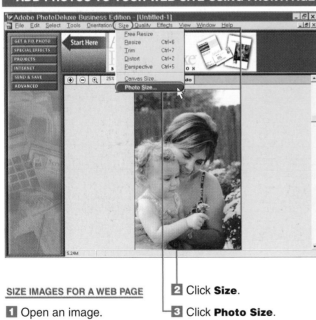

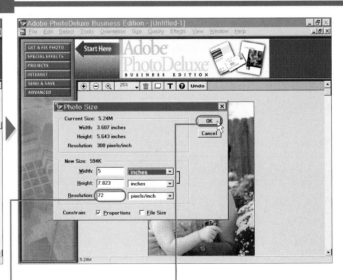

SIZE IMAGES FOR A WEB PAGE

1 Open an image.

Note: See "Open an Image" in Chapter 9 for instructions.

2 Click **Size**.

3 Click **Photo Size**.

■ The Photo Size dialog box appears.

4 Set the resolution to 72 pixels/inch.

■ You can change the width and height.

5 Click **OK**.

■ PhotoDeluxe resizes your image.

Why should I set the resolution to 72 ppi?

Monitors cannot display any more than 72 ppi so additional pixels only increase the time required to load your image.

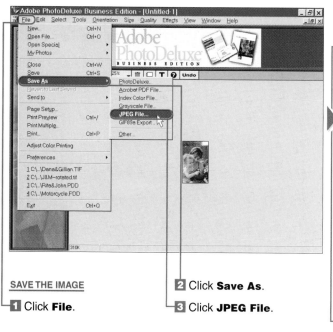

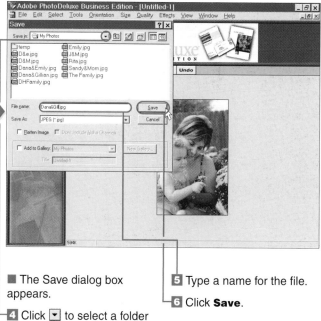

SAVE THE IMAGE

1 Click **File**.

2 Click **Save As**.

3 Click **JPEG File**.

■ The Save dialog box appears.

4 Click ▼ to select a folder where you want to save the file.

5 Type a name for the file.

6 Click **Save**.

CONTINUED

ADD PHOTOS TO YOUR WEB SITE USING FRONTPAGE

After you save your images for Web page use, you can create a new page on which to display your images.

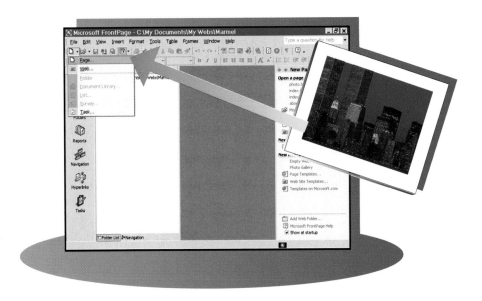

■ The JPEG Options dialog box appears.

7 Click **Advanced**.

■ The JPEG Options dialog box expands to offer more options.

8 Type **5** in the Quality field.

■ Higher numbers make your image slower to load, and lower numbers degrade the quality of the image.

9 Click **OK**.

■ PhotoDeluxe saves the file.

Why must I save my photos as JPEG files and compress them? I thought compression reduced the quality of my image.

JPEG file format is the best-suited format for displaying photos on a Web page. (GIF works well for other kinds of images, such as clip art.) And, you are right — compressing does reduce the quality of an image. However, you will not notice the reduction in quality when you view the photo on a monitor. You would notice the reduced quality if you tried to print the photo.

ADD A PAGE TO YOUR WEB SITE

1 Click **Start**.

2 Click **Programs**.

3 Click **FrontPage**.

■ You can also open FrontPage by clicking its Desktop icon.

4 Click ▾ on the button.

5 Click **Page**.

■ The Page Templates dialog box appears.

6 Click **Photo Gallery**.

7 Click **OK**.

CONTINUED

ADD PHOTOS TO YOUR WEB SITE USING FRONTPAGE

You can take advantage of the page layout on Front Page's Photo Gallery page and replace the sample photos with your photos.

ADD PHOTOS TO YOUR WEB SITE USING FRONTPAGE (CONTINUED)

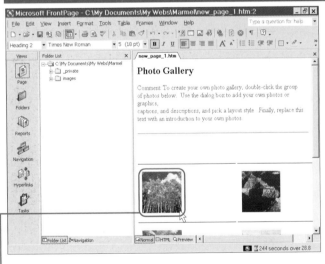

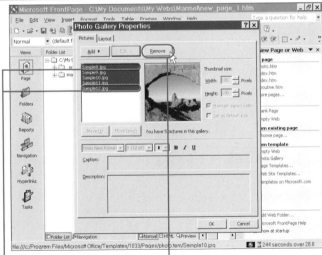

■ A Photo Gallery page containing sample photos appears.

8 Double-click a sample photo.

■ The Photo Gallery Properties dialog box appears.

REMOVE SAMPLE PHOTOS

1 Click the first sample photo file.

2 Press and hold the Shift key while clicking the last sample photo file.

■ All filenames appear highlighted.

3 Click **Remove**.

■ The sample photo files disappear from the list.

I am not using FrontPage, and my Web page design software does not have a Photo Gallery template. How do I add photos to a Web page?

Add a blank Web page to your Web site and use the Insert Picture From File command. You usually find this command by clicking **Insert** and then clicking **Picture**. You can use this approach in FrontPage if you want more control over the layout of photos on the Web page. Click **Insert**, click **Picture**, and then click **From File**.

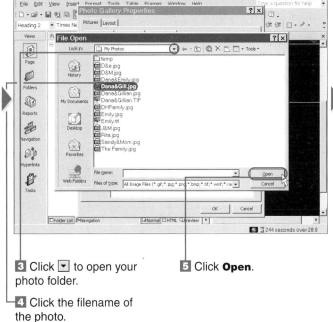

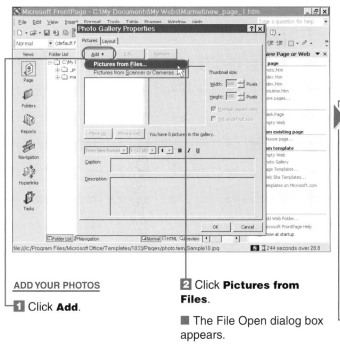

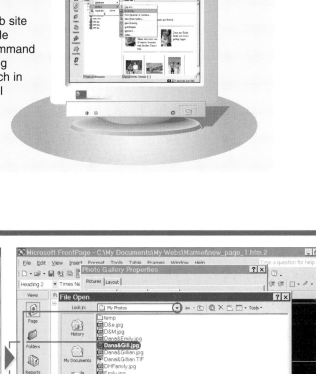

ADD YOUR PHOTOS

1 Click **Add**.

2 Click **Pictures from Files**.

■ The File Open dialog box appears.

3 Click ▾ to open your photo folder.

4 Click the filename of the photo.

5 Click **Open**.

CONTINUED ▶

ADD PHOTOS TO YOUR WEB SITE USING FRONTPAGE

You can add as many pictures to your Photo Gallery page as you can fit and then save the page.

ADD PHOTOS TO YOUR WEB SITE USING FRONTPAGE (CONTINUED)

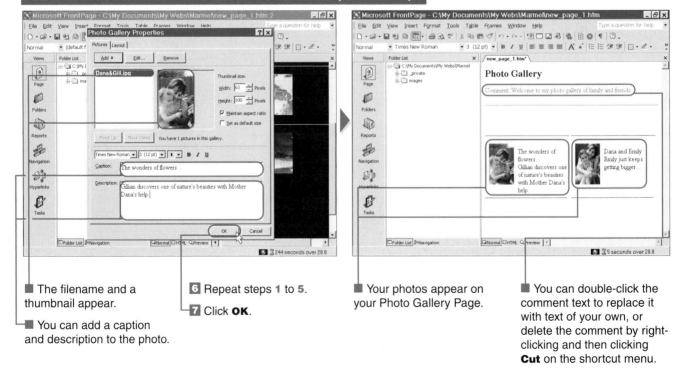

■ The filename and a thumbnail appear.

■ You can add a caption and description to the photo.

6 Repeat steps 1 to 5.

7 Click **OK**.

■ Your photos appear on your Photo Gallery Page.

■ You can double-click the comment text to replace it with text of your own, or delete the comment by right-clicking and then clicking **Cut** on the shortcut menu.

Can I control the way FrontPage lays out my photos on the Photo Gallery page?

Yes. In the Photo Gallery Properties dialog box, click the **Layout** tab and choose a layout.

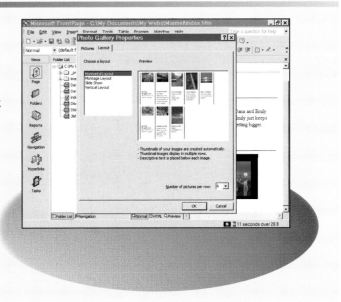

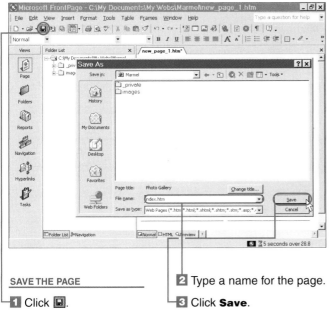

SAVE THE PAGE

1 Click ▣.

■ The Save As dialog box appears.

2 Type a name for the page.

3 Click **Save**.

■ The Save Embedded Files dialog box appears, where you can click **OK** to finish saving.

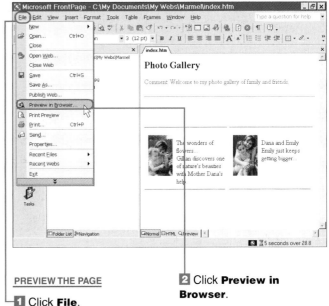

PREVIEW THE PAGE

1 Click **File**.

2 Click **Preview in Browser**.

CONTINUED ▶

ADD PHOTOS TO YOUR WEB SITE USING FRONTPAGE

You can preview your Photo Gallery Web page in any browser that you have installed on your computer. When you are satisfied, you can publish your page to your Web site for the world to see.

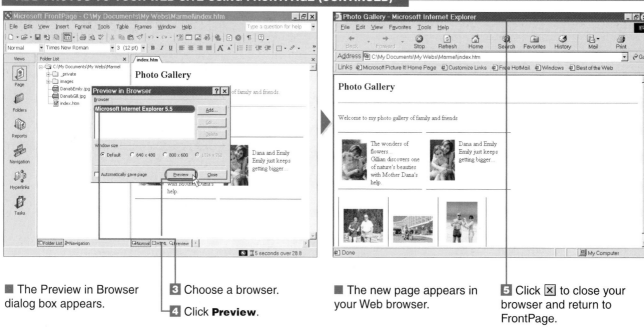

■ The Preview in Browser dialog box appears.

3 Choose a browser.

4 Click **Preview**.

■ The new page appears in your Web browser.

5 Click ⊠ to close your browser and return to FrontPage.

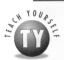

I have another browser installed on my computer, but it does not appear in the Preview Browser dialog box. How can I preview my page in my other browser?

In the Preview in Browser dialog box, click **Add**. The Add Browser dialog box appears. Type the name of the browser and the path name to launch the browser. Then, click **OK**.

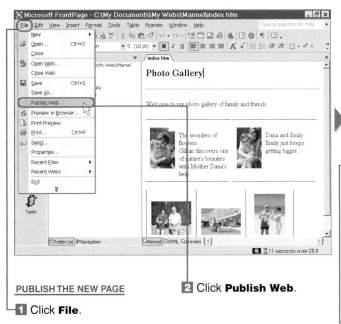

PUBLISH THE NEW PAGE

1 Click **File**.

2 Click **Publish Web**.

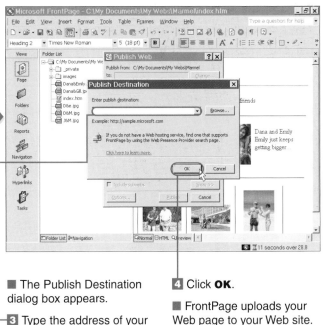

■ The Publish Destination dialog box appears.

3 Type the address of your Web site using instructions provided by your ISP or Web host provider.

4 Click **OK**.

■ FrontPage uploads your Web page to your Web site.

RESTORE AN OLD PHOTO

You can correct damage
in an old photo using
one of the PhotoDeluxe
guided procedures.

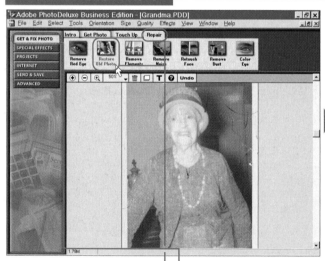

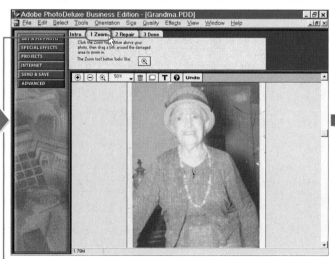

1 Open an image.

*Note: See "Open an Image" in
Chapter 9 for instructions.*

2 Click **Get & Fix Photo**.

3 Click the **Repair** tab.

4 Click **Restore Old Photo**.

5 Click the **1 Zoom** tab.

■ You can click the 🔍 and
then click the photo to zoom
in on an area to repair.

Can I accomplish the same thing using the Clone tool?

Yes. The Guided Procedures simply walks you through the process. You can, instead, click **Tools** and then click **Clone** to display the Clone palette and the Sampling Point (⊕). Then follow steps **8** to **10**. For more detailed steps, see "Use the Clone Tool" in Chapter 12.

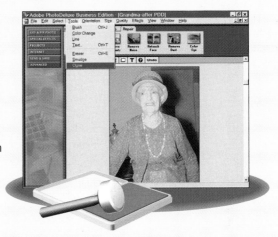

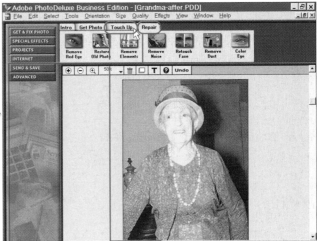

■ Click the **2 Repair** tab.

■ Click the **Clone** tool.

■ Drag ⊕ to an area of the photo that contains undamaged pixels you can copy.

■ Click a brush.

■ Click a damaged part of the photo to replace the damaged pixels with good pixels.

■ Repeat steps **8** to **10** to repair all damaged pixels.

■ Click the **3 Done** tab.

■ The Repair tab appears.

■ You can apply Extensis IntelliFix and, if necessary, crop the photo.

Note: See "Enhance Images Automatically" in Chapter 9 and "Crop a Photo" in Chapter 10 for help applying Extensis IntelliFix and cropping.

■ You can click **Touch Up** to apply other effects.

WORK WITH PHOTODELUXE GALLERIES

You can use PhotoDeluxe galleries to obtain sample photos, clip art, or templates, and to organize your photos. PhotoDeluxe contains four gallery palettes: Samples, Clip Art, Templates, and My Photos.

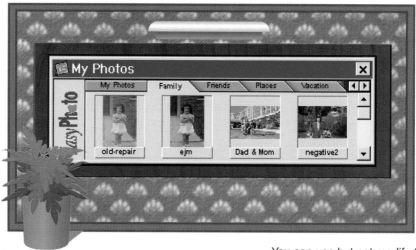

You can use but not modify the first three palettes; you can use galleries in the My Photos palette to organize and group your photos. In a gallery, images appear as *thumbnails*, which are small versions of the image.

WORK WITH PHOTODELUXE GALLERIES

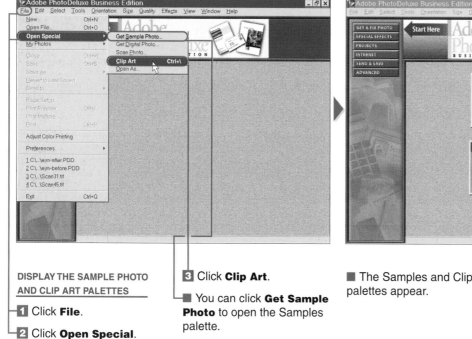

DISPLAY THE SAMPLE PHOTO AND CLIP ART PALETTES

1 Click **File**.

2 Click **Open Special**.

3 Click **Clip Art**.

■ You can click **Get Sample Photo** to open the Samples palette.

■ The Samples and Clip Art palettes appear.

■ Each tab is a gallery.

■ You can click ☒ to close the windows.

How do I display the Templates window?

This window appears automatically when you click the **Projects** tab in PhotoDeluxe.

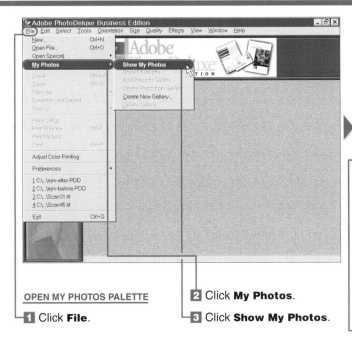

OPEN MY PHOTOS PALETTE

1 Click **File**.

2 Click **My Photos**.

3 Click **Show My Photos**.

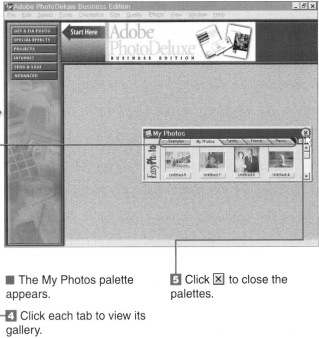

■ The My Photos palette appears.

4 Click each tab to view its gallery.

5 Click ☒ to close the palettes.

CONTINUED ▶

WORK WITH PHOTODELUXE GALLERIES

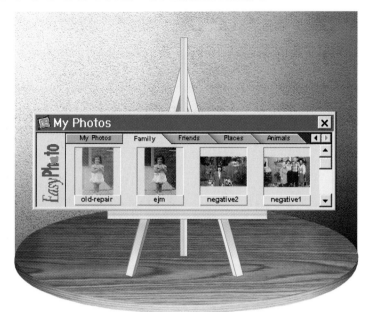

Using menus, you can create new galleries in the My Photos palette and add photos to those galleries. Galleries are the tabs that appear in the palette.

WORK WITH PHOTODELUXE GALLERIES (CONTINUED)

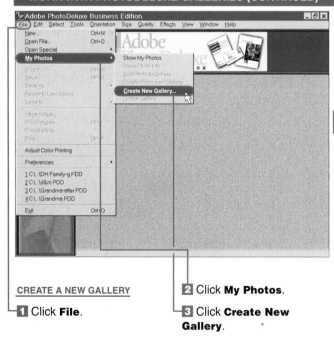

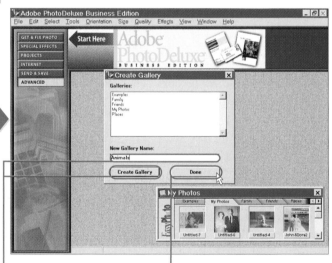

CREATE A NEW GALLERY

1 Click **File**.

2 Click **My Photos**.

3 Click **Create New Gallery**.

■ The My Photos palette and the Create Gallery dialog box appear.

4 Type a name for the new gallery.

5 Click **Create Gallery**.

6 Repeat steps **4** and **5** for each gallery you want to create.

7 Click **Done**.

■ New galleries appear behind existing galleries.

Are gallery names case sensitive?

Yes. You can have both *Holidays* and *holidays* as separate galleries.

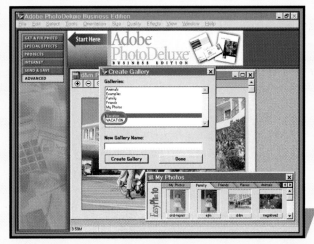

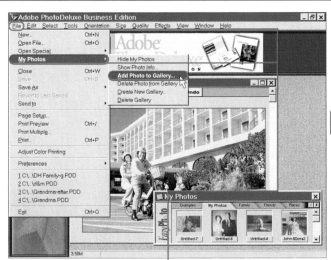

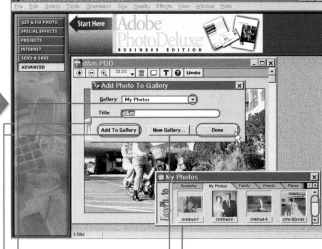

ADD A PHOTO USING MENUS

1 Open an image.

Note: See "Open an Image" in Chapter 9 for instructions.

2 Open the My Photos palette.

Note: See "Open My Photos Palette," earlier in this section, for instructions.

3 Click **File**.

4 Click **My Photos**.

5 Click **Add Photo to Gallery**.

■ The Add Photo to Gallery dialog box appears.

6 Click ▼ to select a gallery.

■ You can type a title for the photo.

7 Click **Add to Gallery**.

■ The photo appears at the end of the gallery. Use the scroll bar to find the photo.

8 Click **Done**.

CONTINUED

WORK WITH PHOTODELUXE GALLERIES

You can add photos to galleries in two additional ways: by dragging or by saving a photo.

ADD A PHOTO BY DRAGGING

1 Open an image.

Note: See "Open an Image" in Chapter 9 for instructions.

2 Open the My Photos palette.

Note: See "Open My Photos Palette," earlier in this section, for instructions.

3 Click the gallery tab where you want to store the photo.

4 Click and drag your photo to the My Photos palette.

■ The photo appears to the right of the large I-beam's position.

Can I move a photo within a gallery if I drop it in a place I do not like?

You can click and drag from one location in the gallery to another. PhotoDeluxe places the photo in the gallery to the right of the large I-beam.

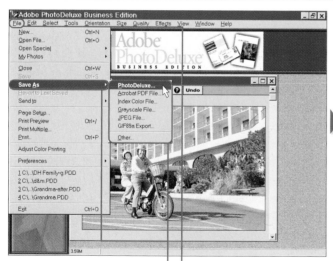

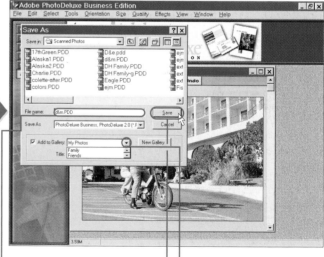

ADD A PHOTO WHEN SAVING

1 Open an image.

Note: See "Open an Image" in Chapter 9 for instructions.

2 Click **File**.

3 Click **Save As**.

4 Click any file type except Acrobat PDF File and Index Color File.

■ The Save As dialog box appears.

5 Type a filename.

6 Click ▼ to select a gallery.

7 Click **Save**.

CONTINUED ▶

WORK WITH PHOTODELUXE GALLERIES

You can move a photo to a different gallery. You also can provide a title and caption for a photo in a gallery.

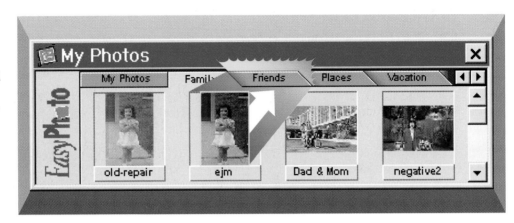

MOVE A PHOTO TO A

DIFFERENT GALLERY

1 Open the My Photos palette.

Note: See "Open My Photos Palette," earlier in this section, for instructions.

2 Minimize or close all open photos.

3 Click and drag the photo you want to move from the gallery onto the PhotoDeluxe window.

■ The photo appears in the PhotoDeluxe window.

4 Click the gallery tab where you want to store the photo.

5 Click and drag the photo from the window onto the gallery.

Can I move a photo to a different position in the same gallery?

Yes. Open the My Photos palette, click the gallery that you want to rearrange, and drag the photo to its new location in the gallery.

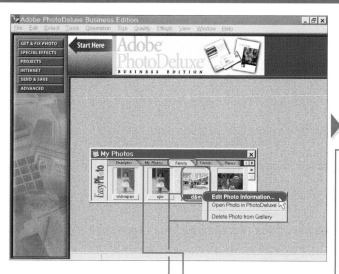

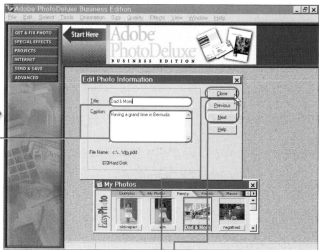

ADD A TITLE OR CAPTION TO A PHOTO

1 Open the My Photos palette.

Note: See "Open My Photos Palette," earlier in this section, for instructions.

2 Click the gallery containing the photo.

3 Right-click the photo.

4 Click **Edit Photo Information**.

■ The Edit Photo Information dialog box appears.

5 Type a name for the photo.

6 Type a caption.

■ You can click **Previous** or **Next** to add information about other photos.

7 Click **Close**.

■ Photo titles appear at the bottom of the photo.

CONTINUED ▶

WORK WITH PHOTODELUXE GALLERIES

You can delete photos from galleries, and you can delete entire galleries.

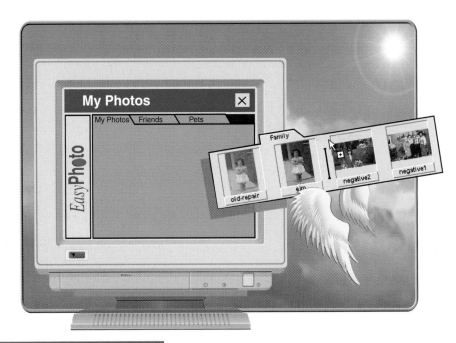

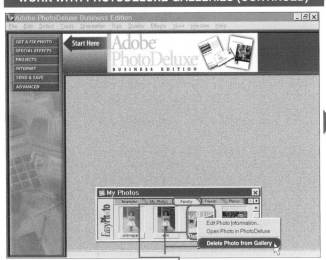

DELETE A PHOTO FROM A GALLERY

1 Open the My Photos palette.

Note: See "Open My Photos Palette," earlier in this section, for instructions.

2 Click the gallery containing the photo.

3 Right-click the photo you want to remove from the gallery.

4 Click **Delete Photo from Gallery**.

■ PhotoDeluxe removes the photo from the gallery.

How can I see the caption I created for a photo?

Click the title of the photo in the gallery.

Diving in the Bahamas

Scuba Diver

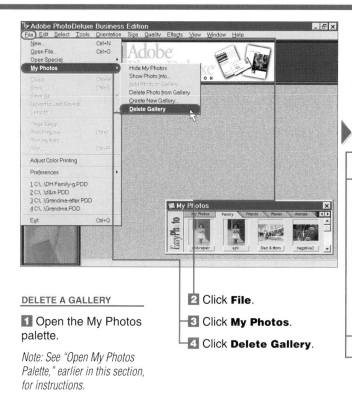

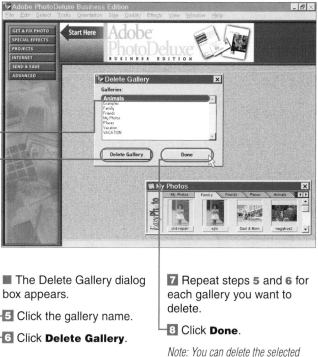

DELETE A GALLERY

1 Open the My Photos palette.

Note: See "Open My Photos Palette," earlier in this section, for instructions.

2 Click **File**.

3 Click **My Photos**.

4 Click **Delete Gallery**.

■ The Delete Gallery dialog box appears.

5 Click the gallery name.

6 Click **Delete Gallery**.

7 Repeat steps **5** and **6** for each gallery you want to delete.

8 Click **Done**.

Note: You can delete the selected gallery.

DESIGN GREETING CARDS

For a personalized touch, you can use PhotoDeluxe to design invitations and greeting cards — and include photos on the card.

Each card layout is different; some include text and some do not. You can edit the text on a card by double-clicking it.

DESIGN GREETING CARDS

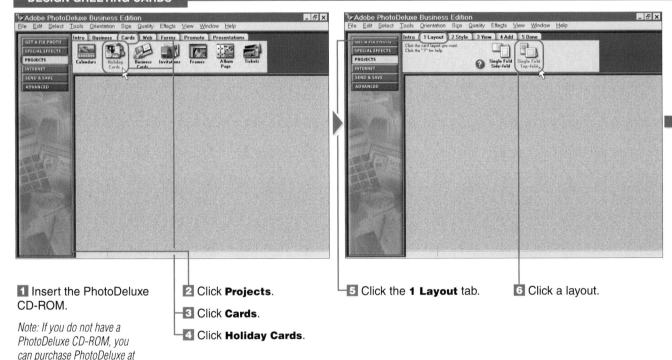

1 Insert the PhotoDeluxe CD-ROM.

Note: If you do not have a PhotoDeluxe CD-ROM, you can purchase PhotoDeluxe at www.adobe.com.

2 Click **Projects**.

3 Click **Cards**.

4 Click **Holiday Cards**.

5 Click the **1 Layout** tab.

6 Click a layout.

How can I print the card so that I can use it? My printer only prints 8½-by-11-inch sheets of paper.

After you start printing, one entire side of the card will print. Then, an on-screen prompt asks you to load the paper back into the printer so that PhotoDeluxe can print the other side.

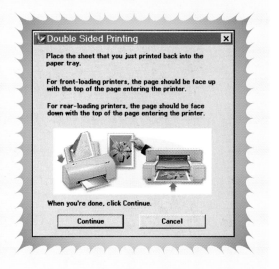

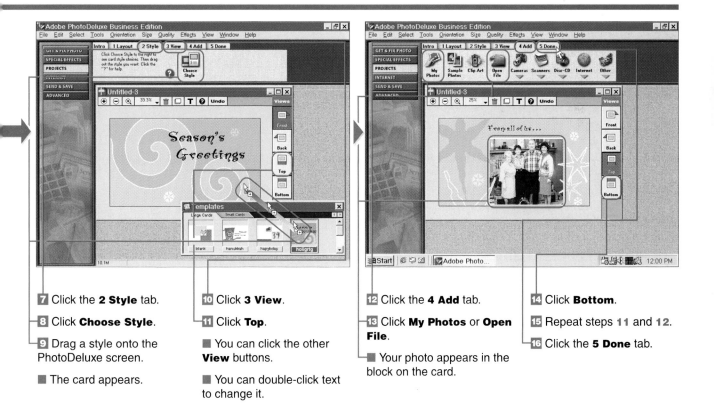

7 Click the **2 Style** tab.

8 Click **Choose Style**.

9 Drag a style onto the PhotoDeluxe screen.

■ The card appears.

10 Click **3 View**.

11 Click **Top**.

■ You can click the other **View** buttons.

■ You can double-click text to change it.

12 Click the **4 Add** tab.

13 Click **My Photos** or **Open File**.

■ Your photo appears in the block on the card.

14 Click **Bottom**.

15 Repeat steps **11** and **12**.

16 Click the **5 Done** tab.

CREATE A PROJECT IN MICROSOFT WORD

You can create visual projects by using digital photographs in presentations as a reinforcement.

CREATE A PROJECT IN MICROSOFT WORD

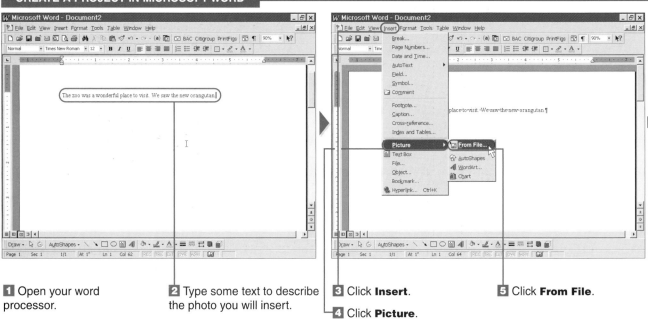

1 Open your word processor.

2 Type some text to describe the photo you will insert.

3 Click **Insert**.

4 Click **Picture**.

5 Click **From File**.

Microsoft Word seems to be inserting the pictures so that each takes up half a page. Can I make the pictures smaller — and put three pictures on one page?

Yes. Right-click the photo and click **Edit Picture** from the shortcut menu. The picture appears in a new window. Position the mouse ⟨ over a corner and drag toward the center of the photo to make it smaller and retain proportions. When you finish sizing the photo, click **Close Picture**.

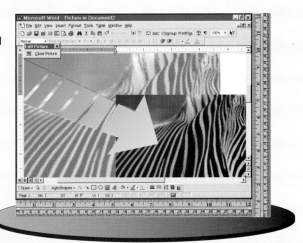

■ The Insert Picture dialog box.

6 Click ▾ to locate the photo files.

7 Click the file to insert.

8 Click **Insert**.

■ The photo appears on-screen.

9 Repeat steps **2** to **8** for each additional photo.

10 Click 🖫 to save the document.

11 Click 🖨 to print the document.

CREATE A CALENDAR

You can use
PhotoDeluxe to create
your own personalized
calendar that contains
your photos.

CREATE A CALENDAR

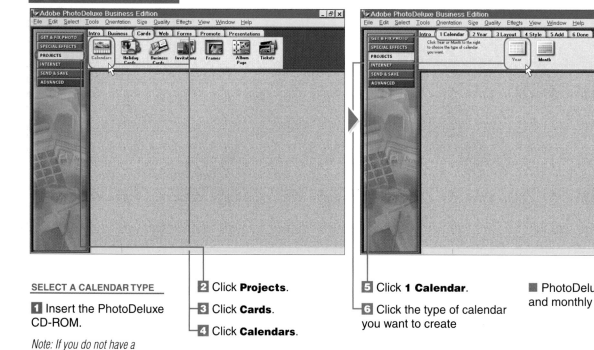

SELECT A CALENDAR TYPE

1 Insert the PhotoDeluxe
CD-ROM.

*Note: If you do not have a
PhotoDeluxe CD-ROM, you
can purchase PhotoDeluxe
at www.adobe.com.*

2 Click **Projects**.

3 Click **Cards**.

4 Click **Calendars**.

5 Click **1 Calendar**.

6 Click the type of calendar
you want to create

■ PhotoDeluxe offers yearly
and monthly styles.

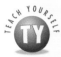

If I want to create monthly calendars, how do I tell PhotoDeluxe which month?

When you complete step **6** in the task steps, click **Month**. PhotoDeluxe displays the Month dialog box where you can select a month.

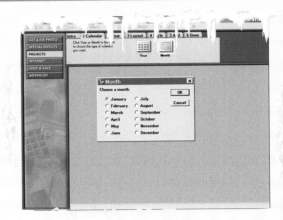

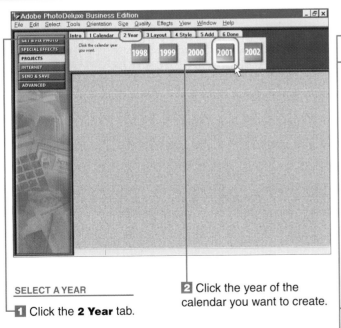

SELECT A YEAR

1 Click the **2 Year** tab.

2 Click the year of the calendar you want to create.

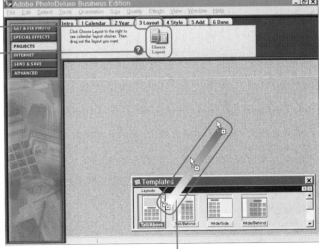

SELECT A LAYOUT

1 Click the **3 Layout** tab.

2 Click **Choose Layout**.

■ The Templates palette appears.

3 Drag a layout onto the PhotoDeluxe window.

■ Layouts exist for portrait or landscape calendars.

■ The layout appears in a PhotoDeluxe window.

CONTINUED

CREATE A CALENDAR

For each PhotoDeluxe calendar, you choose not only a layout, but also a background style. And, as you would expect, you can add photos to calendars.

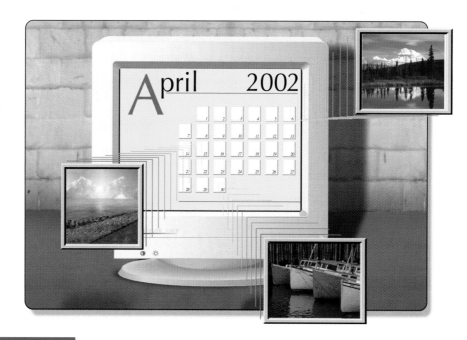

CREATE A CALENDAR (CONTINUED)

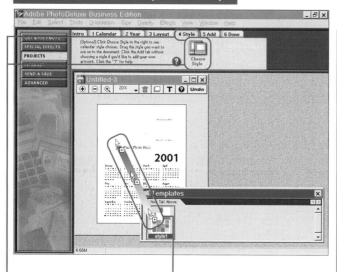

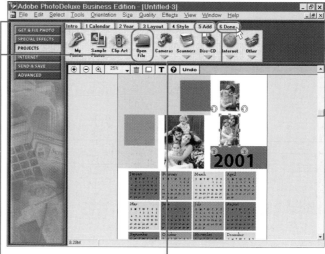

SELECT A BACKGROUND STYLE

■1 Click the **4 Style** tab.

■2 Click **Choose Style**.

■ The Templates palette appears.

■3 Drag a style onto the calendar.

■ The style appears on the calendar.

ADD PHOTOS TO THE CALENDAR

■1 Click the **5 Add** tab.

■2 Click **Open File**.

■ Your photo appears in the block on the calendar.

■3 Click the **6 Done** tab.

My photo layout calls for more photos. When and how, during the Guided Process, do I add more photos?

You can repeat step **2** in **Add Photos to the Calendar** as many times as the calendar layout you chose permits. PhotoDeluxe layouts enable you to add as many as four photos to an annual calendar.

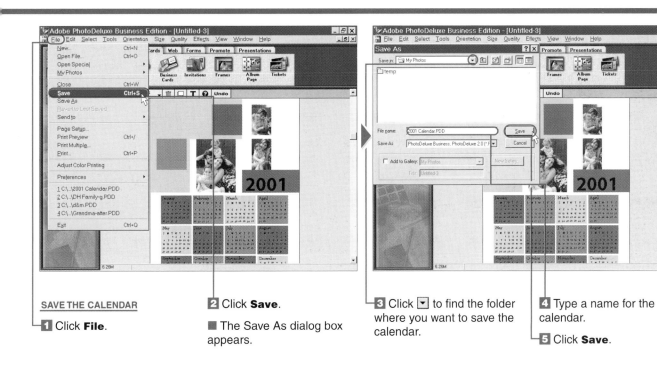

SAVE THE CALENDAR

1 Click **File**.

2 Click **Save**.

■ The Save As dialog box appears.

3 Click ▼ to find the folder where you want to save the calendar.

4 Type a name for the calendar.

5 Click **Save**.

MAKE BUSINESS CARDS

You can use PhotoDeluxe to create business cards that contain photos to make potential clients remember you.

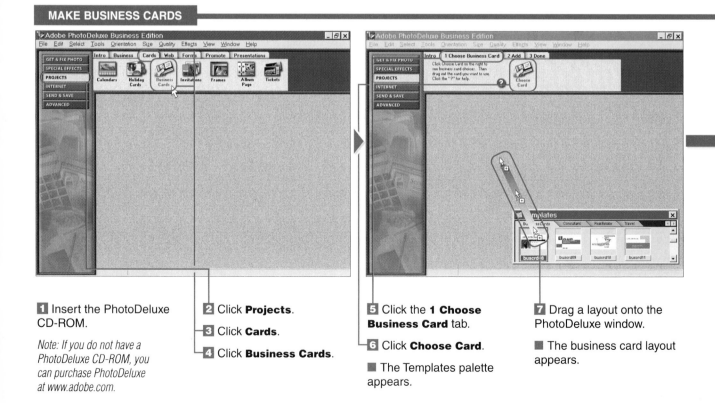

1 Insert the PhotoDeluxe CD-ROM.

Note: If you do not have a PhotoDeluxe CD-ROM, you can purchase PhotoDeluxe at www.adobe.com.

2 Click **Projects**.

3 Click **Cards**.

4 Click **Business Cards**.

5 Click the **1 Choose Business Card** tab.

6 Click **Choose Card**.

■ The Templates palette appears.

7 Drag a layout onto the PhotoDeluxe window.

■ The business card layout appears.

I understand how to create a business card, but how do I print them?

Head down to your local office supply store and look for Avery business cards. Load the business card stock into your printer and click **File**. Then, click **Print Multiple**. Choose an Avery label that matches the stock you bought — or choose an Avery label that is close in size.

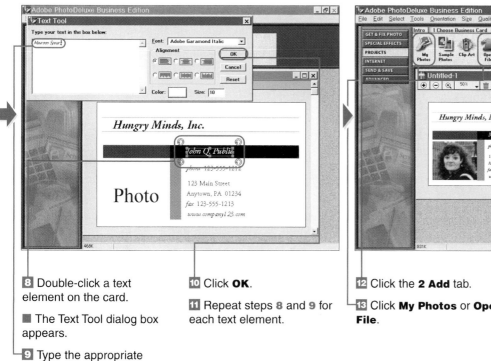

■8 Double-click a text element on the card.

■ The Text Tool dialog box appears.

■9 Type the appropriate information.

■10 Click **OK**.

■11 Repeat steps 8 and 9 for each text element.

■12 Click the **2 Add** tab.

■13 Click **My Photos** or **Open File**.

■ Your photo appears in the block on the card.

■14 Click the **3 Done** tab.

DESIGN REPORT COVERS

You can use PhotoDeluxe to create report covers that contain photos to help drive your point home.

DESIGN REPORT COVERS

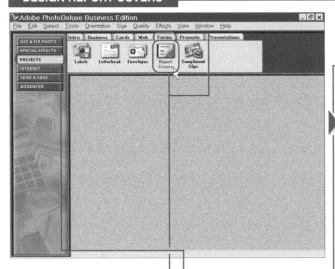

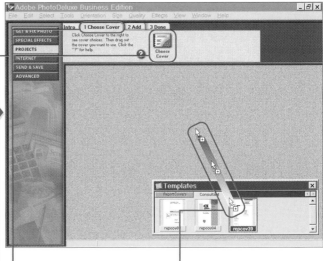

1 Insert the PhotoDeluxe CD-ROM.

Note: If you do not have a PhotoDeluxe CD-ROM, you can purchase PhotoDeluxe at www.adobe.com.

2 Click **Projects**.

3 Click **Forms**.

4 Click **Report Covers**.

5 Click the **1 Choose Cover** tab.

6 Click **Choose Cover**.

■ The Templates palette appears.

7 Drag a layout onto the PhotoDeluxe window.

■ The report cover layout appears.

How many report cover layouts does PhotoDeluxe contain?

PhotoDeluxe provides 13 cover layouts — ten on the ReportCovers gallery tab and three on the Consultant gallery tab.

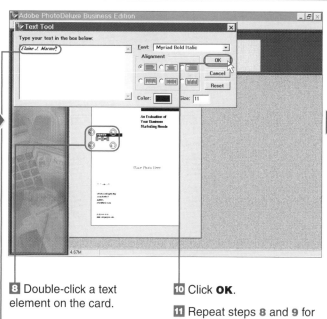

8 Double-click a text element on the card.

■ The Text Tool dialog box appears.

9 Type the appropriate information.

10 Click **OK**.

11 Repeat steps **8** and **9** for each text element.

12 Click the **2 Add** tab.

13 Click **My Photos** or **Open File**.

■ Your photo appears in the block on the report cover.

14 Click the **3 Done** tab.

CREATE A PICTURE-BASED INVENTORY

PhotoDeluxe can help you create a picture-based inventory — and you can use the technique described here to create a home or product inventory.

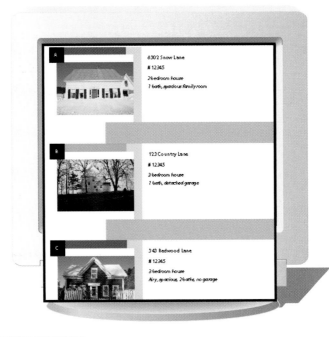

Close each page after saving it, and repeat the steps in this task for each additional page you need to create.

CREATE A PICTURE-BASED INVENTORY

1 Insert the PhotoDeluxe CD-ROM.

Note: If you do not have a PhotoDeluxe CD-ROM, you can purchase PhotoDeluxe at www.adobe.com.

2 Click **Projects**.

3 Click **Cards**.

4 Click **Album Page**.

5 Click the **1 Choose Album Page** tab.

6 Click **Choose Page**.

■ The Templates palette appears.

7 Drag a layout onto the PhotoDeluxe window.

■ The album page layout appears.

INDEX

Read Less, Learn More™

Visual

Simplified®

Simply the Easiest Way to Learn

For visual learners who are brand-new to a topic and want to be shown, not told, how to solve a problem in a friendly, approachable way.

All *Simplified*® books feature friendly Disk characters who demonstrate and explain the purpose of each task.

Title	ISBN	Price
America Online® Simplified®, 2nd Ed.	0-7645-3433-5	$27.99
Computers Simplified®, 5th Ed.	0-7645-3524-2	$27.99
Creating Web Pages with HTML Simplified®, 2nd Ed.	0-7645-6067-0	$27.99
Excel 97 Simplified®	0-7645-6022-0	$27.99
FrontPage® 2000® Simplified®	0-7645-3450-5	$27.99
Internet and World Wide Web Simplified®, 3rd Ed.	0-7645-3409-2	$27.99
Microsoft® Access 2000 Simplified®	0-7645-6058-1	$27.99
Microsoft® Excel 2000 Simplified®	0-7645-6053-0	$27.99
Microsoft® Office 2000 Simplified®	0-7645-6052-2	$29.99
Microsoft® Word 2000 Simplified®	0-7645-6054-9	$27.99
More Windows® 95 Simplified®	1-56884-689-4	$27.99
More Windows® 98 Simplified®	0-7645-6037-9	$27.99
Office 97 Simplified®	0-7645-6009-3	$29.99
PC Upgrade and Repair Simplified®, 2nd Ed.	0-7645-3560-9	$27.99
Windows® 95 Simplified®	1-56884-662-2	$27.99
Windows® 98 Simplified®	0-7645-6030-1	$27.99
Windows® 2000 Professional Simplified®	0-7645-3422-X	$27.99
Windows® Me Millennium Edition Simplified®	0-7645-3494-7	$27.99
Word 97 Simplified®	0-7645-6011-5	$27.99

Over 10 million *Visual* books in print!

with these full-color Visual™ guides

The Fast and Easy Way to Learn

 Discover how to use what you learn with "Teach Yourself" tips

For visual learners who want to guide themselves through the basics of any technology topic. *Teach Yourself VISUALLY* offers more expanded coverage than our bestselling *Simplified* series.

Title	ISBN	Price
Teach Yourself Access 97 VISUALLY™	0-7645-6026-3	$29.99
Teach Yourself FrontPage® 2000 VISUALLY™	0-7645-3451-3	$29.99
Teach Yourself HTML VISUALLY™	0-7645-3423-8	$29.99
Teach Yourself the Internet and World Wide Web VISUALLY™, 2nd Ed.	0-7645-3410-6	$29.99
Teach Yourself Microsoft® Access 2000 VISUALLY™	0-7645-6059-X	$29.99
Teach Yourself Microsoft® Excel 97 VISUALLY™	0-7645-6063-8	$29.99
Teach Yourself Microsoft® Excel 2000 VISUALLY™	0-7645-6056-5	$29.99
Teach Yourself Microsoft® Office 2000 VISUALLY™	0-7645-6051-4	$29.99
Teach Yourself Microsoft® PowerPoint® 2000 VISUALLY™	0-7645-6060-3	$29.99
Teach Yourself More Windows® 98 VISUALLY™	0-7645-6044-1	$29.99
Teach Yourself Office 97 VISUALLY™	0-7645-6018-2	$29.99
Teach Yourself Red Hat® Linux® VISUALLY™	0-7645-3430-0	$29.99
Teach Yourself VISUALLY™ Computers, 3rd Ed.	0-7645-3525-0	$29.99
Teach Yourself VISUALLY™ Digital Photography	0-7645-3565-X	$29.99
Teach Yourself VISUALLY™ Dreamweaver® 3	0-7645-3470-X	$29.99
Teach Yourself VISUALLY™ Fireworks® 4	0-7645-3566-8	$29.99
Teach Yourself VISUALLY™ Flash™ 5	0-7645-3540-4	$29.99
Teach Yourself VISUALLY™ FrontPage® 2002	0-7645-3590-0	$29.99
Teach Yourself VISUALLY™ iMac™	0-7645-3453-X	$29.99
Teach Yourself VISUALLY™ Investing Online	0-7645-3459-9	$29.99
Teach Yourself VISUALLY™ Networking, 2nd Ed.	0-7645-3534-X	$29.99
Teach Yourself VISUALLY™ Photoshop® 6	0-7645-3513-7	$29.99
Teach Yourself VISUALLY™ Quicken® 2001	0-7645-3526-9	$29.99
Teach Yourself VISUALLY™ Windows® 2000 Server	0-7645-3428-9	$29.99
Teach Yourself VISUALLY™ Windows® Me Millennium Edition	0-7645-3495-5	$29.99
Teach Yourself Windows® 95 VISUALLY™	0-7645-6001-8	$29.99
Teach Yourself Windows® 98 VISUALLY™	0-7645-6025-5	$29.99
Teach Yourself Windows® 2000 Professional VISUALLY™	0-7645-6040-9	$29.99
Teach Yourself Windows NT® 4 VISUALLY™	0-7645-6061-1	$29.99
Teach Yourself Word 97 VISUALLY™	0-7645-6032-8	$29.99

The Visual™ series is available wherever books are sold, or call **1-800-762-2974.** *Outside the US, call* **317-572-3993**

TRADE & INDIVIDUAL ORDERS

Phone: (800) 762-2974
or (317) 572-3993
(8 a.m. – 6 p.m., CST, weekdays)
FAX : (800) 550-2747
or (317) 572-4002

EDUCATIONAL ORDERS & DISCOUNTS

Phone: (800) 434-2086
(8:30 a.m.–5:00 p.m., CST, weekdays)
FAX : (317) 572-4005

CORPORATE ORDERS FOR VISUAL™ SERIES

Phone: (800) 469-6616
(8 a.m.–5 p.m., EST, weekdays)
FAX : (905) 890-9434

Qty	ISBN	Title	Price	Total

Shipping & Handling Charges

	Description	First book	Each add'l. book	Total
Domestic	Normal	$4.50	$1.50	$
	Two Day Air	$8.50	$2.50	$
	Overnight	$18.00	$3.00	$
International	Surface	$8.00	$8.00	$
	Airmail	$16.00	$16.00	$
	DHL Air	$17.00	$17.00	$

Subtotal _____

CA residents add
applicable sales tax _____

IN, MA and MD
residents add
5% sales tax _____

IL residents add
6.25% sales tax _____

RI residents add
7% sales tax _____

TX residents add
8.25% sales tax _____

Shipping _____

Total _____

Ship to:

Name_____

Address_____

Company _____

City/State/Zip_____

Daytime Phone_____

Payment:　□ Check to Hungry Minds (US Funds Only)
　　□ Visa　□ Mastercard　□ American Express

Card # _____ Exp. _____ Signature_____

Hungry Minds™

maranGraphics®